JAMES
MADISON
ALDEN

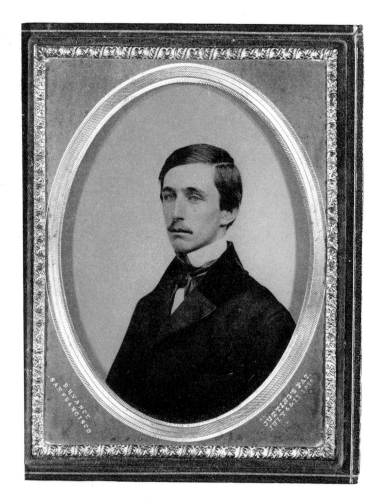

James Madison Alden as a young man.
Ambrotype. R. H. Vance, photographer.
Collection Mrs. Henry Windsor Adams, Gallesville, Maryland.

JAMES MADISON ALDEN

YANKEE ARTIST OF THE PACIFIC COAST, 1854-1860
BY FRANZ STENZEL, M.D.

ACCOMPANYING EXHIBITION PRESENTED AT:
AMON CARTER MUSEUM, FORT WORTH
GLENBOW-ALBERTA INSTITUTE, CALGARY
THE WASHINGTON STATE HISTORICAL SOCIETY, TACOMA
ANCHORAGE HISTORICAL AND FINE ARTS MUSEUM, ANCHORAGE
OKLAHOMA ART CENTER, OKLAHOMA CITY
OREGON HISTORICAL SOCIETY, PORTLAND

AMON CARTER MUSEUM
FORT WORTH

The Amon Carter Museum was established in 1961 under the will of the late
Amon G. Carter for the study and documentation of westering North America.
The program of the Museum, expressed in publications, exhibitions, and
permanent collections, reflects many aspects of American culture, both
historic and contemporary.

The Museum has been assisted by the National Endowment for the Arts in
publication of this catalog and the accompanying exhibition.

PREFACE

Of the major regions of the American West, the Northwest Coast—northern California to Vancouver Island—was historically the earliest to be recorded, and yet the latest to be studied and evaluated by modern scholars. It is the more surprising when we realize that although ships of the major maritime powers, England, Spain, France, and Russia, explored and recorded the American coast, the visual record has been neglected by art historians, relegated to the mountainous documentation of exploration of the New World.

In the past decade our curiosity for these first sightings of the American Northwest has been rewarded by valued studies in the field of North American exploration, and the recognition of a body of pictorial documents of aesthetic quality and great historic value. In Oregon, Franz Stenzel has retrieved nearly two centuries of our recorded experience along the Pacific Coast and the Columbia River through his thorough research on the first travelers in this part of the continent.

The Amon Carter Museum of Western Art shares a scholarly interest in the Northwest, and welcomes this opportunity to present the work of James Madison Alden, artist of the U. S. Coastal Survey, the first survey of this region after acquisition of California, and the Canadian-U. S. Boundary Survey from the Pacific to the Continental Divide. We are honored to recognize the artist, and particularly the work of Franz and Kathy Stenzel, Alden's best friends.

Mitchell A. Wilder

ACKNOWLEDGMENTS

To the approximately 350 institutions, collectors, galleries, and individuals who responded to inquiry, my sincere appreciation. Special thanks to the three granddaughters of James Madison Alden for making available the family collection of documents, photographs, and paintings. Mrs. Henry Windsor Adams enthusiastically spearheaded family participation. Her two sisters, Mrs. J. William McLure and Mrs. Sidney F. Parham, unstintingly joined in providing paintings, documents, and recollections of their grandfather in detailed interviews since 1965. Sadly, Mrs. McLure and Mrs. Parham did not survive to see the results. Thanks, also, to the six great-grandchildren, Vernon Dorsey Adams, Mrs. Albert W. Ayers, Mrs. Robert Herron, J. William McLure, Mrs. Robert W. Orme, and Miss Sarah Alden Parham, who loaned material and provided paintings for illustration.

For this excellent example of bookmaking, my thanks to the Amon Carter Museum of Western Art; to the guiding hand of Mrs. J. Lee Johnson III and her Board of Trustees in providing generous support; to the expertise and experience of Mitchell A. Wilder, Director; Ron Tyler, Curator of History; and the other members of the staff who played varied roles in bringing this book into being. My closest relationship has been with "Mitch" Wilder, and for his continued support, encouragement, and guidance, my warmest thanks and appreciation.

Individuals and institutions who must be thanked for their help in the search for James Madison Alden material and paintings are listed. Any omissions are inadvertent.

Alden Kindred of America, Mrs. W. H. Haslett, Secretary; The Bancroft Library, University of California, Berkeley, James D. Hart, Director; The Provincial Archives and Library of British Columbia, Willard E. Ireland, Librarian and Archivist; The Boston Museum of Fine Arts, Miss Elinor Sayre, Curator of Prints and Drawings; The Beinecke Rare Book and Manuscript Library, Yale University, Archibald Hanna, Curator; Dr. Joseph Baird; Bostonian Society, Mrs. Ropes Cabot, Curator; Lawrence F. Barber; University of British Columbia Library, Special Collections Division, Miss Frances Woodward, Reference Librarian; Boxborough, Massachusetts, Mrs. Clyde L. Richardson, Town Clerk; Public Archives of Canada, C. MacKinnon, Head, Research and Inquiries, Manuscript Division and A. Vachon, Acting Head, Paintings, Drawings and Prints; National Gallery of Canada, Mrs. Mary Clark, Acting Executive Assistant to the Director; California Historical Society, J. S. Holliday, Director; State Historical Society of Colorado, Ms. Alice L. Sharp, Reference Librarian; The Library of Congress, Milton Kaplan, Curator, Historical Prints, Jerry Kearns, Head, Reference Section, and John McDonough, Historian, Manuscript Division; Captain Edward Maynard Day, USN (Ret.); Denver Public Library, Mrs. Alys Freeze, former Head, Western History Department; Glenbow-Alberta Institute, J. A. Hammond, Executive

Vice President; Mrs. Elizabeth Janes; Kennedy Galleries, Inc., Rudolf G. Wunderlich, President, and Mrs. Hermann Wunderlich; Historian Lake County, California, Henry Maudlin; the Mariners Museum, William D. Wilkinson, Director; Metropolitan Museum of Art, Department of Prints, Miss Mary L. Meyers, Associate Curator; Maine Historical Society, Mrs. Esta Jane Astor, Reference Librarian; Lewis L. McArthur; New-York Historical Society, Richard J. Koke, Curator of the Museum, and James Gregory, Librarian; New York Public Library, Miss Elizabeth Roth, Keeper of Prints; The Old Print Shop, Robert L. Harley; Portland, Maine, Mrs. K. M. Lane, City Clerk; National Archives and Records Service: Editor, *Territorial Papers of the U. S.*, Senior Specialist for Western History, John Porter Bloom; former Chief, Cartographic Branch, A. P. Muntz; Diplomatic, Legal and Fiscal Branch, Acting Chief, James B. Rhodes; Civil Archives Division, Industrial and Social Branch, Chief Jerome Finster, and Arthur Hecht; Navy Branch, Archivist in Charge, Elbert L. Huber; Old Military Records Branch, Assistant Chief, Elmer O. Parker; Civil Archives Division, Legislative, Judicial and Fiscal Branch, Chief, Mark G. Eckhoff; United States Navy: Director of Naval History and Curator for the Navy Department, Vice Admiral Edwin B. Hooper, USN (Ret.); Department of the Navy, Assistant Director of Naval History, Captain F. Kent Loomis, USN (Ret.); Department of Navy, Still Photo Branch, Head, Robert A. Carlisle; United States Naval Academy Library, Special Collections, Head, Patrick F. Clausey; Naval Historical Foundation, Biographies Branch, Assistant Curator, Terence P. Bolger; Mr. and Mrs. Lee Stossell; The Sutro Library, Richard H. Dillon, Librarian; The Tate House, Portland, Maine, Chairman, Mrs. M. S. Peabody; Washington State Historical Society, Bruce LeRoy, Director, and Frank L. Green, Librarian; University of Washington Libraries, Special Collections Division, Robert D. Monroe, Head; Ernest D. Wichels, Historian of Mare Island Navy Yard (Ret.)

Special mention for repeated and sustained helpful participation requires me to name Michael Harrison, California historian and bookman, and John Barr Tompkins, Curator, Pictorial Collections at the Bancroft Library.

One person has accompanied and assisted me in traveling, visiting museum and libraries, making research notes, interviewing people, and the diverting part of preparing to write. Then followed the daily treadmill for nine months when that same person assumed the monotonous, sometimes onerous task, of typing unending letters, first, second, and final drafts, arranging material, checking spelling, dates, and names, etc. with an unflagging staunchness that sustained and encouraged my own efforts. We were so absorbed that at night we both dreamed of James Madison Alden.

That person is my much loved wife, Kathryn. Her name does not appear on the title page though she had a great deal to do with the writing of this book.

Franz Stenzel, M. D.
Portland, Oregon
January, 1975

CONTENTS

COLOR PLATES

BLACK AND WHITE PLATES

JAMES
MADISON
ALDEN

I. YOUTH AND ART TRAINING

In April, 1854, a tall lanky youth sporting a newly grown moustache and wearing a new uniform inquired the way to Pacific Wharf on the San Francisco waterfront. Striding along, he could see the patchwork appearance of the city. Hastily built wooden structures stood alongside dirty and worn tents and even some vessels set up on the shore, as if by a hurricane, with entrances cut in their hulls. These were used as offices, stores, and banks. The gold rush had reached a plateau of activity and the streets were crowded. The excitement around him stimulated his emotions and he quickened his pace as he approached the waterfront—and the adventure that lay before him.

Pacific Wharf was deserted. He made his way to a warehouse door beneath a bold sign, United States Coast Survey. Entering the office, he found an older man casually dressed in Navy attire seated at a desk. The young officer had doubtless practiced for this moment a hundred times. He probably saluted briskly and reported to his new superior in a trembling voice.

The older man recognized the Yankee accent. The black hair, the striking pale blue eyes, and the angular face strongly resembled the features of Lieutenant James Alden, the commanding officer. The arrival of the commander's nephew had been announced to the officer behind the desk. He introduced himself as Jim Thompson, the purser of the *Active*, and they became acquainted. Thompson mentioned that the *Active* with Lieutenant Alden aboard was surveying to the south in the Santa Barbara Channel and was due to return most any day.

Alden and Jim Thompson spent much of the day together. A horse-drawn wagon carried them to the water's edge in another part of San Francisco Bay. Alden learned that the vast flotilla of neglected ships, with rotting sails and shrouds partially torn away by the winds, had accumulated in the past five years since gold was discovered. The crews had deserted to the mines, leaving the vessels to the rats and ravages of the elements. He related his sailing from Boston to Panama in February, and his crossing the isthmus partially by small boat on the Chagras River and then on foot. He had lost a month in waiting for a vessel to continue on to San Francisco. He had arrived only that day. Alden's eyes probably sparkled as he related his tale to the older naval officer. This was high adventure and quite in contrast to his ordered life as a schoolboy in conservative New England.

Alden's bedroll and his other gear from aboard ship were loaded into the rented boat and the pair rowed back to shore. The wagon carried them to the Survey Office and warehouse where his belongings were stowed. His new sea chest was a fine piece of craftsmanship, made of beautifully grained butternut wood with a brass plaque engraved "James Madison Alden."[1]

Now that he had arrived in San Francisco, Alden proved eager for the next phase of his new career. During supper at a waterfront restaurant he probably plied Jim with questions and in turn, answered Jim's queries. Two hundred thousand people speaking a dozen or more languages and from all parts of the world had poured into San Francisco in the first two years after gold was discovered. The sleepy little town could not begin to house or feed the gold seekers. They slept wherever there was room to spread a bedroll. They paid excessive prices for poor food. In the intervening five years things were not much improved. A local rumor claimed that it was cheaper still to have laundry done in China and shipped back than to have it done locally. Everyone wanted to try his hand at mining. Picks, shovels, and pans were soon scarcer than gold itself. The inexperienced, half-starved, and poorly equipped often fell sick by the wayside. Most who made it to the mines found all claims staked. Some desperately worked miserably poor gravel beds until their hopes ran out. The reports were only of big strikes and lucky miners. So immigrants kept coming. Those skilled in building, carpentry, masonry, and even helpers, were better paid than most miners. Still the newcomers had to try for gold. They would not hear any words of advice. They had to learn from experience.

Alden probably was shocked at Jim's revelations but knew that his new friend spoke from certain knowledge. Reality was different from the romantic fantasy he had gleaned from reading and the news he heard bandied about in Boston.

Alden, in turn, related his interest since childhood in drawing, his art training for the Survey, and his uncle's invitation for him to join in recording the first government survey of the West Coast. Alden was born in the small village of Boxborough about twenty-five miles northwest of Boston on September 26, 1834. His parents, Captain Robert Tate Alden and Sarah Brewer Taylor, both of Boston, and their new son returned to Boston, where his five sisters were born. The Captain, like most of his family, was engaged in maritime pursuits. He owned and operated several vessels during his life and was a noted sailmaker.[2]

Alden attended Elliott Grammar School in Boston. A report card for January, 1844, indicates that he was in the third class and attained a rank of fourth in his division. He was graduated in July, 1849, with honors, winning the Benjamin Franklin Medal as a prize in American Literature.[3]

Alden next attended English High School, also in Boston. Three quarterly report cards, dated 1850 and 1851, now among family records, indicate that he was fourth in his division. Teaching of drawing and music, recently introduced into the curriculum, provided instruction and stimulated Alden's continued interest in art. He graduated in July, 1852.

Family lore attests to his interest in drawing since an early age. The first example located is dated 1850 and pictures a dwelling and an outbuilding near a river's edge. It is an oval pen and ink drawing labeled "Near Mouth of Narraguagus River—Milbridge [sic] Maine." Others are extant showing the homes of his relatives scattered about New England. These drawings lack organization and perspective, with little to portend his later accomplished work.

Alden was close to his father; there were five sisters at home and sometimes he might have felt outnumbered. He valued the opportunities to go fishing with his father, to take long walks with him, and to visit his place of business on the waterfront. 108 Commerce Street had a special significance for Alden. There was the odor of creosote which pervaded the ships' supplies, the cordage, the gleaming brass, the red and green lanterns and all of the racks and bins on the first floor. He was not sure where the smell came from, but it was pleasant. It even ascended into the sail loft above.

It was here that communication between the father and his only son reached an apex. Young Alden found himself assimilating, using and reusing, his father's expressions—Yankee phrases and quotations from past generations. The meaning was so clear when his father spoke that Alden never forgot them.

On one of their first fishing trips, the father told of the Pilgrims and their struggle for freedom to worship. He described their sailing from England,

the long voyage across the Atlantic, and finally, the landing of the small craft and the settlement at Plymouth, Massachusetts. He told of John Alden who arrived on the *Mayflower* in 1620. The son probably had just learned that name in school and was surprised when his father told him that he was seventh in direct male descent from John Alden and his wife Priscilla Mullens. The father continued on to tell of the struggles of the new colony and of John Alden's role in assuming financial responsibility, along with the other leaders, as a signer of the Mayflower Compact. More family lore followed.

Alden's questions were endless. It was the beginning of his interest in family history. He began keeping a record of his ancestors, adding dates, names and details as related in the stories by his father and mother. He also kept a scrapbook of newspaper clippings concerning his family and the people with whom he was associated.

His uncle, James Alden, Jr., became his principal and enduring hero when in Passed Midshipman's uniform he visited the Alden home. He had just signed on the United States Exploring Expedition, the Navy's first round-the-world cruise, with Lieutenant Charles Wilkes in command. The imprint was indelible in Alden's young mind. He probably followed his uncle's exploits on the cruise by asking an incessant string of questions.

James Alden, Jr., exhibited certain qualities which won the approval of his superior officers and the loyal support of his men. He did not get caught up on either side of the controversial aspects of the 1838-1841 Wilkes Expedition which resulted in the court-martial of Lieutenant Wilkes and a reprimand for excessive flogging of members of his crew. Rather, the Passed Midshipman maintained his dedication to the Navy by his controlled devotion to his assigned duty. He always tended to look and act the part of the ideal young officer. He utilized tact or daring, restraint or zest, steadfastness or innovation as each situation required. He could adequately verbalize while keeping an attractive degree of humility. Before the completion of the Exploring Expedition, he received his commission as Lieutenant in 1841.

Alden was no doubt proud to learn of his uncle's promotion. His uncle's daring participation in the Mexican War at the capture of Vera Cruz and Tabasco led to published citations. These newspaper clippings were added to Alden's growing scrapbook. Lieutenant Alden was given command of his own ship, and both the vessel and its captain were loaned by the Navy to the United States Coast Survey. The assignment placed Lieutenant Alden in charge of the hydrographic portion of the new survey along the West

Coast. In early 1853 Alden wrote to his uncle in San Francisco expressing interest in joining the Survey. He enclosed some of his drawings.

In April, 1853, Alden's father died of pneumonia. On that day Alden sought solace in the yard behind the house, where he drew in pencil a 4½ by 6 inch picture. On the face is noted "J. M. Alden. Rear view of House No. 222 Hanover St. Boston, Near Charles Street. April 12, 1853." (Plate 1) The drawing shows the adjacent houses with their chimneys and roof lines. Included is the cupola of the new Old North Church built by the famous architect Charles Bulfinch in 1804.[4] It is a simple drawing but shows improvement. The buildings are related so that the picture achieves unity. The successful juxtaposition of roof lines, windows, chimneys and the cupola evidences new understanding of perspective. Alden placed the drawing in a leatherbound scrapbook. Years later, his daughter was to add beneath his inscription "Where my father lived."

With a letter of condolence from Lieutenant James Alden came a separate letter to Alden. The opportunity to gain experience aboard ship, as well as to test his ability as an artist had been arranged. He was to enlist in the Navy at the nearby Charlestown base. He would be assigned to the United States Coast Survey. Then, after a period of instruction in cartographic drawing at the Survey Headquarters' Printing Office in Washington City, he would become a junior officer on the Survey ship U. S. S. *Active*.

Alden wrote a letter of thanks promising his best efforts to improve his drawing and be a credit to his uncle and the Navy. A note soon arrived from Dr. Abraham Thompson of Charlestown.[5] He would accompany Alden to the Charlestown Navy Yard for his induction.

Alden completed necessary arrangements and traveled to the nation's Capitol. He located a room near the Printing Office. Since it was Sunday, he spent the rest of the day walking around the town. It was his first visit to Washington City. He probably delighted in seeing many of the official buildings including the Capitol and the White House. He was fortunate to see President Franklin Pierce and his wife leaving in their carriage. Unquestionably exhilarated, he returned to his boarding house for supper. After completing letters to his mother, Lieutenant Alden, and Dr. Thompson, he retired in anticipation of the day to follow.

Alden's arrival at the Printing Office was expected, and he was introduced to several of the cartographers and engravers. On request he showed some of his drawings and was advised that the requirements in drawing were for scientific rather than artistic use. The Survey stressed drawing to

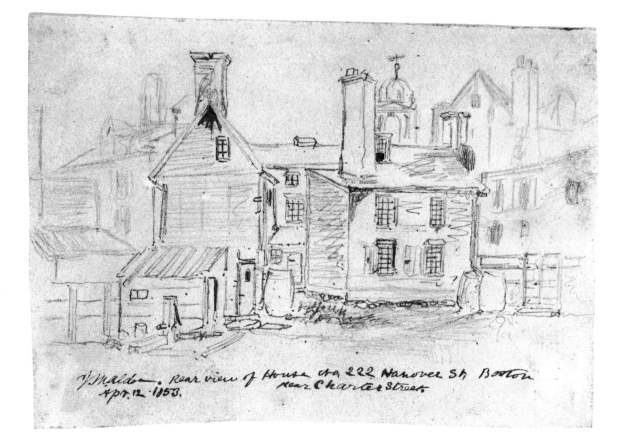

Plate 1. House at 222 Hanover Street.
James Madison Alden lived in the house at 222 Hanover Street, Boston in 1853.
The cupola in the background is the old New North Church built by Charles Bulfinch
in 1804. The artist's drawing is from his own scrapbook.
Pencil, 4⅛ x 6⅛ inches, 1853.
Collection Mr. and Mrs. Henry Windsor Adams, Galesville, Maryland.

scale, accuracy to the finest detail, and shading or color were used only to indicate distance. The office's charts were used all over the globe. They supplied views to point out important landmarks and unfamiliar harbors, also to avoid deceptive hazards. Looking down on a chart gave a picture that a bird flying high in the air could see. From the ship's bridge the problem was different. For example an island, even at some distance from the shore, may look as if it were part of the mainland. Difference in shading or variation in color indicated its separation from the mainland.

Alden was given a book by one of his instructors on the history of the United States Coast Survey with the suggestion that he learn about the organization he was joining. The Coast Survey was the oldest bureau of the Federal Government with its inception during the presidency of Thomas Jefferson. A restrictive, German-born Superintendent, Ferdinand R. Hassler, had no faith in American scientist and instruments, and had ordered all his instruments from Europe. But the War of 1812 necessitated canceling appropriations for the Coast Survey.

Subsequently Alexander Dallas Bache, great-grandson of Benjamin Franklin, was made Superintendent. Beside being immensely popular with his men, he was a scientist of international renown and his recommendations carried great weight with Congress. Adequate annual funds moved the work forward, and every year more of the Atlantic Coast was surveyed and charted. Alden noted that each area was completely surveyed, the depth of waters measured and the nature of the bottom noted, obstructions located, and accurate longitude and latitude determined. Then, by copper plate engraving, a chart was issued recording all of the above information which was of inestimable value to navigation for peacetime and in wartime defense. Alden was apprised of the history and tradition of the Coast Survey and better understood the aims of the service.

Gradually, by example and by drawing from exact charts, Alden absorbed the basics of cartography. He was also finding answers to drawing problems which had puzzled him. The techniques employed by cartographers and knowledge of the devices used by engravers was fundamental. He had been drawing for so long that he readily grasped what was new to him and expanded his capabilities. His interest and enthusiasm were apparent to his instructors. The work was engrossing, and the weeks grew into months. Alden could now evaluate his own work and could gauge the progress he had made.

As he neared completion of his training, young Alden learned of an ambitious project about to be undertaken. Subject to final arrangement, the Congress of the United States would authorize the publication of a ten

to twelve volume report on the transcontinental exploration for the route of the proposed railroad. Chief Artist John Mix Stanley and his assisting artists had prepared watercolor paintings illustrating the progress of the expedition, the Indians encountered, the scenic rivers and mountain passes, and other natural formations along the route to the Pacific Ocean. The large, handsome volumes would be generously illustrated. The cost now being whispered was a staggering figure.

The project would be certain to enhance the esteem of the United States of America around the world and would be visible evidence of our national excellence in art and in science. Separate volumes would consider the animal life, the botany, the character of the soil, mineral deposits, available waterpower, and those characteristics to induce migration and industry so as to fill the great empty space. Finally, it was believed that the publication would insure the success of the long anticipated transcontinental railway.

Since Congress was establishing a precedent in fostering the railroad volumes, it seemed not unlikely that the first survey of the West Coast would be considered worthy of publication by Congress.

Toward this end, Lieutenant Alden arranged further training for his nephew and explained that William McMurtrie was the designated Official Artist. Young Alden would be working with him, but with a difference in objective. McMurtrie was to furnish views from which the Survey would select for publication on the navigational charts. Alden's work would go further, using color and making each picture artistically appealing with the objective of possible publication.

It was arranged that Professor Thomas Cummings of New York City would accept Alden as his pupil.[6] Cummings was a fine teacher and helped to train several expedition artists, including Alfred Agate who headed the art contingent for the Wilkes Expedition, according to Lieutenant Alden. Agate spoke well of Professor Cummings and had expressed to Lieutenant Alden his debt to the professor for the help he received in preparation for that *tour du monde*. Professor Cummings was expecting to hear from Alden on his arrival in New York City.

Alden seized on the chance to further expand his art capabilities. He seems to have worked under Professor Cummings from September, 1853, through January, 1854. No art-related books published by this date were found in Alden's library to indicate his interest in or possible influence of any certain artists. He had the opportunity of seeing exhibitions and galleries while studying with Professor Cummings in New York City. That his own work improved dramatically, there is little doubt.

About the first of February, 1854, following a visit to his family, Alden sailed for Panama on the first leg of the trip to join his uncle in San Francisco.

The *Active* returned from the spring survey in Santa Barbara Channel and approached her berth at Pacific Wharf.[7] As she neared her moorage, Lieutenant Alden, in the wheelhouse, probably chuckled as he recognized the spare young man on the pier. As soon as the gangplank was positioned, the youth probably bounded aboard and embraced the captain.

Alden met the captain's wife, his Aunt Sarah, and became acquainted with the officers and crew.[8] They quickly solved the dilemma of the similar names by calling him "Madison." His father had admired James Madison and named his son to honor the fourth President of the United States. His proper name was entered in the ship's log.[9]

The days were busy in preparation for the cruise to survey in northern waters. Alden was surprised at the vast stores of food and sundries loaded each day. The days in port enabled him to explore San Francisco. His wanderings took him to the burned-out four-story brick building on California and Montgomery Streets. The stark skeleton had been the Custom House and the warehouse of the Coast Survey. Valuable instruments and all stored supplies had been burned. The building had been replaced by the warehouse and offices on Pacific Wharf. He later sat for his photographic portrait. It was placed in a gilded metal frame and housed in a leather case with a red velvet lining. He sent it home to his mother. (*Frontispiece*)

One evening Alden was taken by his uncle to visit Assistant George Davidson in his home. Uncle James briefed him concerning the man he was to meet. Davidson had been a student under Survey Superintendent Alexander Dallas Bache, when the latter was a teacher in Philadelphia's Central High School. Bache became Chairman of Chemistry and Natural Philosophy at the University of Pennsylvania, and Davidson had followed him there. Both had achieved world renown for their excellence in science. Bache had become Superintendent of the Coast Survey in 1843, and Davidson had joined the Survey two years later. In June, 1850, Davidson had arrived in San Francisco to become Superintendent of the Survey on the West Coast and was engaged there for the next fifty years.[10] Davidson, James S. Lawson, his Chief Assistant,[11] an associate from Central High School, and two volunteer Assistants were chosen for their superior work to form the first Survey party in the West. Alden was doubtless impressed by the tradition and dedication of the Survey leaders.

Alden and his uncle arrived at the Davidson home and the neophyte was introduced to the thirty year old veteran. Davidson was a tall man. His full

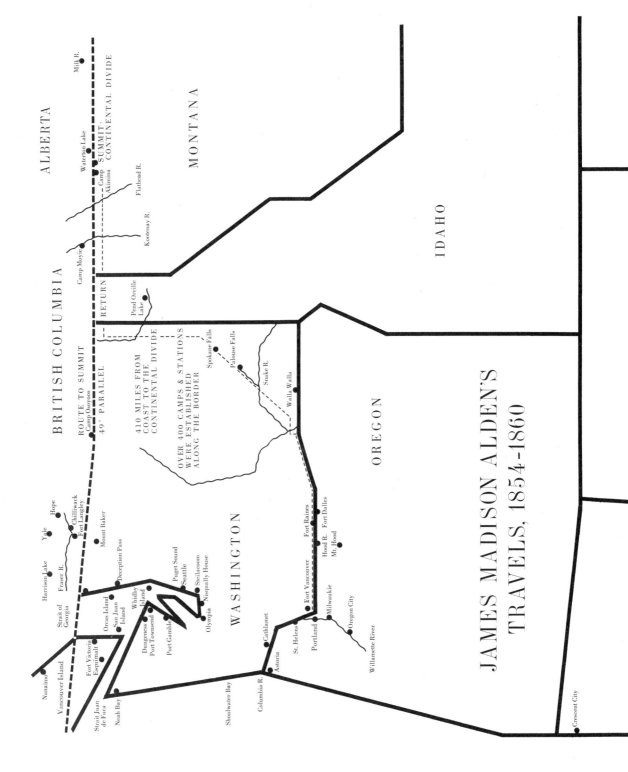

JAMES MADISON ALDEN'S
TRAVELS, 1854-1860

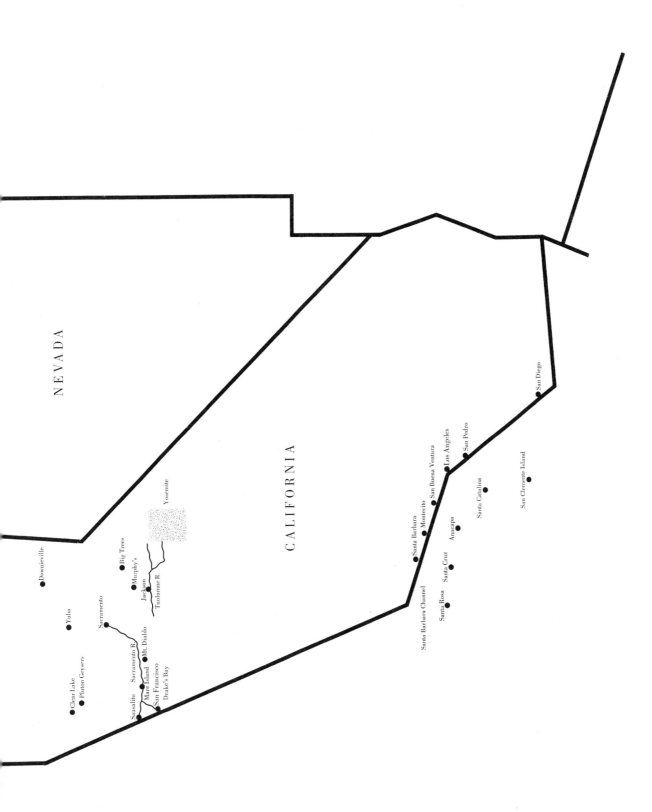

dark beard accentuated his bright eyes. He radiated a kindly no-nonsense aura as he greeted Alden.

Davidson probably inquired about the recent progress in the Santa Barbara Channel as he and Lieutenant Alden spoke of various problems. Some objectives of the seasonal survey in Oregon Territory likely were reviewed while Alden listened with great interest. He was presumably flattered by their open consideration of Survey problems in his presence and felt it was a vote of confidence. He was aware of the respect with which everyone, including Assistant Davidson, regarded his uncle.

Davidson probably had seen Alden's work in paintings Lieutenant Alden had shown him. He might have pointed out the opportunity of making a record of the entire coast from Mexico to Canada, as few others could because it was all changing so rapidly. There were still wild Indians and the country was wild, especially in the Oregon and Washington territories. Alden's sense of adventure probably was evident as he inquired regarding Davidson's close calls with the Indians.

As the evening progressed, Assistant Davidson might have regaled his listeners with the story of the occupation of Neeah Station in Oregon Territory (known now as Neah Bay in the state of Washington). Hostile Indians were a constant and real threat. Only the presence of armed guards, particularly at night, kept the Survey party from being attacked. Revolvers were often fired in full view of the Indians. Each man drew a revolver out of a chest which contained many revolvers and after firing once, replaced it in the chest. The Indians assumed they were seeing a demonstration of a white man's revolver which would fire and refire indefinitely without reloading. The surveyors could have fired sixty rounds without reloading. Guard was kept eight hours every night.[12]

Meantime, there was some serious work to be done by the Survey. The United States acquired California in 1848, at the end of the Mexican War. Almost 1,100 miles of coastline were added to our boundary. There was not a lighthouse, buoy, or any other aid to navigation along the entire western coast.

Gold was discovered January 24 at Sutter's Fort, forty miles from Sacramento, a week before the treaty with Mexico was signed. It took time for the word to spread in California and then around the world. Practically all of the quarter million gold seekers came by ship. No navigational charts were available. Land maps from the Wilkes Exploring Expedition were used by some vessels sailing from the East Coast of the United States, but they were of little help. The latitude was in error by as much as ten to fifteen degrees.

The result was frequent shipwreck along the coast, particularly in the fog. Worst of all, the hazards of the Golden Gate to an unfamiliar navigator caused many to founder. The deficiency was recognized by 1848, and the problem became the first priority of the Survey. Superintendent Bache selected the Survey schooner *Ewing* and placed United States Navy Lieutenant William Pope McArthur in command. By the time she was fitted out and sailed around the horn, it was a year later. Gold Fever was raging. Pay for the crew was but a small fraction of what they would earn ashore. The bay was filled with deserted ships. The crews were off to the "diggins." McArthur took the ship to Monterey in the hope of keeping the crew aboard. "When the sounding began it was often necessary to have the boats [*sic*] crew in irons to prevent their desertion. So great was the temptation to desert that the men would submit to any loss, resort to violence, and even attempt murder to get away," Assistant Lawson reported.[13]

On the night of September 13, 1849, five enlisted men tried to escape by throwing an officer overboard. They were apprehended, and a court-martial was convened. Three of the men were flogged, and the two principals were hanged. One was left dangling from the rigging of the flagship U. S. S. *Savanah* in Sausalito, and the other from the *Ewing* in the San Francisco harbor. Their bodies hung in view for one and one half hours as a warning to potential deserters.[14]

Government wages failed to attract enough men to fill the vacancies in the crew. In December, 1849, McArthur took the *Ewing* to the Hawaiian Islands. He hired some Kanakas at Survey pay rates. On April 1, 1850, he sailed through the Golden Gate and northward up the coast to start the survey.[15]

Before the year of 1850 was over, three-sheet preliminary reconnaissance charts of the West Coast of the United States had been published by the United States Coast Survey. Though the charts needed correction and refinement, they were a great boon to navigation and the pressure was off until the final charts could be issued.

Lieutenant McArthur had sailed for Panama on his way to Washington City. He was to survey a larger steamer to replace the *Ewing*. He became ill and died of yellow fever the day before Christmas as his vessel was entering the harbor at Panama City. His body was returned for burial on Mare Island, California, the site he had recommended for a navy yard. Lieutenant Alden had been selected to succeed McArthur as head of the hydrographic portion of the survey.

Davidson's summary of the Survey's activities probably sobered young Alden. His new job would obviously not be without difficulty.

While the *Active* was made ready, the reconnaissance of San Francisco Bay continued. In the winter season, diverse areas of the bay were surveyed and sounded with the use of small boats. Alden observed the information gathering process and took advantage of the opportunity to visit and paint several small communities around the edge of the bay.

He became acquainted with Governor Isaac Ingalls Stevens of the newly created Washington Territory and currently head of the northern exploration party for the projected transcontinental railroad. The exploration had completed its first year's work with great success. His knowledge of the West and of the savage Indians made him the object of attention.

He had a particular interest for members of the United States Coast Survey. Five years previously, Superintendent Bache had appointed Major I. I. Stevens as second in charge of the Survey. Stevens had completed a masterful accomplishment in reorganizing the District of Columbia offices. From a few employees in a single house, the office had burgeoned to almost 100 men in several adjacent houses. Stevens had transformed the haphazard organization into a model of efficiency and had endeared himself to Bache and all under him. He resigned to accept new responsibilities.

Stevens was in San Francisco on his way to the East. The newspapers made much of his visit. On April 13, he was introduced by Mayor William K. Garrison to the crowded audience in the Music Hall on Bush Street. Alden and his uncle were in the audience and spoke to Governor Stevens after his talk. The next day, the Governor visited the *Active*.[16]

Alden's initiation to sea duty on the *Active* came on May 8 when a distress call was received. The *Sea Bird* lost her rudder and was drifting south of San Francisco. The crew was hastily assembled and the search began. The distressed vessel was sighted eight days later and was towed 200 miles back to port. A second ship, the steam packet *Peytona*, became disabled on her way from San Francisco to Oregon two weeks after the first rescue. She was found drifting and towed back to San Francisco. Voluntary rescue efforts were commonplace in Lieutenant Alden's record and added to his popularity.

Alden was becoming familiar with procedure aboard ship and naval jargon. The two rescue episodes were exciting, and he relayed his experience in a letter home.

Alden and his uncle were becoming better acquainted. Alden was increasingly aware of Aunt Sarah's emotional problem. She was sometimes depressed and silent, at other times overly talkative. She misinterpreted situations and conversations. Alden learned that she had become very an-

gry with George Davidson, insisting he had insulted her. She would not be pacified. His presence or the mention of his name distressed her, so she had not been included in the visit to Assistant Davidson's home. Alden increasingly tried to placate his aunt. He seemed able to quiet her. Sometimes he took her for a walk or a carriage ride. The other ship's officers, too, were helpful and tactfully varied their manner according to her fluctuation in mood. Alden realized that his aunt could not be left ashore by herself and yet it was difficult at times to have her aboard.

Departure time was near. Alden was summoned by his uncle, who wanted to be certain of his having adequate supplies for drawing and painting. There would be no source of art materials once the *Active* left San Francisco.

Alden probably inquired about McMurtrie, who had gone to complete drawings for which the Printing Office was waiting. He likely felt he would be less distracted if he did not remain on board. McMurtrie's work had been delayed because of his illness, which was a peculiar kind of rheumatism. He walked with difficulty and had considerable pain. When his uncle suggested he consider McMurtrie as a partner and not as a rival, Alden probably was relieved. He almost surely had been worrying about his relationship with the Official Artist.

Alden's uncle presumably gave him some rules of safety. They were forging into wild country and the foremost precaution was never being alone. The Indians were unpredictable. Usually friendly, they could become agitated and hostile for no apparent reason. Visiting members of some tribes from Vancouver Island were the troublemakers and incited the natives of Puget Sound. Constant caution was advised. Arms would be issued when needed and there would be practice in their use.

There were other hazards. Wild animals usually shrank from man and kept out of sight, but they might attack during mating season, when they felt threatened or when there were young offspring.

Ability to swim was also important. Transferring into or out of a boat required knowledge; an unskilled man could risk not only his own but other lives by causing a boat to capsize. There had been drownings among the crew on Survey work. It required a good swimmer to oppose the strong currents and a man could stay alive only a short time in cold water.

The admonition might have been given in a firm voice to be fully regarded and practiced. Alden promised his uncle that he would observe and learn, applying his best efforts to be alert. This probably was their last talk prior to the journey up the coast.

II. ARTIST ON THE SURVEY OF
THE WEST COAST, 1854-1857

On Friday morning, June 30, the *Active* departed San Francisco and headed toward her 1854 surveying season in the Columbia River. Steam engines pulsing and paddle wheels on each side whooshing, she sped through the Golden Gate into the Straits of the Farralones and then veered northward. The fog of early morning had dissipated and the high California coastline passed in review. So early in the season the foliage was green, contrasting with the red-brown earth colors of the cliffs and the blue water breaking into white-crested waves along the shore. It was a most exhilarating trip for Alden, now launched as a recorder of visual history with a mission to be accomplished.

Alden and the Official Artist, William Birch McMurtrie, had first met a short time before the ship departed. They surely eyed each other probingly, McMurtrie wondering if he were seeing his replacement and Alden wondering if he would qualify in the opinion of McMurtrie. The uncertainty of the first moments likely passed into compatible interest. They were on their way toward an enduring relationship. McMurtrie became like a father. He was twice Alden's age and almost as old as Alden's uncle. He was a veteran, having served as artist under William Pope McArthur from the beginning of the Survey in 1849. He was helpful to Alden in his acclimatization to the Survey. The never-ending problems and techniques of their art provided ample material for discussion as they traveled and worked together.[1]

McMurtrie was to take views for the Survey as usual, and Alden was to make a pictorial record of the country visited for his uncle. Lieutenant Alden probably suggested their working together and, when practical, recording the same scene. He might have reminded them of Titian Peale and

his unfortunate experience on the Wilkes Expedition. The artist was detached to join the Emmons party on the first overland trip by white men from Oregon to California. His horse lost its footing and fell into the canyon of the Sacramento River. Peale's finished work and drawing materials were irretrievably lost.

There was a considerable similarity in Alden's and McMurtrie's work, but McMurtrie used a heavy line to accentuate the division of the land against the sky and stressed the shoreline against the water, with little detail between the two. Alden, in contrast, blended the upper limit of the land with the cloud formation in the sky. The ocean along the shore made a gradual transition. The shallow water was indicated by more pronounced waves, these changed to whitecaps, and finally broke into a foamy ribbon along the shore. Between the shore and the horizon, the steep cliff held the indefinite appearance of a series of eroded steps. Alden had accentuated the steps into a well defined pattern. Even before Alden applied his watercolor, the content of his picture was greater and more highly organized. Rather than stressing the components as water, land, and sky, he had molded the elements into a harmonious relationship.

McMurtrie admired Alden's work. Alden pointed out that McMurtrie's drawing preserved strict scale and accuracy, while he was unaccustomed to drawing from a moving boat where the scene changed from each angle and made a problem he would have to work on.

McMurtrie likely seized the chance to help Alden and demonstrated his dividing the drawing into three parts. The approaching section of the subject became the right third which he completed first. Then when the central portion of the picture came into view, he concentrated on that part of the drawing, and completed the last third as the view was receding.

Shortly after daybreak on July 2, Alden stood with Lieutenant Cuyler in the wheelhouse. The ship was about six miles out from the coast and turning in toward the mouth of the Columbia River. Cape Disappointment loomed high to port and in half an hour was abreast. To starboard lay Peacock Spit, named for the Wilkes Expedition ship which had foundered here thirteen years ago. It was high tide and the spit was submerged with only a few timbers of the wrecked vessel protruding above water.

Lieutenant Alden entered the wheelhouse and asked for the latest sounding. There was plenty of depth. It was standstill with no tidal movement. The Columbia bar, feared from Port Said to Tasmania to Hong Kong, was temporarily as smooth as glass. The ship felt differently and responded less to the wheel's turning. In a few minutes they were in the river and welcomed the sight; a small cluster of buildings marked the village of Astoria.

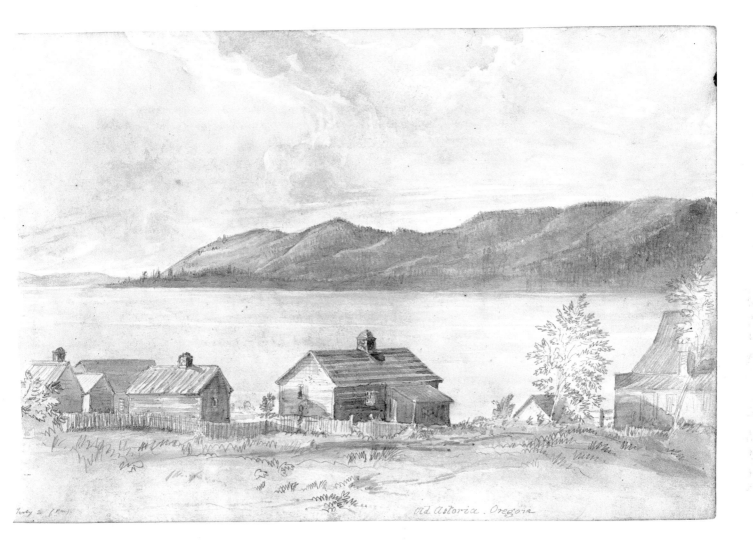

Old Astoria. Oregon

Plate 2. Old Astoria, Oregon.
Watercolor, 7⅛ x 10⅝ inches, 1854.
Collection Mr. and Mrs. Albert W. Ayers, Jr., Darien, Connecticut.

They continued up to Astor's Point. There was no wharf large enough for the *Active* so the anchor was dropped in the river. The arrival of a vessel was infrequent enough to assure a gathering to witness the event. Long-awaited supplies, newspapers, and mail were hopefully anticipated.

Alden's first Oregon Territory scene is dated to the exact hour. (Plate 2) The pen drawing of old Astoria is the earliest of Alden's surviving work so far located from his 1854 Columbia River trip. The seven wooden structures in proximity to the bank overlooking the river present a similar appearance to the pencil drawing by Dr. Charles Guillou, U. S. N. Assistant Surgeon, shipwrecked on the *Peacock* in 1841.[2]

At the same location, too, is *Astoria, on the Columbia River*, the 1841 drawing by Alfred T. Agate, Chief Artist of the United States Exploring Expedition.[3]

Alden then illustrated *Old Astoria, Columbia River from the Beach near the "Union House."* This view, twelve miles from the mouth of the river, is almost identical in location with *Fort George Formerly Astoria* painted by Lieutenant, and later Sir, Henry Warre in 1846.[4] Astoria was still Fort George to that English tourist, in reality an intelligence agent who reported on the number of settlers, armaments, preparedness, and general activities of the Americans *vis-a-vis* the Hudson's Bay Company. Alden's watercolor shows the addition of a single building in eight years.

Around a bend in the river shoreline, the first real estate subdivision of the region was taking place. *New Astoria, Oregon* (Plate 3) illustrates the presence of several homes and commercial buildings. This proliferation of town sites was to occur all along the banks of the river. There was free land for anyone who would build a home or a business building. Each town site vied to be the future metropolis.

In Alden's wandering, he found a *Grave Yard—Astoria.* (Plate 4) "Here are some of the old pioneers of Oregon buried in the forest near the village of Astoria," he wrote. "The two graves near each other are those of a U. S. soldier & sailor who died here some years since." The names and dates are not decipherable. Possibly they were casualties from the *Peacock* or even an earlier shipwreck.

The *Active* halted about twenty miles from Astoria at Cathlamet on the north bank of the Columbia. A call was made at the home of James Birnie, the Scottish factor of a Hudson's Bay Company agency, whose house stood on the riverbank. He had been stationed at Fort George from 1820 until he retired as Chief Factor when the post reverted to the Americans after the war with England and was again called Astoria.

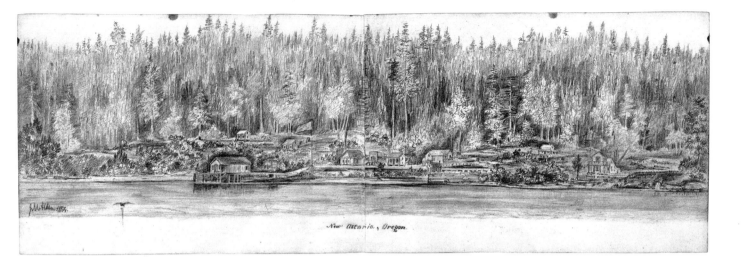

New Astoria, Oregon.

Plate 3. New Astoria, Oregon.
Pencil, 7⅛ x 21¼ inches, 1854.
Collection Dr. and Mrs. Franz Stenzel, Portland, Oregon.

22

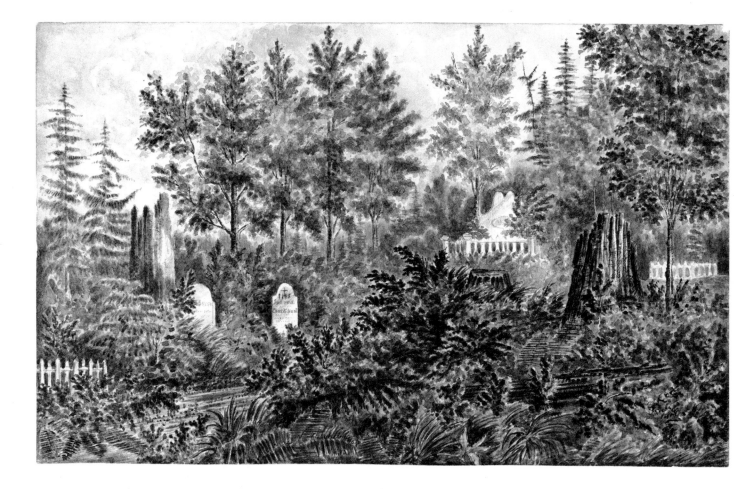

Plate 4. Grave Yard — Astoria.
Watercolor, 6¼ x 10¼ inches, [1854].
Collection Dr. and Mrs. Franz Stenzel, Portland, Oregon.

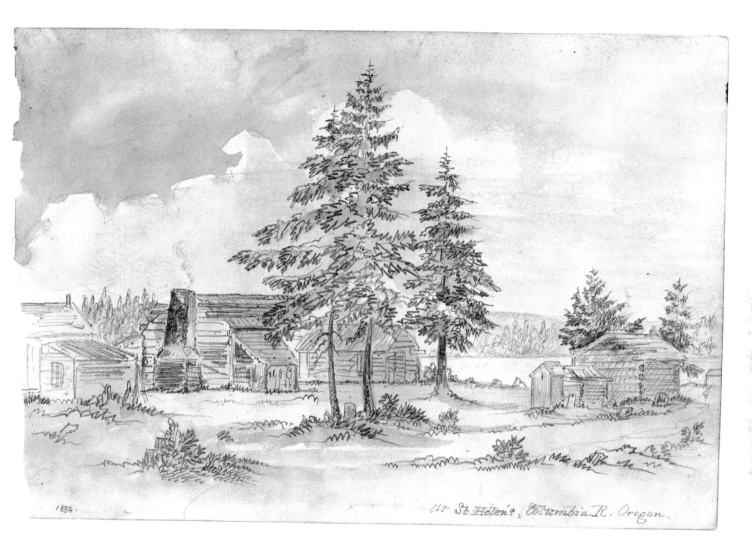

1834.

At St. Helen's, Columbia R. Oregon.

Plate 5. At St. Helen's, Columbia R. Oregon.
Henry Knighton's claim at St. Helen's, Oregon Territory, on the Columbia River, 1854.
Pencil/wash, 7⅛ x 10¾ inches, 1854.
Collection Mr. and Mrs. Albert W. Ayers, Jr., Darien, Connecticut.

Alden was introduced to the full-bearded factor by his uncle and was fascinated by the Indian half-breed wife and the brood of small children who scurried timidly away. Birnie's thirty-four years in the region made him a knowing source of local information.

As the vessel proceeded up the Columbia River, Alden made drawings. It was early summer and the runoff from mountain snows was still keeping the water high. In this area, the bank on one side is precipitous, the opposite is flat and swampy. The silt carried down by swift waters forms shifting sandbars and necessary sounding made the going slow. They passed several tiny communities on the upriver trip. Farther along, the river flows between flat banks on each side, punctuated by varying sized creeks and rivers which flowed into the Columbia.

About seventy-five miles from Astoria, Alden drew *At St. Helen's, Columbia R. Oregon* (Plate 5) at the land claim of Captain Henry M. Knighton, born in St. Helens, Lancashire, England. In 1847 he purchased the Oregon Territory land and named it after his home town. In 1850 he engaged William Henry Tappan, artist and veteran of the Mounted Rifles who crossed the plains to Oregon in 1849, to survey the town and lay out the streets and lots. Knighton's enterprising activity soon made St. Helens a threatening rival of Portland.[5] Knighton was an informed and important man, and Lieutenant Alden would not have passed by without paying his respects. Alden probably met the proprietor of the township and drew views of Knighton's projected metropolis.

This was not purely a social call, however. Lieutenant Alden was assessing the situation concerning "Indian trouble" in each area he visited. Older settlers were aware of the wave of restlessness. In some instances, trusted Indians were showing thinly veiled antagonism. The open hostility on the Plains and in the Southwest was known and there was fear that the Indians in the Northwest might openly attack.

The *Active* passed the mouth of the Willamette River and came to anchor at Fort Vancouver. There are no 1854 drawings or watercolors to suggest a visit up the Willamette to Portland or Oregon City in that year. Fort Vancouver on the Columbia River is situated twelve miles above the mouth of the Willamette and extends back from the Columbia on a broad plain. In 1849 the Hudson's Bay Company had moved to their Northwest Headquarters in Victoria, British Columbia, but maintained a store and trading post at Fort Vancouver until 1859. Alden made drawings of the fort, the earliest dated on July 27. He shows the American flag flying over the fort in two of seven renditions. One pencil and watercolor view shows the American flag being raised to its full height. (Plate C-1) It is early morning, since shadows

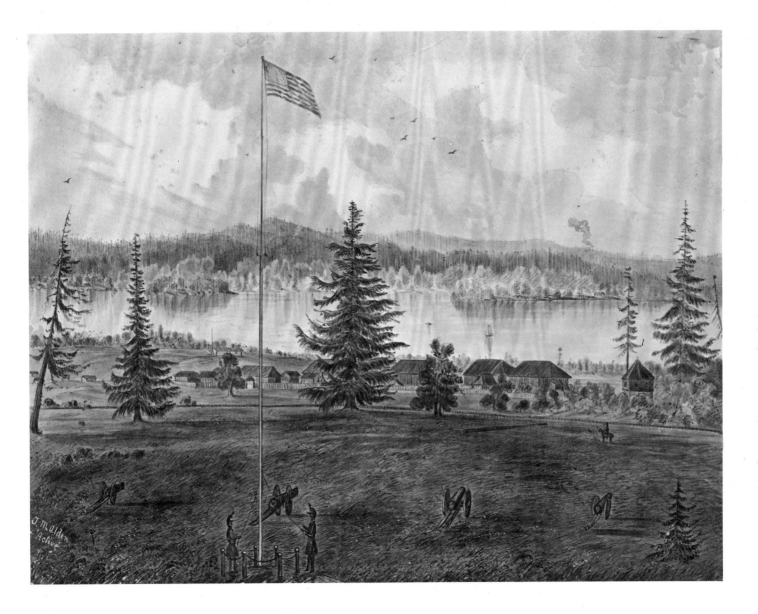

Plate C-1. Fort Vancouver, Oregon.
Raising the colors at Fort Vancouver, Washington Territory, in 1854. The new territory was
formed one year earlier by splitting off from Oregon Territory, seen across the Columbia River.
Watercolor, 9¼ x 12⅛ inches, [1854].
Collection Beinecke Rare Book and Manuscript Library, Yale University, New Haven, Connecticut.

26

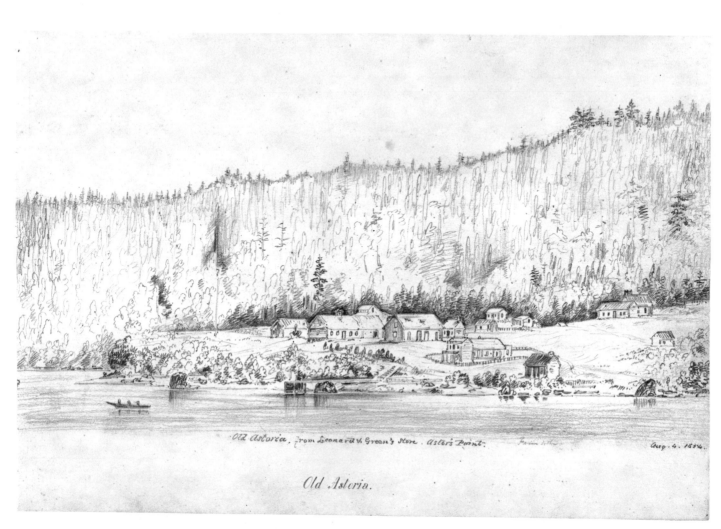

Old Astoria, from Leonard & Green's Store. Astor's Point. ~~~~~ *Aug. 4. 1854.*

Old Astoria.

Plate 6. Old Astoria. From Leonard & Green's Store. Astor's Point.
Pencil, 7⅛ x 10⅝ inches, 1854.
Collection Dr. and Mrs. Franz Stenzel, Portland, Oregon.

of several cannon in the foreground fall obliquely to the west. The *Active* remained for two days. Alden completed several drawings and paintings of the historic bastion. The last is dated July 28, 1854.

After returning downriver, Alden drew in pen and ink Old Astoria, from Leonard & Green's Store, Astor's Point. (Plate 6) Alden and his uncle called on General John Adair, first Collector of Customs for Oregon Territory, living at Adairville. His claim was later absorbed by Astoria.

Alden's anticipation increased as the *Active* crossed the Columbia River bar and turned north along the coast of Washington Territory for his first visit to Puget Sound. They put in to shore and anchored at Point Grenville, which seems a most unlikely place. It is a small hook, facing southwest, along the ocean shore about halfway between Astoria and Neah Bay. It proved to be a safe anchorage to ride out a storm which came in from the northwest. His watercolor of the point shows the ship at anchor in the little cove; it might have been anywhere but for Alden's notation.

After the storm passed, the trip continued. About 150 miles from Astoria they rounded the westernmost and northernmost tip of the United States, Cape Flattery. They headed into Neah Bay and anchored. Alden recalled George Davidson's tale of thwarting an Indian attack by building a breastwork, firing a pistol which never needed reloading, and posting an armed guard all night. The Spanish had occupied the area and built a brick fort in 1792 which the Indians later carried off brick by brick. It was the principal abode of the Clallam tribe. Numerous longhouses, each housing a family and relatives, stood along the beach, having been there long before the white men arrived. From the deck of the *Active* the Indians looked peaceful enough, but Alden was happy to remain on ship and noted with relief that a guard was posted on deck that night.

In the morning they continued down the Straits of Juan de Fuca. Alden was called to the wheelhouse by Lieutenant Cuyler. A school of killer whales had appeared. The twenty-five to thirty-five-foot-long mammals were swimming on both sides of the *Active*. An occasional thump was heard as one bumped against the hull of the ship. Each animal broached the surface, clearing the water, arced through the air and then sounded with a flip of its ten-foot horizontal tail. The process was repeated so that Alden estimated each animal resurfaced about every 100 yards. Alden counted, as nearly as possible, about 100 of the bold patterned black and white monsters which adopted the ship as a swimming companion and escorted her for nearly 100 miles. The whales changed their course to the north as the *Active* left her playmates and headed toward Puget Sound.

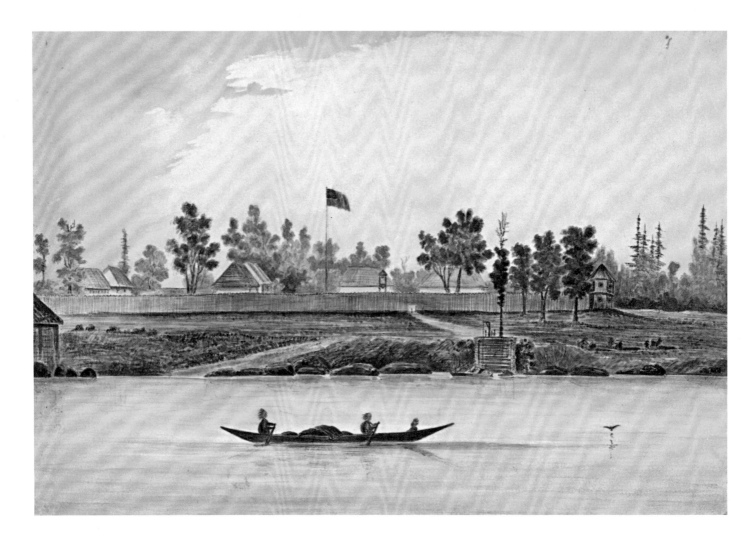

Plate C-2. Fort Victoria.
The Hudson's Bay Company Log Fort at Victoria, Vancouver Island, September, 1854.
A high picket wall leads toward two bastions at diagonal corners where cannon were kept
in readiness. No trace of the fort remains. It was located at the foot of Fort Street,
now in the heart of Victoria.
Watercolor, 7 x 10¼ inches, 1854.
Collection Provincial Archives of British Columbia, Victoria, British Columbia.

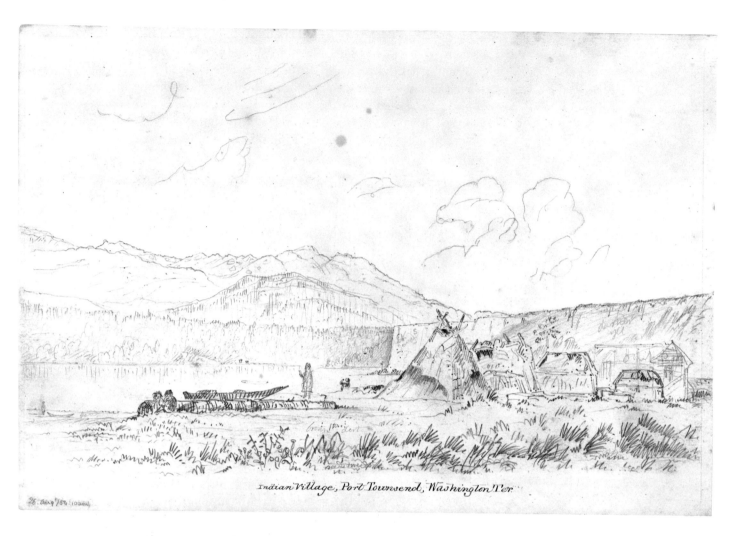

Indian Village, Port Townsend, Washington Ter.

Plate 7. Indian Village, Port Townsend, Washington Ter.
Point Hudson Indian village blocks the view of the few whitemen's buildings of beginning
Port Townsend, Washington Territory. Spanish explorers visited here in the 1790's.
Captain George Vancouver named it for the marquis of Townsend when he visited
May 8, 1792.
Pencil, 7⅛ x 10⅞ inches, 1854.
Collection Dr. and Mrs. Franz Stenzel, Portland, Oregon.

The vessel stopped at Whatcom, Bellingham Bay, August 10, 1854. Alden went ashore with fellow officers and found a fresh water pond where they all took a bath. They enjoyed the suds which formed from the soap and felt cleaner than after a salt water bath. Alden made another pen and ink drawing, the mill at Bellingham Bay, and a watercolor, *Bellingham Bay, Washington Territory, 1854*. Whatcom, Howards Harbor and several other closely grouped communities around the shore lost their separate identity and were fused to become Bellingham.

The party reached the Indian village at Port Townsend, Washington Territory, August 26, 1854. (Plate 7) Alden's unfinished pen and ink drawing shows Indian tepees and shanties on Point Hudson in the middleground. These structures hide the lightly sketched few buildings of the town. In the background is the sandy cliff of the hill, later cut down for access to the elevated section of the town. Port Townsend was slated to become the most important port in Washington Territory because of its protected year-round deep water harbor. It was also accessible to war-loving Haidas from Vancouver Island, who had recently visited local tribes.

The voyage continued southward from Port Townsend through Puget Sound, passing the few small settlements of Olympia, Steilacoom, and Seattle. Most of the other settlers were widely scattered. They continued up Skagit Bay and out through the entrance to Deception Passage at Rosario Straits. (Plate 8) Alden's painting is sited just before the extremely narrow and very dangerous pass leading north into Rosario Strait. The trough had to be executed at or near stand of the tide. It was like a narrow gate through which the vast waters filling and emptying Skagit Bay were forced with each ebb and flow of the tide. The turbulent current reached eight to ten knots. In the narrow funnel, bordered on each side by jagged and barely submerged rocks, the rush of water caused one gigantic whirlpool. Even the largest of vessels were seized, rotated, and thrown off their course except every eight hours at the end of the tide's flow when the waters briefly rested at standstill. After approximately twenty minutes, the direction was reversed. Alden was entranced and impressed by the display of natural forces, but his pictorial recording of the phenomenon is lost.

From August 26 to September 5 there is a hiatus in known paintings. The steamer *Active* could cover a lot of water, and there is no record where Alden traveled and no dated views to follow his path. The vessel was back again at Howards Harbor, Bellingham Bay on September 5, 1854, as reported by a pencil drawing.

About this time Alden participated in a confrontation with the Indians. A messenger reported nearby Indians had caused a disturbance at New

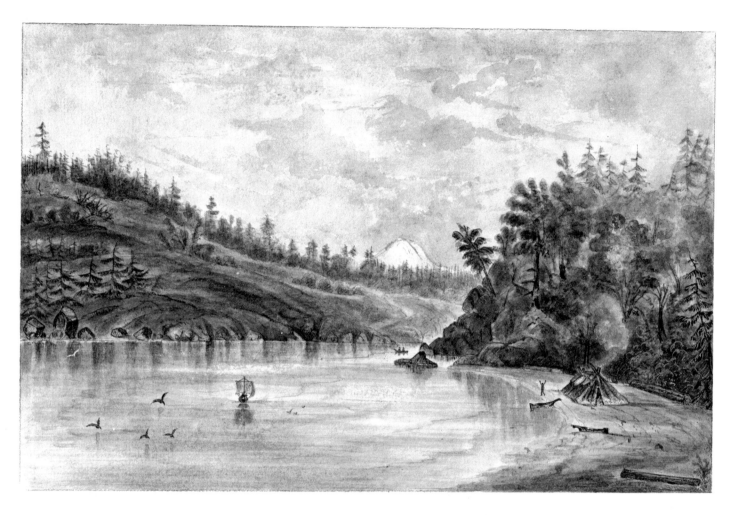

Plate 8. Entrance to Deception Passage, Rosario Straits. [sic] **W. T. Mt. Baker in the Distance.**

Dangerous Deception Passage leading to Rosario Strait, Washington Territory, is barely out of sight and to the right. Painted at standstill but during ebb and flow an eight to ten-knot current creates a huge, seething whirlpool. Snowcapped Mount Baker is also shown. Watercolor, 6¾ x 10⅝ inches, 1854.

Collection Dr. and Mrs. Franz Stenzel, Portland, Oregon.

Dungeness on the southern shore of Juan de Fuca Straits, a few miles west of Port Townsend. A white man had been killed and the natives had hidden the murderer among the tribe camped on a sandspit opposite the settlement. They refused to give him up.

Lieutenant Alden assembled the officers and crew. Arms were issued. The officers were instructed to get into their dress uniforms. They were cautioned not to smile or laugh and to maintain a dignified bearing. Alden asked to go along and to his delight he was included in the party.

The *Active* was anchored off the sandspit, her guns loaded and showing. The armed crew lowered small boats and rowed the officers ashore. Lieutenant Alden appraised the situation and led his uniformed, armed officers to the center of the Indian camp. He demanded the culprit. The Indians, confronted by such armed splendor, decided to produce the offender. He was secured and later delivered to Fort Steilacoom.[7]

Alden was assuredly proud to have played a role in the capture of the Indian murderer. His uncle's performance had demonstrated him to be equal to any situation and possessed of heroic qualities. He certainly viewed his uncle with increased admiration. It was a high spot in Alden's life of which his grandchildren would never tire of hearing.

The *Active* was at Port Townsend, Admiralty Inlet, on September 14, 1854. The pencil and pen drawing indicates Kala Point on the western shore, named in 1841 by the Wilkes Expedition, and across the water an Indian encampment. The vessel proceeded to Canadian waters. It was Alden's first visit to British America. He found interesting Indian graves at Laurel Point, near Victoria, Vancouver Island on September 17, 1854, and drew them in pencil. (Plate 9) These spectacular grave figures, sometimes painted in bright colors, were an essential part of the tribal rites of the Northwest Indian culture and varied in detail according to the tribe.

Alden's final picture located from the northern cruise for 1854 is the watercolor rendition of the Hudson's Bay Company fort at Victoria, Vancouver's Island, made in September. (Plate C-2) The log structure, similar to Fort Vancouver, Washington Territory, disintegrated in time. The site is now in the center of the city.

A resurvey of the Straits of Rosario and the Canal de Haro was completed by September 19. The officers and crew rechecked figures of latitude and longitude for the final charts. Alden worked on his drawings; some he redrew and to others he added watercolor washes.

Before leaving British Columbia the *Active* called at Esquimalt, the naval base just around the corner from Victoria, to load coal for the trip

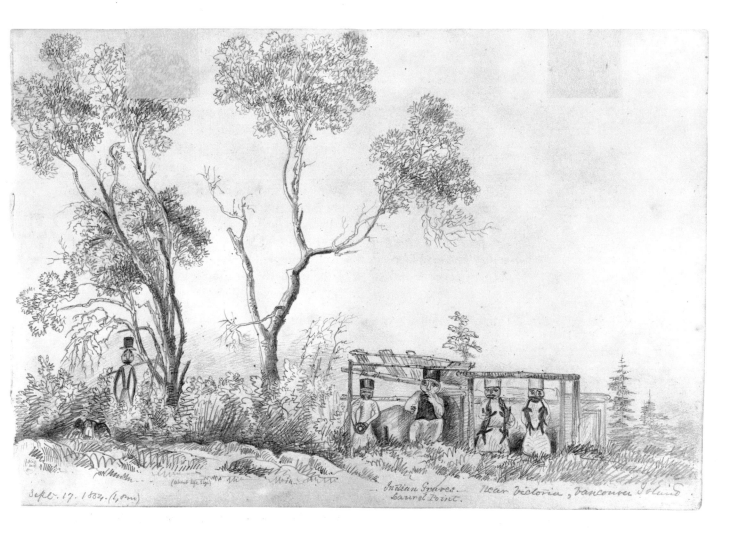

Plate 9. Indian Graves. Laurel Point. Near Victoria, Vancouver Island.
Indian tomb markers used to honor the dead. Alden saw and recorded the scene
September 17, 1854, at one o'clock in the afternoon. Laurel Point, near Victoria,
Vancouver Island.
Pencil and ink, 7⅛ x 10¾ inches, 1854.
Collection Mr. and Mrs. Albert W. Ayers, Jr., Darien, Connecticut.

home. Esquimalt was the storage point for the Hudson's Bay Company mines at Nanaimo, Vancouver Island. Through the cooperation of Governor James Douglas a continuing supply was assured.

Alden's birthday was September 26, his twentieth. The end of September heralded the time when severe winter storms could suddenly occur. The days were noticeably crisp. The *Active* headed out to sea through the Straits of Juan de Fuca. Three days later she was back at Pacific Wharf in San Francisco.

The first section of the corrected marine chart from San Diego to San Francisco, bearing Lieutenant James Alden's name and carrying his hydrographic corrections and the accurate latitude and longitude revisions, had been printed and delivered. All enjoyed seeing the final chart on which they had long labored. It was illuminated by eleven cartographic vignettes showing the appearance of principal harbor entrances and prominent headlands. These were credited on the chart to McMurtrie.[8]

Though McMurtrie is listed as present in the log of the *Active*, none of his drawings on the northern trip have been located. McMurtrie left the ship during November to complete his drawings along the Santa Barbara Channel. These were sent to the Survey Printing Office, along with Lieutenant James Alden's corrections of hydrography, latitude and longitude, for the second final chart from San Francisco to the Umpqua River on the southern Oregon coast. Printing was completed and it was circulated before the end of 1854. It utilized twelve cartographic vignettes, again credited to McMurtrie.[9]

Alden and McMurtrie joined the Survey crew as they sounded and surveyed the more remote sections of San Francisco Bay, their winter assignment. The weather was mild and the between season work agreeable. Many of the little bayside settlements were visited and their appearance set down. One particularly appealing watercolor of Alden's is extant. It shows a spate of buildings which comprised *Saucelito Cove, San Francisco Bay* (Plate C-3) and was Alden's final surviving example from his first year's work on the West Coast.

In January, 1855, the reconnaissance of San Francisco Bay ". . . and about Punto de los Reyes. . . then the work on the bar and the entrance of San Francisco Bay including some ten miles off the coast on either side was commenced and steadily continued, with occasional interruption by the weather." It was completed by March 15 of the same year.[10]

Alden observed that the work now differed since it was to produce a harbor chart. This meant the scale was smaller, therefore the details were

Plate C-3. Saucelito Cove, San Francisco Bay.
Saucelito, or Little Willow, Cove had various spellings. The fenced area may be
John Reed's place which in 1838 was included in the Saucelito grant to William A.
Richardson, Fort Captain of San Francisco.
Watercolor, 9 x 12 inches, 1855.
Collection Dr. and Mrs. Franz Stenzel, Portland, Oregon.

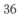

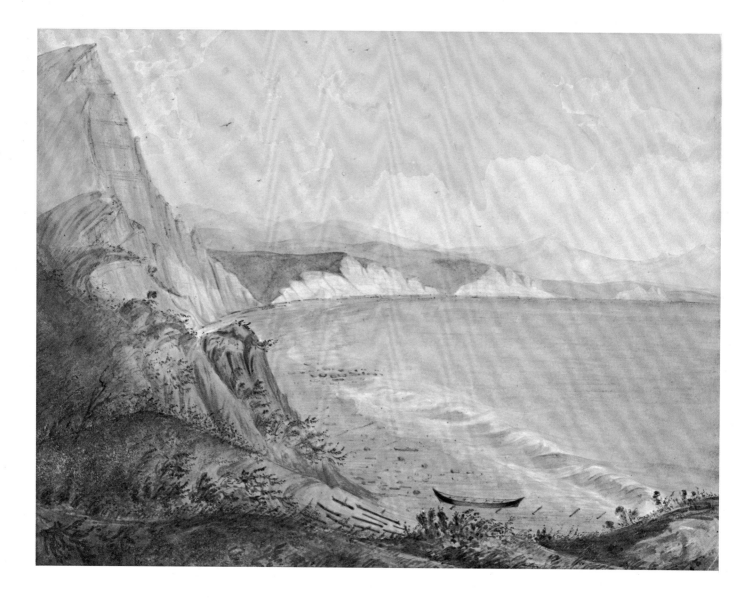

Plate C-4. Bay of Sir Francis Drake.
Captain Sir Francis Drake landed here in 1579 leaving a brass plaque discovered a few
years ago.
Watercolor, 9¼ x 12 inches, 1855.
Collection Mr. and Mrs. Robert Herron, Bowie, Maryland.

magnified and required greater precision. Using such a chart a foreign vessel could enter any harbor, follow the indicated channel, avoid all dangers, and safely anchor or dock at a wharf. In addition, regional charts were to be issued for hazardous areas. The Santa Barbara Channel was a good example where many islands, shoals and wrecked ships compounded the problem of navigation.

Alden was shown the completed chart for San Francisco Harbor. 25,693 soundings had been taken to record the depth. 691 theodolite readings were taken for hydrographic position. Sextant readings numbered 5,767 for accurate determination of latitude and longitude. To plot the character of the bottom as needed in anchoring, 227 specimens of the bottom had been collected. The figures were impressive but alone could not indicate the hard work and commitment involved. Since Alden often accompanied the Survey crews, he had an appreciation of the effort expended to obtain the results.

Their travels in small Survey boats gave Alden and McMurtrie accessibility to places difficult or impossible to reach by land. One of Alden's watercolors is his *Bay of Sir Francis Drake*. (Plate C-4) One of the Survey boats is pulled onto the shore across several tree branches which form a skid road.

Other watercolors by Alden made during the hydrography of the bay were located, one being *Molate Island or Red Rock [Island], San Francisco Bay, California. Feb. 1855*. Molate Point projects, or did, into the bay near the eastern end of the Bay Bridge between Berkeley and Oakland. It was a secondary triangulation point used in the Coast Survey of 1854. Molate Island was nearby.

Another regional painting is *Shanghai Rancho near Saucelito-Cal^a·-San Francisco Bay*. (Plate C-5) Present reference sources fail to identify this Rancho. However William Antonio Richardson, a seafaring Englishman and Port Captain of San Francisco in 1835 for whom Richardson Bay was named, was the grantee of Saucelito Rancho and Land Grant. "Rancho Shanghai" may have been a jocular appellation described to Alden.

Most sinister is Alden's *Foot of Tamel Pais (or Table Mountain) with Widow Reed's Rancho—near San Francisco Bay, Cal^a·* (Plate 10) "This Mt. is said to be the Devil's abode!" Alden noted. A spilled drop of ink in the sky and across the top of the mountain lends a foreboding appearance, for the widow of John Reed (or Read or Reid) and her Marin County, Corte Madera Rancho. Her husband has not been identified with certainty.

The *Active* proceeded into San Pablo Bay. Here at Benecia lay the disabled U. S. S. *St. Mary's* and the *Active* towed her about eight miles to Mare

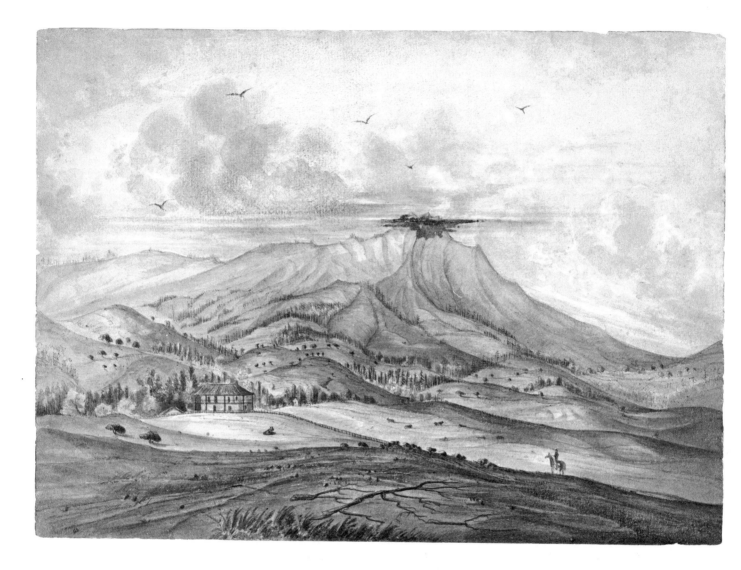

**Plate 10. Foot of Tamel Pais (or Table Mountain) with Widow Reed's Rancho
— near San Francisco Bay, Cala.**
Widow Reed's (Reid or perhaps Read) Rancho Corte Madera in 1855 at the foot of
Mount Tamalpais, California.
Watercolor, 9¼ x 12 inches, 1855.
Collection Dr. and Mrs. Franz Stenzel, Portland, Oregon.

Island. This was the new navy yard which Commander David G. Farragut, the first Commandant, instituted the preceding September. On May 15, 1855, he wrote in his letterbook that "The surveying Steamer *Active* with the Schr. *Ewing* have been lying at the Yard fitting out."[11]

Artist Alden painted a watercolor of the U. S. S. *St. Mary's* and an interesting oval pencil and watercolor view of *Mare Island Navy Yard—Cal^a.—View from the South.* (Plate 11) On the verso he inscribed, "View of Mare Island with the tules or marshes in the distance. The *Active* can be seen above the Sloop of War *St. Mary's* that she has just towed up from San Francisco. Don't mistake the *Active's* two masts & a smoke-stack. On the opposite side can be seen part of the City of Vallejo with the former state house. The steamer from Napa Valley to San Francisco is coming down to the Navy Yard. The workmen are crossing to Vallejo to go home to supper to see fleet of boats. Mare Isld. Navy Yard from S. end Mare Isld.—looking up Napa Creek. Feb. 1855."

The *Active* was back in San Francisco at her usual berth by June 6. She had been fitted out with arms, deck guns and ammunition to suppress the Indians, if needed. On the following day she departed. Alden, his Aunt Sarah and McMurtrie were aboard. They were returning to Puget Sound and northern waters. Cruising about to make their armed presence known to the Indians and regional charting was the summer's assignment.[12]

Crescent City, about twenty land miles below the Oregon border, became their anchorage on July 10. Here they found a tragedy had been played on the beach. "The most sad sight that I have beheld for a long, long while is the burnt and charred wreck of the once beautiful steamer *America* . . . Major [Henry] Prince is here with about 150 soldiers and very anxious that Captain Alden should take him and his command to Steilacoom, which I think he will do as he (the Major) is losing from six to eight by desertion every day." Then, the next day ". . . we took the soldiers, camp, women, and their dunnage on board early this morning and started for Steilacoom . . ."[13] Alden's pictures of these events have not been found; he did make a view of Crescent City in 1859. (Plate 12) By that time no trace of the burnt and wrecked *America* is visible in the watercolor. Major Prince and his command debarked at Steilacoom on July 13.

Alden's drawings and watercolors of Steilacoom have not come to light. McMurtrie's drawing of *Mt. Ranier* [sic] *from Steilacoom—W. T. July 16, 1855.* is one of only three located examples of his 1855 work and establishes McMurtrie's presence on this trip.[14]

Alden next toured the landlocked waters of beautiful Puget Sound, little changed from 1792 when Lieutenant Peter Puget participated in Captain

Plate 11. Mare Island Navy Yard — Cala. View from the South.
Mare Island navy yard across Napa Creek from Vallejo, California, as painted by
Alden in February, 1855, just six months after its opening. The first commandant was
Commander and later Admiral David J. Farragut.
Watercolor, 5½ x 6⅝ inches, 1855.
Collection California Historical Society, San Francisco, California.

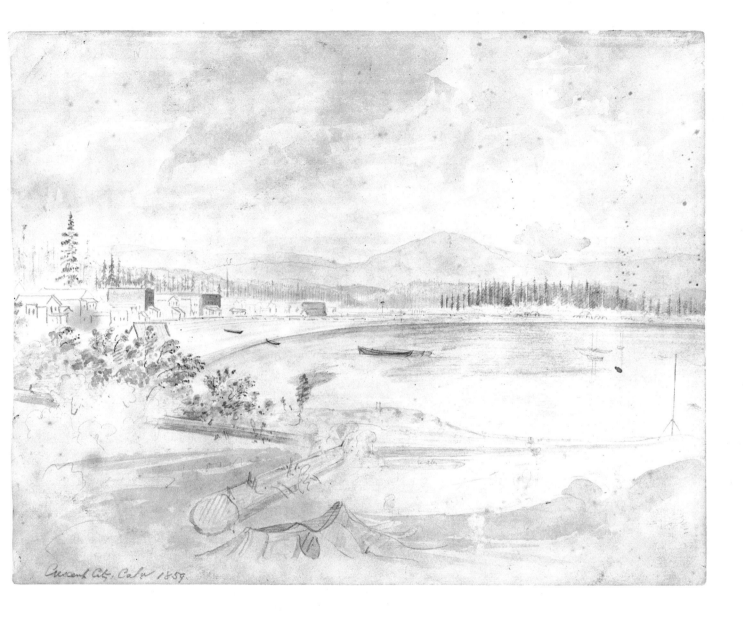

Crescent City, Cala 1859.

Plate 12. Crescent City, Cala.
Nothing can be seen of the *America* wrecked on this beach in 1855. Major Henry Prince
was stranded with 150 of his men until rescued by the *Active*.
Watercolor, 8⅝ x 11¼ inches, 1859.
Collection California Historical Society, San Francisco, California.

George Vancouver's exploration of that body of water. In return, Puget received the honor of having the entire sound bear his name. Mountains, islands, promontories, channels, bays and straits carry the names of Captain Vancouver's officers, Royal Navy friends and associates, and British Royalty he wished to honor. Amost 300 names supplied by the great explorer have been retained along the Northwest Coast of the Oregon Territory and northward to include the Queen Charlotte Islands.

The *Active* was a fearsome symbol of white man's strength as she chugged along, puffing out black smoke. Her new guns were exposed for all, but especially the Indians, to see. Her circuitous route was a show of force to reassure the settlers and hopefully to quash any plans for attack by the natives.

Olympia, Port Townsend, Seattle and Whidbey's Island were ports of call before Victoria, where the *Active* docked on July 30. "On August 1st Governor Douglas gave a ball for the British ships H. M. S. *Dido* and H. M. S. *Brisk*, anchored at Esquimalt, and the American officers were invited. It proved interesting—with many ladies, some quite pretty. Everything that could be had in the eating and drinking line was on the table. The Governor looks all over and acts exactly what he is. He is quite tall and well made and Pomposity itself," wrote Philip C. Johnson, a crew member.[15] Alden was welcome, since there were several young ladies near his age present. He was a good dancer and left reluctantly when the festivity was concluded.

When the *Active* anchored off Port Townsend, Midshipman Johnson wrote in his diary on August 21, "The Indians for the last few days have been raising the very devil on shore. They are in great fear of the northern Indians coming down to attack them, so they have been evoking the evil spirit to do very naughty things to their enemies, and the good spirit to watch and protect them. The whole arrangement is more like one of our revival or tent meetings than anything I can compare it to, but that gives one a very faint idea of the excitement to which they work themselves up —going so far as to cut and lacerate their own bodies."[16]

Midshipman Johnson had witnessed a "Black Tomanawos" ceremony, which James G. Swan had viewed and painted on the same beach at Port Townsend.[17] After a night of dancing, noisy cries and chants, during which time self-inflicted lacerations occurred, the celebrants left the confines of their longhouse. Then other dances and rituals were carried out on the beach for all to see. These periodic pagan procedures celebrated the achievement of maturity by a chief's scion or other great accomplishments. They

assured good fishing and lured whales ashore. The Black Tomanawos were powerful medicine.

Johnson left an interesting though not entirely accurate diary. He spiced it with remarks which would have been embarrassing to him later had it been published. "Colonel Ebby [Isaac N. Ebey] the collector of Port Townsend [Whidbey's Island], who is the dirtiest (except Governor Stevens) man I ever met and who stutters most painfully . . ." This from a man who recorded the details of his daily ablutions, in his cabin, in streams and over the ship's side into the salt water. His own predilection for bathing may have qualified him to make these judgments which all other historians seem to have overlooked.[18]

The next port of call for completion of hydrography was Port Gamble which Alden probably thought was the prettiest harbor on the coast. Formerly called Teekalet and situated at the entrance of Hood Canal, it was the site of the Talbot & Co. mill, the most productive of all mills in the Washington Territory.

The cruise continued, occasionally surveying a harbor, but even the crew complained of inactivity. Already Indian depredations had occurred during the year. One instance was east of the Cascade Mountains in Washington Territory and another near The Dalles in Oregon Territory. Puget Sound was entirely deficient in military force. The *Active* most nearly approximated a naval vessel and was on patrol now to insure tranquility. All was quiet so far.

At this time artist McMurtrie composed his only remaining dated watercolor for that year, *Mt. Baker from St[rait] of Fuca. Sept. 7, 1855.*[19]

In mid-September Captain Charles J. W. Russell arrived on the *Potter* and the two ships proceeded to Neah Bay and down the coast. Alden's uncle disclosed that Captain Russell had introduced oysters to San Francisco in 1851 from his oyster beds in Shoalwater Bay, their next destination.

The *Active*, with the guidance of Captain Russell, crossed the extremely shallow bar into Shoalwater Bay [now Willapa Bay] on September 14. He pointed out channels for moving about and anchoring during the course of the reconnaissance. Even then, they went aground several times but floated free with high tide.

Alden went with Captain Russell to his home and oyster beds at nearby Bruceport where Alden's closest contact with the Indians took place. Russell spoke their language fluently and had lived among them for almost a decade. Alden entered several of the rude dwellings with Russell. One hospitable host offered them food and following Russell's lead, Alden ate a

stew with gusto. It tasted good. His host presented him with the carved and decorated "grease dish" from which he had eaten the meal. Alden expressed his thanks and returned to the ship with his present which became one of the treasured possessions from his years on the West Coast. Alden did not learn until later that he had eaten dog stew which disgusted his grandchildren each time he told them.

Captain Russell and Alden visited Swan's residence on the nearby Querquelin (Mouse) River above its entrance to the bay. Swan invited them into his home. Alden seemingly liked the little man and his fund of local information and amusing tales of the Indians. He spoke several dialects and went among them freely, as no other white in the territory dared to do. His writings were printed in newspapers in Olympia, San Francisco, and London. Alden was fascinated by Swan's drawings of the Indians, some of which were colored with crayon. Swan later visited the *Active* and Alden showed his fellow artist his own work.

On October 4 the survey of Shoalwater Bay and its tributary rivers was completed. The local Indians seemed peaceful and the ship headed homeward. Three days later she was moored at her Pacific Street Wharf.

San Francisco was Alden's residence for the next ten days. There was mail from home. He visited several "art galleries"—stores which sold art supplies and whose windows and a portion of the interior walls exhibited artists' works for sale on commission. At that time there were a number of artists living in and around San Francisco. They produced lithographic views of the gold mining towns, illuminated lettersheets with part or all of the first page showing California subjects, oil and watercolor paintings. There was considerable demand for their work.

Carrying out his uncle's commission, Alden made his first trip to southern California on October 15. He and McMurtrie joined Philip C. Johnson, who noted in his diary, the only written record of the trip, "I went down in the *Republic* to Santa Barbara and from there took horse and rode to San Buena Ventura where I found the schooner [*Ewing*]. My trunk did not arrive till late on the following day. On the morning after it did arrive, the *Ewing* sailed for San Pedro, where we remained several days. I went to Los Angeles and had a feast upon grapes and figs . . ." The three men continued on to San Diego.

Johnson continued, "On our return to Santa Barbara, Madison Alden gave me an invitation to take a ride with him to the hot sulphur springs about six miles from town. I accepted the invitation and took a bath in water at about 80° F."[20]

Plate C-5. Shanghai Rancho near Saucelito-Cala. San Francisco Bay.
Saucelito Rancho was the home of San Francisco Port Captain Richardson in 1855.
"Shanghai Rancho" would seem to be a nickname with some innuendo.
Watercolor, 9¼ x 12 inches, 1855.
Collection Dr. and Mrs. Franz Stenzel, Portland, Oregon.

Plate C-6. Valley of Montecito near Sta. Barbara, Cala.
Watercolor, 9¼ x 12 inches, 1855.
Collection Dr. and Mrs. Franz Stenzel, Portland, Oregon.

Several of Alden's dated paintings survive which resulted from this trip to southern California. One is *Valley of Montecito near Sta. Barbara, Cal^a.* (Plate C-6) The valley is unoccupied. The hot springs where Alden and Johnson bathed is a tropical dell surrounded by lush vegetation, *Sulphur Springs near Sta. Barbara, Cal^a.* (Plate 13) Johnson may have wished Colonel Ebey and Governor Stevens had been along to participate.

Alden painted a watercolor of *The Mission of Santa Barbara, 1855* which is still in the possession of the mission. At the same time he executed *The Presidio Chapel at Santa Barbara*, now in private hands.

The thirty-five mile ride on horseback from Santa Barbara south provided a dramatic change of scenery for Alden. They followed El Camino Real, the old Spanish trail between missions. The subtropical nature of the country was indicated by palm trees and varieties of cactus plants, some containing enough liquid to sustain life if a traveler were deprived of water, Alden discovered. Other desert vegetation, some in bloom, was strange in appearance but added color to the country. Poppies covered entire hillsides. Quail scurried across the road and the osprey, with a six foot wingspread, soared high above—all foreign to a Yankee.

They arrived at a cluster of small houses around a larger church building and Alden painted *Mission San Buena Ventura.* (Plate 14) The Mission had been established and named on Easter Sunday, March 31, 1782.

The party boarded the *Ewing.* From the nearby Channel Island emanates *Rancho & Valley Santa Cruz Island—California.* (Plate 15)

On arrival in Los Angeles, they ate their fill of fresh fruits. Alden, on a later trip, recorded the unoccupied bay *San Pedro, Cal^a.* (Plate C-7) Today every inch of this waterfront on the dredged and improved busy port for Los Angeles is in use. In the right half of the two-page watercolor one can make out *The Deadman's Island Pedro Bay—California*, which Alden also painted separately. Once a convenient burial ground for persons who died aboard ship, it was removed by dredging and is now only a shoal in San Pedro Harbor. Also in the right half of San Pedro Bay can be seen *Alexander Banning's—At San Pedro, Cal^a.* (Plate 16), which Alden also illustrated as a separate drawing.

A year earlier Alden had met Alexander Banning as a passenger on the *Active.* Along with his brother Phineas, Banning operated the first stage line between San Pedro and Los Angeles in the 1850s. He became the foremost promoter of improved transportation in southern California and the owner of vast vineyards. He was one of the leaders in the development of Los Angeles. The pencil drawing shows a stage in the background returning to home base.[21]

48

Plate 13. Sulphur Springs near Sta. Barbara, Cala.
Lush, semi-tropical scenery surrounded the Sulphur Springs near Santa Barbara, California, in 1855 where Alden bathed, then painted this view.
Watercolor, 12⅛ x 9¼ inches, 1855.
Collection Dr. and Mrs. Franz Stenzel, Portland, Oregon.

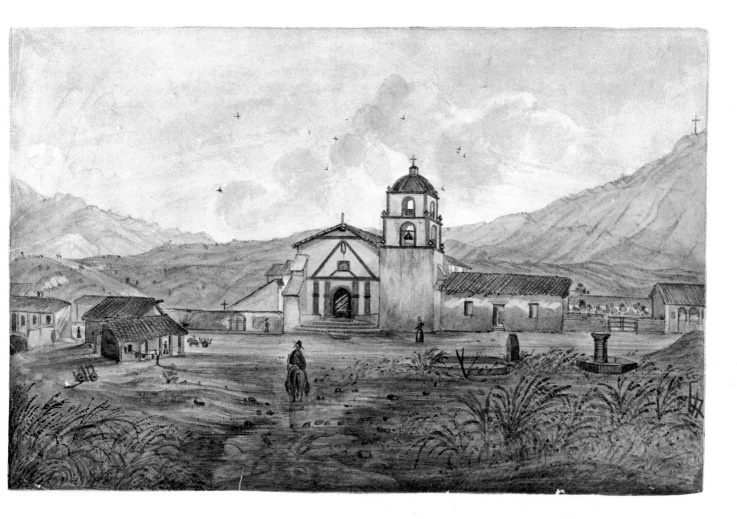

Plate 14. Mission San Buena Ventura.
Already 75 years old when Alden saw it in 1855, Mission San Buena Ventura is 35 miles
south of Santa Barbara, California.
Watercolor, 7⅜ x 11⅜ inches, 1855.
Collection California Historical Society, San Francisco, California.

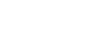

Plate 15. Rancho and Valley Santa Cruz Island, California.
Watercolor, 7 x 10⅜ inches, 1855.
Collection Dr. and Mrs. Franz Stenzel, Portland, Oregon.

Plate 16. Alexander Banning's — At San Pedro, Cala.
Pencil, 8½ x 14⅜ inches, 1855.
The Honeyman Collection, Bancroft Library, University of California, Berkeley, California.

Of Alden's drawings or watercolors, none remain from the northwest trip of that summer. From June 6 to October 7, 1855, only one of McMurtrie's paintings could be located, although both artists were together. There are five undated McMurtrie pencil and watercolor items which may have resulted from the northwestern and southern California trips of 1855.[22] The Johnson diary relates only that "Madison gave me an invitation to take a ride with him to the hot sulphur springs." From the context of the diary and the dated watercolors, it is obvious that Alden was present on the entire trip down to San Diego and back, as was McMurtrie who is never mentioned. A most interesting watercolor is labeled simply *San Diego*. The figures of the two artists, Alden and McMurtrie, are shown standing a few feet apart drawing in their sketchbooks. The artists' figures are outlined in pencil. The remainder of the picture has been washed with color, leaving the two uncolored and faceless artists. Though unsigned, it is clearly McMurtrie's work. It establishes that Alden and McMurtrie were present and working together. McMurtrie had worked at San Diego previously; however, 1855 and 1856 are the only years when he and Alden were there together. Therefore, the unfinished portrait of the two artists drawing on the San Diego beach was done by McMurtrie in 1855 or 1856. From 1856 to 1858 McMurtrie is not mentioned in the Annual Reports of the Coast Survey but dated drawings and watercolors document his presence. In 1850 McMurtrie was delaying the publication of a preliminary chart to the point that Lieutenant McArthur had to explain to the Superintendent ". . . Mr. McMurtrie has suffered so severely for the last two weeks past with acute rheumatism that he has not been able to work."[23]

McMurtrie related that "lung disease" (tuberculosis) in childhood and adolescence had delayed his education so that he did not enter high school until he was 25 years of age. In the care of a family friend, he had spent more than a year in Colorado seeking a cure in high altitude. During this time he painted some Colorado scenes.[24] His disease was ameliorated but left him with a recurring arthritis.

In San Francisco there was disrupting news of an Indian uprising. The *Active* was not required for winter surveying and Lieutenant Alden offered her to Commodore William Mervine, Commander of the United States Navy's Pacific Squadron, to help quell Indian disturbances in the Washington Territory.

Alden and McMurtrie were transferred to the *Ewing* in charge of Lieutenant Cuyler. Lieutenant Alden continued on the *Active* and Sarah Alden remained in San Francisco with friends because of possible danger from the Indians. Alden's own records state that he "Re-enlisted at San Fran-

cisco November 17, 1855. This enlistment expired May 17, 1856." Just before the *Active* left, Lieutenant Alden received his commission as Commander.

Alden read in the newspapers that the *Active* joined other Survey and Navy vessels in Puget Sound. The armed fleet was on patrol to induce the Indians to keep the peace. The show of force failed and the natives attacked the little settlement of Seattle on January 26, killing two whites and injuring others. The *Active* and the *Decatur* landed men and cannon. The women from the settlement were taken aboard and the men garrisoned in the blockhouse. Tension subsided. There were incidents and episodes but no other attacks in the Washington Territory. The *Active* returned to San Francisco, arriving March 15, 1856. Alden heard the recounting of the clash with Indians firsthand from his uncle when he transferred back to the *Active*.

The *Ewing* had been assigned to hydrography while the *Active* was in Puget Sound. The assignment read, "Observations on the currents of Santa Barbara channel, including examination of currents outside of and between the Santa Barbara islands."[25]

Alden's *Cave in the Island of Santa Rosa, on the coast of California* is his earliest located watercolor of that year. A problem watercolor is *Los Franca, Blk.* [sic] *Mt. California. S. San Francisco Bay.* This inscription seems garbled. No explanation of "Los Franca" has been found. Black Mountain is named for James Black, a Scottish sailor *emigré* of 1832, but it is in Marin County and not south San Francisco Bay.[26]

On the small island sixty miles offshore, Alden painted *Cañon—S. part San Clemente Island, California.* (Plate 17) The island in Los Angeles County is opposite the mainland town of San Clemente. The figure with a gun seemingly indicates the necessity of the party being armed.

The two survey vessels reunited. Alden's watercolor shows the U. S. Steamer *Active* and the schooner *Ewing* in Santa Barbara Channel on June 7, 1856. (Plate C-8) They finished the reconnaissance of what had been a treacherous channel in the recent past.

Commander Alden reported that the *Active* and the *Ewing* completed the survey in the region of San Clemente. They proceeded to San Diego harbor and remained there from June 16 to July 28. A shallow spot of only three fathoms (18 feet) was found off the nearby coast. At this depth, a hazard would be present for larger ships particularly at low tide. Following this discovery, the adjacent 130 miles were sounded with no other similar dangers to navigation being discovered.[27]

54

Plate 17. Cañon — S. Part San Clemente Island, California.
Watercolor, 10½ x 7¼ inches, 1856.
Collection Dr. and Mrs. Franz Stenzel, Portland, Oregon.

Plate C-7. San Pedro, Cala.
San Pedro, California, as it appeared on June 12, 1859. Dead Man's Island, visible on the
right, has now been removed. The establishment of Alexander Banning appears in the
right middle ground.
Watercolor, 8⅝ x 22¾ inches, 1859.
Collection California Historical Society, San Francisco, California.

Plate C-8. U. S. Steamer *Active* **and Schooner** *Ewing* **in Santa Barbara Channel.**
Watercolor, 9¾ x 13¾ inches, 1856.
Collection Kennedy Galleries, Inc., New York City.

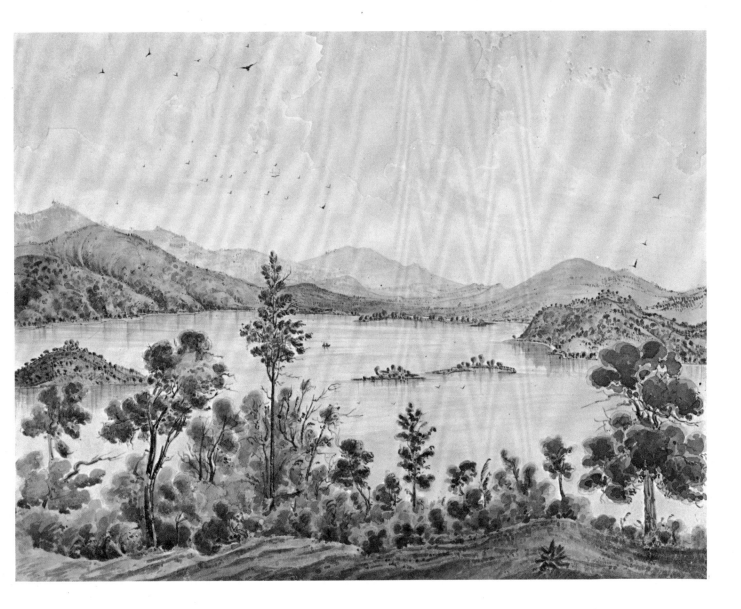

Plate C-9. View from Foot of Mt. Conoktai near Clear Lake, Cala.
In California's Lake County is Clear Lake painted in April, 1857, from the foot of
Mount Conoktai.
Watercolor, 9¼ x 12 inches, 1857.
Collection Dr. and Mrs. Franz Stenzel, Portland, Oregon.

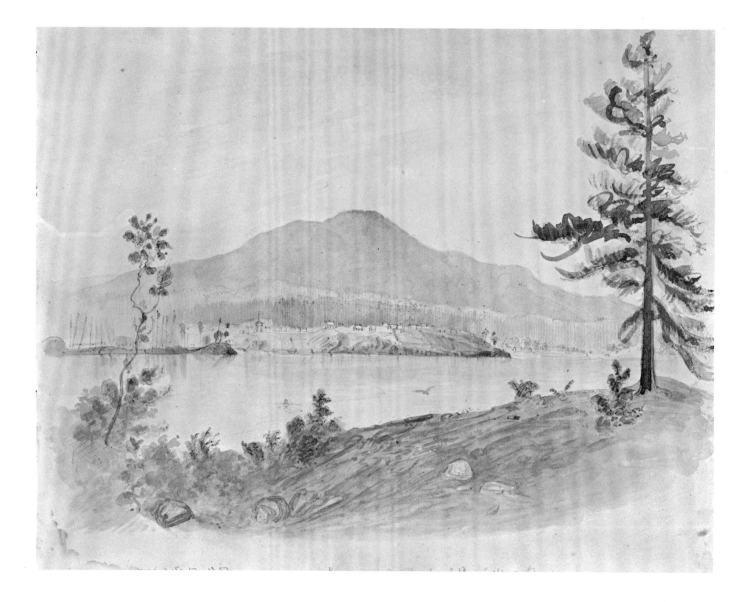

Plate C-10. Nanaimo from Douglas Island, Gallows Point.
View of Nanaimo on Vancouver Island, British Columbia, from Gallows Point,
Douglas Island, September 17, 1857, at 11:00 a.m. The *Active* is anchored below the
town bastion for the purpose of taking on coal. The mines were recently opened and the
lack of wharfage made coaling a tedious procedure.
Watercolor, 12⅞ x 16½ inches, 1857.
Collection Washington State Historical Society, Tacoma, Washington.

McMurtrie was present as evidenced by his *Near Santa Barbara* water-color, and his *U. S. Steamer* Active, *1856*, his surviving works from that year.[28]

By 1857 artist Alden had assembled, over a three-year period, an extensive collection of drawings and paintings from the southern border of the United States near San Diego to the disputed northern border and beyond into British America. Commander Alden examined his portfolio and was more than satisfied with the results. He felt the time had come for his nephew to embark on an artistic jaunt on land.

Alden worked in the area surrounding San Francisco Bay during January, February and March. Sometimes his artist friend was present, as established by McMurtrie's *San Francisco Bay—March 1857.*[29]

Beginning in the latter part of March, Alden, detached from the hydrographic activities, wandered north of the Golden Gate for three months. He traveled through Marin, Sonoma, and Lake counties in the company of a survey party, camping along the way. An armed guard was maintained because of the Indian uprisings throughout the west.

One of Alden's watercolors is *"Pluton River" near Geysers of California.* Several names, including Pluton Geysers and Sulphur River, were attached to the Sonoma County features. Alden continued north and east into Lake County and painted a series of watercolors in the area. One is a *View from Foot of Mt. Conoktai near Clear Lake, Cal*[a.] (Plate C-9) Mount Konoktai, as it is now spelled, and Clear Lake intrigued Alden with their beauty. He composed another long-range view of *Clear Lake, California* (Plate 18) showing it extending many miles into the distance. Borax Lake at the foot of Mount Konoktai impressed Alden. In his scrapbook he pasted a clipping concerning the formation of the California Borax Company for the purpose of mining the lake. The bottom was pure crystalized borax. He wrote beside the clipping, "An inexhaustible supply."

The last of the related group is *Camp at Clear Lake, California.* (Plate 19) Five men and a packhorse are seen. An armed guard is posted near the tent at the lakeshore camp of the survey party which Alden joined. By mid-June the side trip was completed. Alden returned to San Francisco to again cruise northward for the seasonal survey.

Alden was informed that the proposed visit of 1857 to the Northwest would bear political overtones and concern his own future.

When the War of 1812 broke out, the English were already engaged in the Napoleonic War. Their forces were needed in Europe. Their lines of supply were long compared to the Americans fighting on their home ground.

60

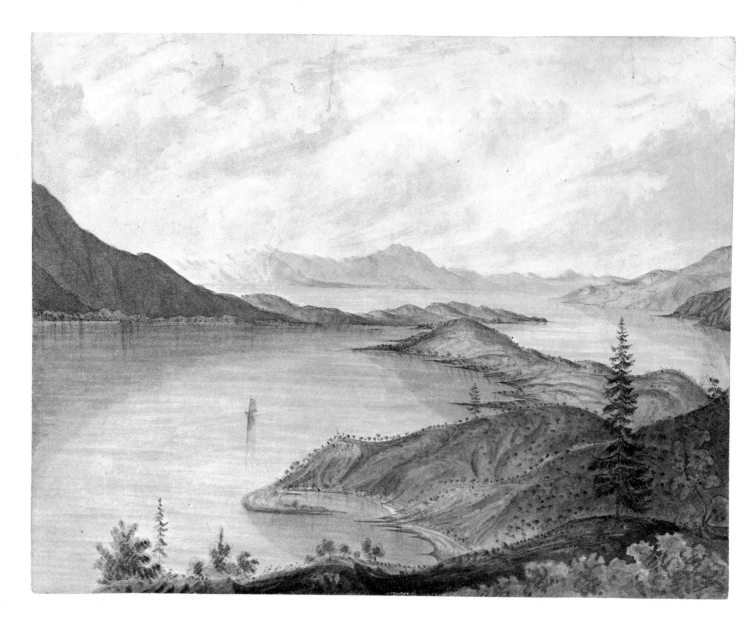

Plate 18. Clear Lake, California.
Watercolor, 9¼ x 12 inches, 1857.
Collection Dr. and Mrs. Franz Stenzel, Portland, Oregon.

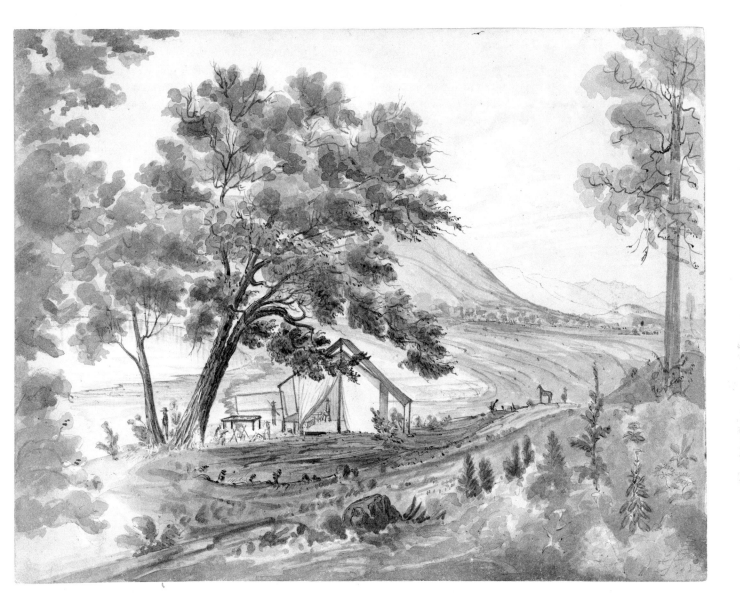

Plate 19. Camp at Clear Lake, California.
Alden's 1857 trek through Marin, Sonoma, and Lake Counties was in the company of a
government land survey party whose camp at Clear Lake, California, is portrayed.
Watercolor, 9⅜ x 12 inches, 1857.
Collection Dr. and Mrs. Franz Stenzel, Portland, Oregon.

The bitterly contested conflict ended after two years on the day before Christmas in 1814. It was a month later before the news reached Army and Navy units on both sides and strife ceased. The terms of peace included the appointment of a commission to settle the disputed boundary between British America and the United States. It was 1842 before the United States Secretary of State Daniel Webster and British Alexander Baring, first Lord Ashburton, and their commissioners sat together in Washington City. The present Maine-New Brunswick border was determined and the United States-Canadian border to the west was extended to a line between Lake Superior and the Lake of the Woods on the 49th parallel. The Boundary Commission met again in twenty years but deferred taking action on the segment between the top of the Rocky Mountains and the Pacific Ocean. This portion, after forty-three years of procrastination, was now about to be surveyed.

Alden and his uncle reviewed the situation. Alden was told that in the course of the summer the *Active* would carry the American commissioners to a preliminary meeting with the British commissioners. There was no dispute concerning the 49th parallel as the boundary, but no one knew where it ran. The scattered residents along the 400 unsurveyed miles were unsure in which country they lived. The water boundary was under contention between the two countries because the principal channel was not defined in the treaty.

Alden probably surprised his uncle by suggesting that he select a dozen of his watercolors painted from Bellingham Bay on to the north into British American territory and make his application to be named Official Artist for the Northwestern Boundary Survey. Commander Alden forwarded the application together with his own endorsement. Alden awaited with some presumptive trepidation for the reply.

The *Active* steamed northward in June. The trip was swift and the weather beautiful. Alden painted *Entrance to De Fuca Strait* and *Classett Village, Cape Flattery*. Classett in Indian means Cape Flattery. After entering the strait there are numerous basaltic rock formations along the southern shore. Some of the largest bear names. Alden drew *De Fuca's Pillar*.

They passed Neah Bay and continued down the strait. Soon after arrival, Alden completed drawing *Victoria Harbor. Songies Village*. The Songies were the local Indians who had moved their village into the harbor where the Hudson's Bay Company built their fort in 1843. The situation gave protection from pugnacious tribes farther up Vancouver Island and the Queen Charlotte Islands, who periodically came on raiding expeditions.

In the afternoon of the same day, Alden drew in pencil *H. B. Co., Fort Victoria*, depicting the steamer *Active* at the dock. The following day he recorded in pencil and watercolor *Indian Graves, Laurel Point, Victoria Harbor*.[30]

Halkett Island, Indian Graves, Victoria, Vancouver Island and again, *Coffin Island, Victoria Harbor* manifests Alden's interest in the burial rites of the Indians. The deceased's canoe, carved dishes and food for his continued sustenance were frequently placed at the grave site. The bodies were placed on platforms in trees or in the owner's canoe. Carved or painted figures of the bear, raven, thunderbird or other familial heraldry were utilized as grave markers. They were attractive and colorful.

Alden painted the anchorage of the Pacific Squadron of the British Royal Navy, *Esquimalt Harbor, Vancouver Island*. He then climbed high for a *View of Esquimalt Bay, From Mt. Seymour, Vancouver's* [sic] *Island*, (Plate 20), a bird's-eye look at the protected naval anchorage. The following day he painted a close-up of *H. B. M. Ship* Satellite *and U. S. C. S. Str.* Active, *Esquimalt Bay, Vancouver's Island*, on verso "June 29, 1857 (1 a.m.)." (Plate 21) The vessels would cooperate on the Boundary Survey now being planned.

The *Active* took on distinguished passengers. Governor James Douglas wrote to Dr. William Fraser Tolmie, physician, executive with the Hudson's Bay Company and in charge of their post at Nisqually, "The *Satellite* and *Active* are both here with British and United States Commissioners on board; my time is therefore much occupied."[31] Daily meetings were held for a week. Alden met and talked with the commissioners from both sides. His uncle told him that the paintings he had sent with his application for Official Artist had been passed among the commissioners, who found them accurate and pleasing. Their decision would soon be announced. Plans were agreed upon for the actual survey the following year.

British Captain James Charles Prevost, R. N., commanding officer of H. M. B. S. *Satellite* and Commander Alden's counterpart on the Boundary Survey, and his party came aboard the *Active*. The vessel was cast off and the cruise began. *View of Orcas Island and Mount Constitution, July 1, 1857* was completed. The British visitors admired Alden's work. Then in pencil and grey wash *Puget Sound Agricultural Company Station. 7:45 p.m.* was completed in fading light. The ship was making good time and reached Fort Nisqually on July 2, 1857. This was the first white settlement on Puget Sound, established by the Hudson's Bay Company in 1833. It is on the Tacoma Peninsula.

Plate 20. View of Esquimalt Bay, From Mt. Seymour, Vancouver's [sic] Island.
Anchorage of the British Royal Navy, Esquimalt Bay, Vancouver Island, British Columbia,
June 28, 1857.
Watercolor, 12⅛ x 16½ inches, 1857.
Collection Washington State Historical Society, Tacoma, Washington.

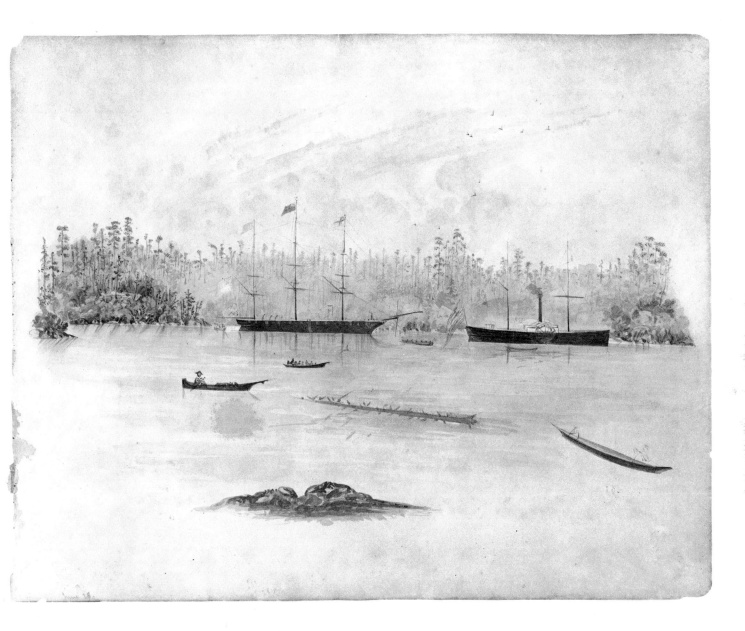

**Plate 21. H.B.M. Ship *Satellite* and U.S.C.S. Str. *Active*, Esquimalt Bay, Van-
 couver's [sic] Island.**
Watercolor, 12⅞ x 16½ inches, 1857.
Collection Washington State Historical Society, Tacoma, Washington.

Plate 22. Olympia.
Olympia, capital of the newly created Washington Territory, as it appeared on
July 3, 1857, at three in the afternoon. Tree stumps remain in the main thoroughfare.
Pencil and wash, 12⅞ x 16½ inches, 1857.
Collection Washington State Historical Society, Tacoma, Washington.

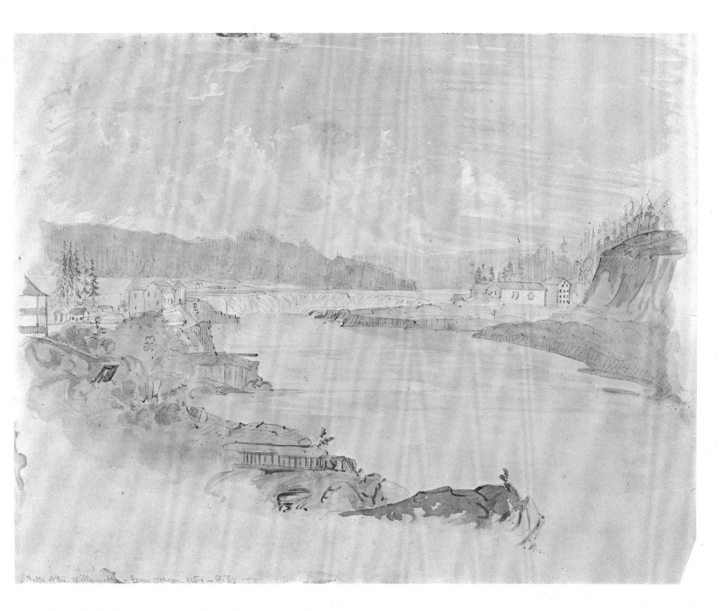

Falls of the Willamette from Oregon City – O.T.

Plate C-11. Falls of the Willamette from Oregon City, O. T.
First known as Willamette Falls, Oregon City was the center of political and commercial
activity in the Oregon Country and later the Oregon Territory. The city flourished
commercially because of the available water power. The first protestant church, the first
Masonic lodge, and the first newspaper west of the Missouri River came into being
within a mile of this falls.
Watercolor, 12⅞ x 6½ inches, 1857.
Collection Washington State Historical Society, Tacoma, Washington.

Plate C-12. Rapids, Columbia R.
The rapids shown here were part of a ten-mile obstruction to navigation on the
Columbia River, Oregon Territory. Until removal by blasting and dredging could be
accomplished, a portage railroad was completed by 1863. A section of an earlier portage
road is seen in this 1857 view.
Watercolor, 9¼ x 12 inches, 1857.
Collection Dr. and Mrs. Franz Stenzel, Portland, Oregon.

The next day Alden made a watercolor of *Nisqually House. 12 a.m.* and then recorded *Tumwater on the Stechus River* near Olympia, Washington Territory.

Olympia (Plate 22) was the capitol of the Washington Territory and so new that there were tree stumps in the main street of the town. It was situated at the southern extremity of Puget Sound and Budd Inlet. Governor Isaac Stevens lived there. It was a port of entry and its excellent harbor made it a rival of Port Townsend. When Alden visited Olympia, it was more important and heavily populated than Seattle.

On July 4 Alden painted *Tumwater Mill.* Tumwater, adjacent to Olympia, was settled by Michael Simmons, veteran of the Mounted Rifles who led a group of Oregon Territory settlers overland in 1845 to form the first independent community north of the Columbia River. That evening Alden, aboard the *Active,* reached Fort Steilacoom. The birthday of our nation was properly celebrated, Captain Prevost and his friends participating and watching fireworks after dark. The vessel continued up the sound into Skagit Bay and Alden made a watercolor of *Sinahomish.* This name, now modified to Snohomish, is applied to the city, county, river and a tribe of local Indians.

Returning north toward the Canadian-American boundary, their ship passed through Elliott Bay and McMurtrie painted *Restoration Point— Puget Sound. July 6, 1857* which is the southeastern tip of Bainbridge Island and directly opposite Seattle.[32]

At *Departure Bay—Vancouver's* [sic] *Island* (Plate 23) more colorful, carved, and painted Indian graves near Nanaimo appealed to Alden. From the island protecting the harbor of Nanaimo against the storms in the Strait of Georgia, Alden painted *Nanaimo from Douglas Island, Gallows Point* (Plate C-10) as the ship took on coal for a trip to Fort Vancouver.

Journeying through the Strait of Juan de Fuca, the party was entertained by several grey whales, broaching and sounding at a distance. These were the largest species of whales, reaching sixty to seventy feet. Each time a whale surfaced, he blew a spray of water ten to fifteen feet into the air. The Indians were unable to capture and kill these large animals, depending instead on their being washed ashore by a storm. Their nutritious fat was considered a delicacy. The whale was included in their carved totem figures and painted decorations. They made offerings to their gods to insure a continuing supply.

The vessel reached Astoria on July 23, 1857. (Plate 24) The arrival was noted by Alden in pencil and watercolor. The trip continued upriver to Fort Vancouver, the destination of Captain Prevost and his party.

70

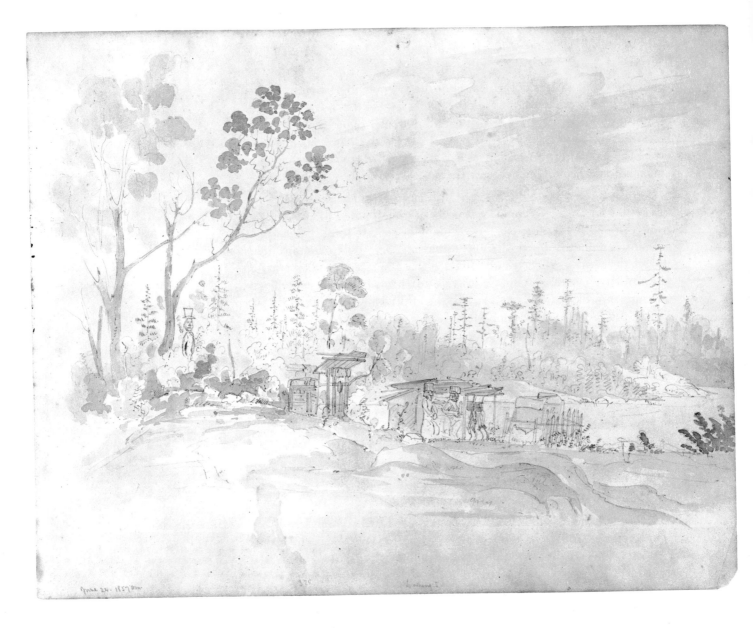

Plate 23. Departure Bay, Vancouver's [sic] Island.
Watercolor, 12⅞ x 16½ inches, 1857.
Collection Washington State Historical Society, Tacoma, Washington.

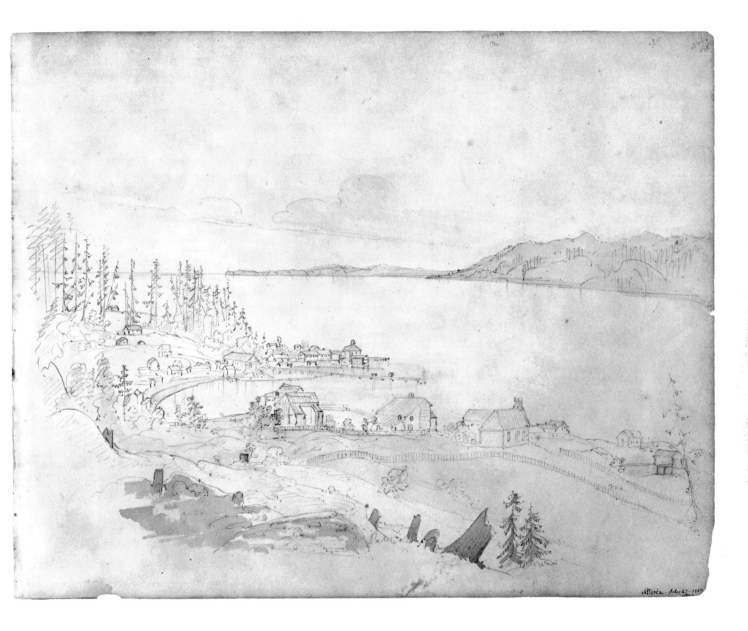

Plate 24. Astoria.
"Old" Astoria or Fort George is in the foreground. Astor's Point in the background,
had acquired larger and more imposing structures by July 23, 1857, when Alden returned
and made this view.
Pencil and watercolor, 12⅞ x 16½ inches [1857].
Collection Washington State Historical Society, Tacoma, Washington.

The ship returned downriver a few miles and entered the mouth of the Willamette River. This was new country to Alden. Ten miles up the river he saw Portland on the west bank. He climbed a small rise to make a pencil and wash drawing of *Portland, O. T. From Dryer's Hill.* (Plate 25) The little town had less than 1,000 inhabitants. Dryer's Hill, not presently identified, was named for Thomas Jefferson Dryer of New York State. He "came to see the elephant" but bought a press in San Francisco and shipped it to Portland. In 1850 he began publishing the still-flourishing *Oregonian.* He was a leader in Territorial affairs and served in the State Constitutional Convention, for which the delegates were already gathering at the time of the *Active's* visit.

The following day Alden moved six miles up the Willamette River and executed a pencil drawing of Milwaukie, a village of about 500 citizens. In the afternoon, he progressed six more miles to the former Capitol City of the Oregon Territory and made a pencil drawing looking downriver from just above the falls into the town, *Oregon City, O.T.* (Plate 26) The same scene had been drawn ten years before by Lieutenant Henry Warre and appeared as a colored lithograph titled *An American Village.*[33] Alden painted a watercolor view looking upriver through the town toward the falls. He titled it *Falls of the Willamette from Oregon City, O.T.* (Plate C-11) The falls provided the first industrial power in the territory but barred navigation, so the *Active* returned to the Columbia River for a cruise through the Columbia Gorge.

Approximately twenty miles beyond Fort Vancouver the river enters the Cascade Range of mountains. The flat land of the mid-river gave way gradually to higher walls on each side. The Columbia Gorge is cut through the Cascade Range and in its deepest portion is several thousand feet below the peaks and bluffs on either side of the river. Only a few miles from the Columbia stands the 11,000-foot-high Mt. Hood. The Cascade Range runs from Canada into California. There are ten perennially snow-covered peaks in Oregon and Washington. The two states are divided for a considerable portion of their common border by the Columbia River.

Alden was inspired on the aesthetic journey to paint some of his most outstanding work. The sheer cliffs broken by waterfalls and the high basalt columns and odd formations hewn out by erosion stimulated him. He emphasized the volcanic structures in his beautiful renditions along the Columbia Gorge, as he painted from the *Active* or landed from a small boat onto a vantage point on the bank, or even climbed higher to obtain a desired vista. A striking example is *Cathedral 2500 Ft. High Columbia R.* (Plate 27) The protuberance is the eroded termination of one of the north-

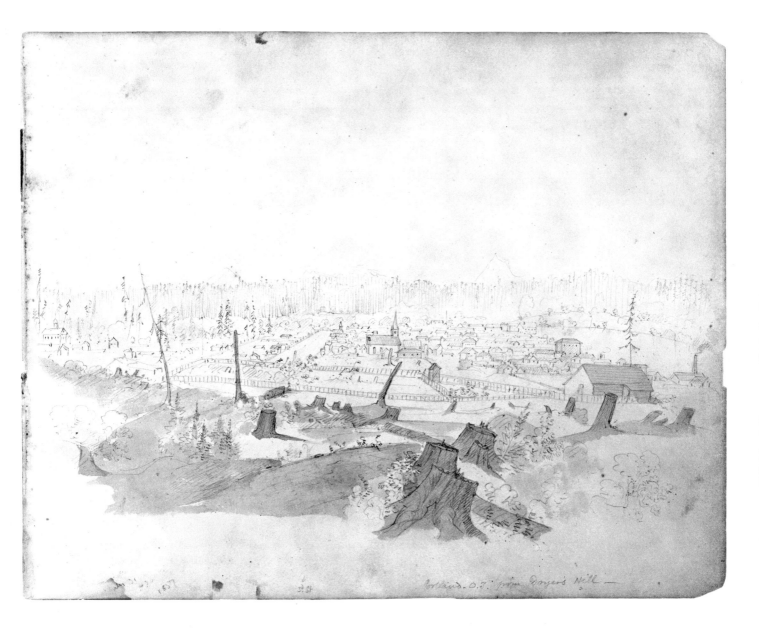

Plate 25. Portland, O. T. From Dryer's Hill.
Pencil and wash, 12⅞ x 16½ inches, 1857.
Collection Washington State Historical Society, Tacoma, Washington.

74

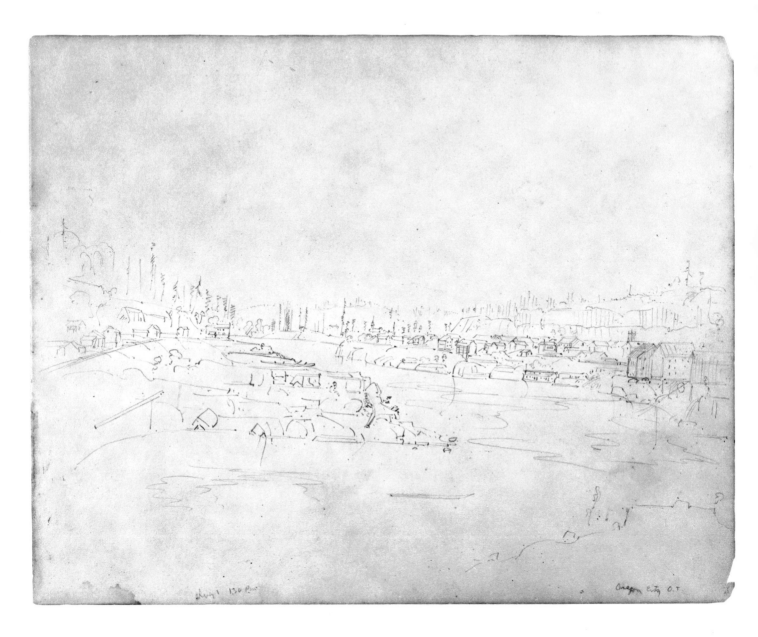

Plate 26. Oregon City, O. T.
Oregon City, August 1, 1857. The first incorporated city west of the Rocky Mountains
began in 1829 as a settlement of former Hudson's Bay Company trappers and voyageurs
and became the site of Oregon's first provisional and territorial governments.
Pencil, 12⅞ x 16½ inches, 1857.
Collection Washington State Historical Society, Tacoma, Washington.

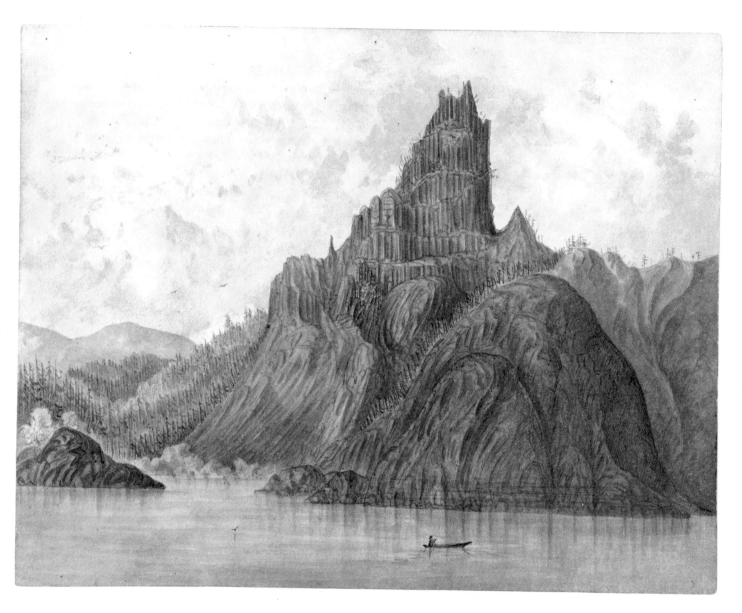

Plate 27. Cathedral 2500 Ft. High Columbia R.
Watercolor, 9⅜ x 12 inches, 1857.
Collection Sarah Alden Parham, Bloomfield, Connecticut.

west spurs from Mt. Hood interrupted by several church-like spires along its summit.[34]

Alden observed and painted the falls, rapids, rocky projections extending out from one bank or the other and sandbars exposed seasonally by variations in the water's depth. Since Alden's visit, obstructions have been blasted away and dredging has deepened the channels to permit safe navigation. Initially, the Columbia River was difficult and dangerous for immigrant parties to float down. With Spring runoff it became a torrent and in dry summers there was insufficient water to cover obstructions. Along the banks of the river, accessible trees to raft together had been exhausted by early pioneer parties.

On the northern bank in Washington Territory, Alden painted what he called *Castle Rock* or *McLeod's Castle*. There are Castle Rocks in every community, and McLeod has faded into obscurity. The 800-foot high basalt monolith is today called Beacon Rock.

About five miles upriver on the Oregon side, Alden painted McCord Falls. It is a double falls with two streams spilling over the first short precipice from east to west and then the single main falls tumbling far down to near river level. Alden has labeled this *Below Cascade Rapids. Ht. 4-600 ft.* (Plate 28)

By the time Alden recorded his trip in watercolor, efforts to build private portage roads had begun. Abortive starts on both sides of the river were washed out with Spring runoff, burned out or collapsed from faulty construction. In the most scenic section, from above The Dalles down to below the Cascades, navigation was impossible. In this section of the river, Alden records an area of the portage as in *Rapids, Columbia R.* (Plate C-12) Five years later saw the beginning of a thirteen-mile portage railroad built on the south bank by Oregon Steam Navigation Company. The portage railroad was operating in 1863.

The several watercolors of this area of the river indicate that Alden was entranced with the unfamiliar scale of the mountains and rugged grandeur awaiting him around each bend. He next painted *View on Cascade Portage —Columbia R.* (Plate 29)

Alden came upon an Indian fishing with a net from a platform. These fishing perches on projecting rocks and platforms were inherited and at an earlier time controlled and dispensed by the salmon chief See-pays, near Kettle Falls on the upper river. The single native fisherman is shown in *Grand Rapids, Cascades of Columbia*. (Plate 30) Alden gave the Indian one of his spare pencils after demonstrating its use. In return, Alden received several fish which he took back to the ship for a salmon bake.

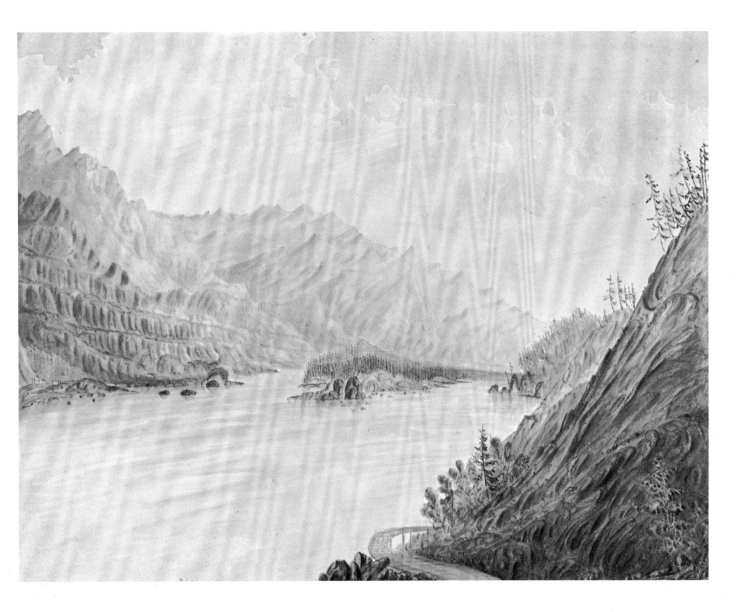

Plate C-13. Columbia R. on the Cascade Portage
A documentary scene of 1857 showing in the right foreground a section of an early
portage road. Across the river in Washington Territory, at low level, is the Fort Rains
blockhouse and two adjacent buildings.
Watercolor, 9¼ x 12 inches, 1857.
Collection Dr. and Mrs. Franz Stenzel, Portland, Oregon.

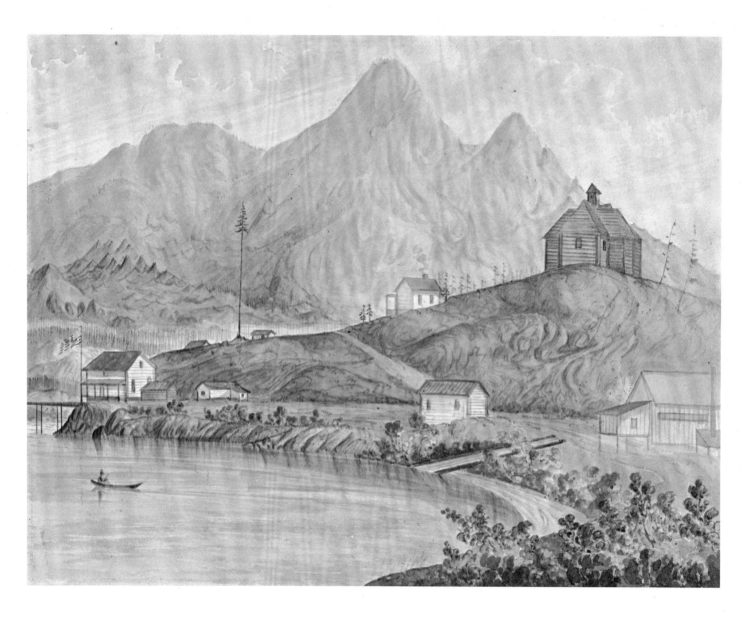

Plate C-14. Upper Cascades, Columbia R.
Fort Rains, Washington Territory, in 1857. The flag is flying and smoke emerges from
blockhouse chimney. These are the only known paintings of the fort during the time it
was garrisoned. The walkway left leads into the next view (Plate C-15).
Watercolor, 9¼ x 12 inches, 1857.
Collection Dr. and Mrs. Franz Stenzel, Portland, Oregon.

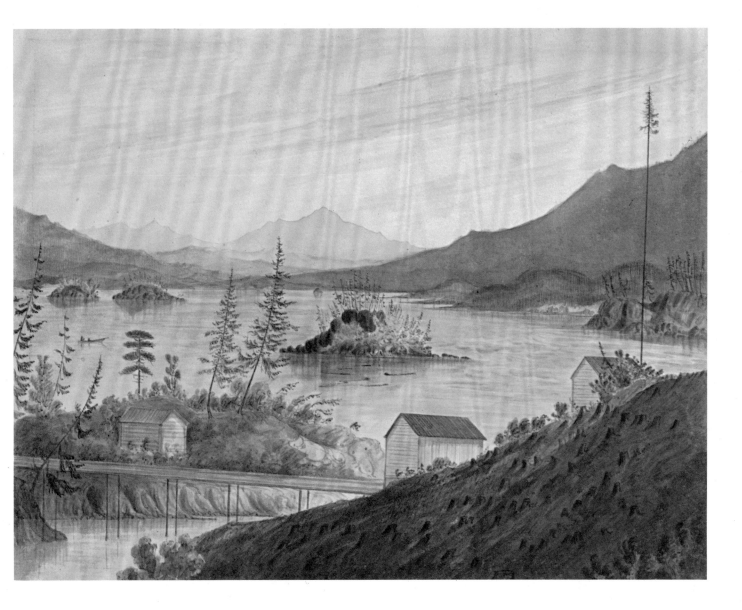

Plate C-15. Upper Cascades, Looking Up Columbia R.
View from Fort Rains, Washington Territory, in 1857 showing out buildings and
roadway to the steamer wharf. Built in 1855, the fort protected regional settlers and
travelers during Indian depredations in 1856.
Watercolor, 9¼ x 12 inches, 1857.
Collection Sarah Alden Parham, Bloomfield, Connecticut.

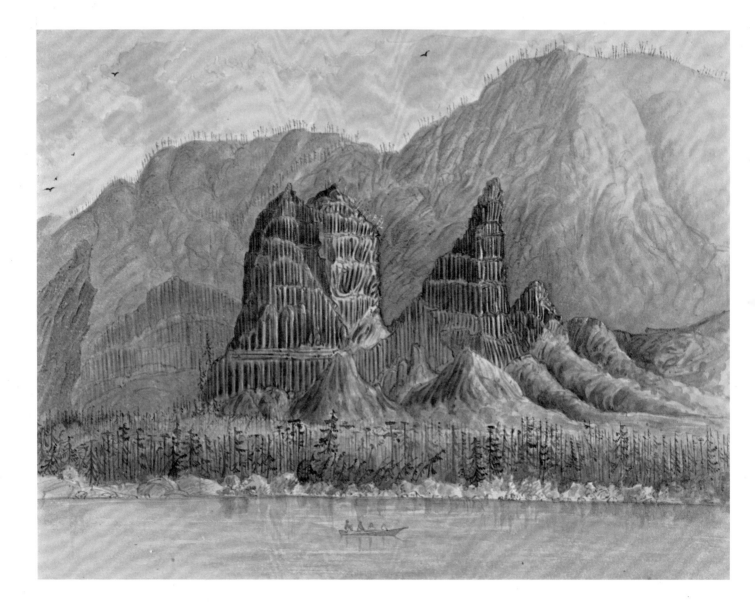

Plate C-16. Cascades, Columbia R. Below the Rapids.
St. Peter's Dome, 1857. Basalt formations remain after erosion of softer volcanic lava
and suggest cathedral-like spires along the Columbia River, Oregon Territory.
Watercolor, 9¼ x 12 inches, 1857.
Collection Dr. and Mrs. Franz Stenzel, Portland, Oregon.

In the related *Columbia R. on the Cascade Portage* (Plate C-13) a portion of an early portage road and a wagon, drawn by three horses or mules in tandem, is very lightly drawn in pencil but not painted. The Fort Rains blockhouse can be seen across the river. Erected by Major Gabriel Rains in 1855 one mile below the Upper Cascade landing, it was for the protection of settlers and travelers. In 1856, staffed only by a sergeant and nine men, the blockhouse was attacked by local Indians incited by upriver Klickitats. During a three-day seige, the blockhouse proved to be a haven of refuge. Demolished in 1861, the promontory on which it stood was removed to clear the channel. Alden arrived within a year of the Indian attack and set down the unique views of the period when the blockhouse was garrisoned. General Philip Henry Sheridan's service there as a young Lieutenant has prompted an alternate name of Sheridan's Blockhouse.[35]

Upper Cascades Columbia R. (Plate C-14) is directed from east to west toward the blockhouse and several adjacent outbuildings on a hill. Alden painted another watercolor view *Upper Cascades Looking Up Columbia R.* (Plate C-15) showing a road on piling running to an adjoining wharf where the *Active* was moored. No earlier paintings of Fort Rains are known.

Natural sculpturing created a group of basalt steeples shown in *Cascades Columbia R. Below the Rapids* (Plate C-16) and has earned the local name of St. Peter's Dome.

Although Alden painted six other watercolors along this stretch of the river, The Dalles was the principal place of interest to overland parties coming West across the continent or returning to the East. It was the end or the beginning of the long and difficult struggle. Here on the Columbia was the site of a twelve mile long series of obstructions beginning with Celilo Falls, which had a drop of twenty feet at low water but could be passed at high water over a steep rapid. Today the falls are bypassed by a ship canal with locks. The other obstructions are underwater due to several hydroelectric dams.

Approaching The Dalles, Alden painted *Columbia R. Below the Dalles.* (Plate 31) and then *Columbia R. Looking Down Fr. Below the Dalles.* (Plate 32) The paintings do not show the impediments to navigation which characterized the area.

Alden's three-page watercolor panoramic view of The Dalles is a unique historical document, since no other painting of this subject at so early a period is known to exist. Moreover, it is the only known painting in which all of the structures of the original Fort Dalles are shown, as well as details of the town. The left section is *Fort Dalles on the Columbia River.* (Plate

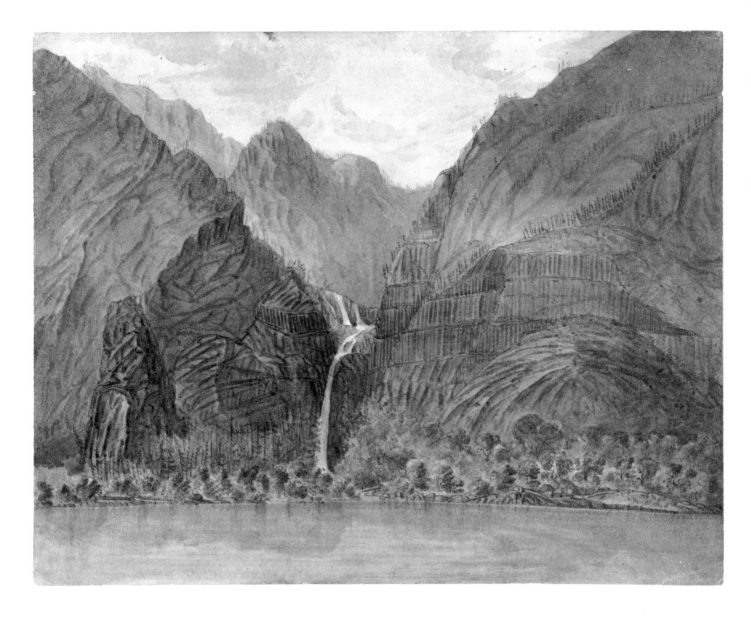

Plate 28. Below Cascade Rapids. Ht. 4 - 600 Ft.
McCord Falls rises from the high Cascade Range and pours into the Columbia River
which divides the territories, now the states of Oregon and Washington.
Watercolor, 9¼ x 12 inches, 1857.
Collection Dr. and Mrs. Franz Stenzel, Portland, Oregon.

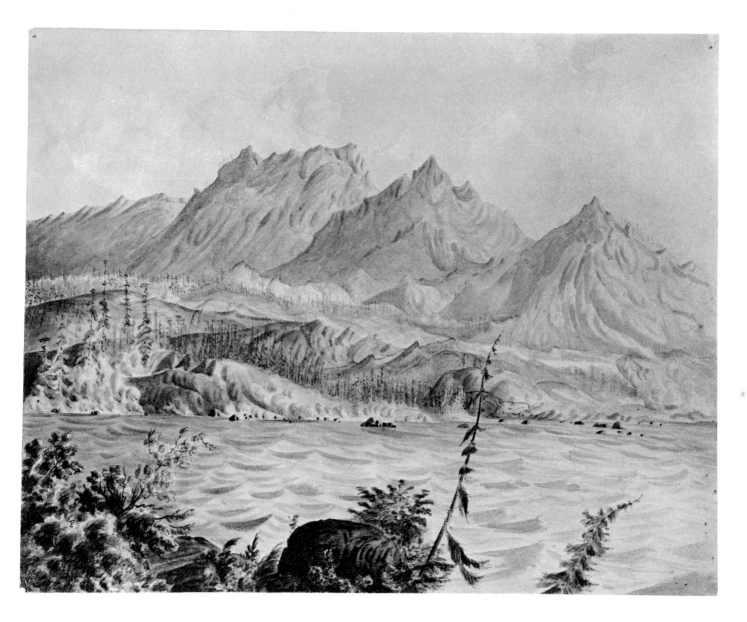

Plate 29. View on Cascade Portage — Columbia R.
A view from the cascade portage road, not shown in this watercolor, demonstrates the
rocky riverbed in this area of the Columbia River, Oregon Territory. Afternoon wind
causes the choppy waves and is a daily occurrence in some sections of the river.
Watercolor, 9⅜ x 12⅛ inches, 1857.
Collection Dr. and Mrs. Franz Stenzel, Portland, Oregon.

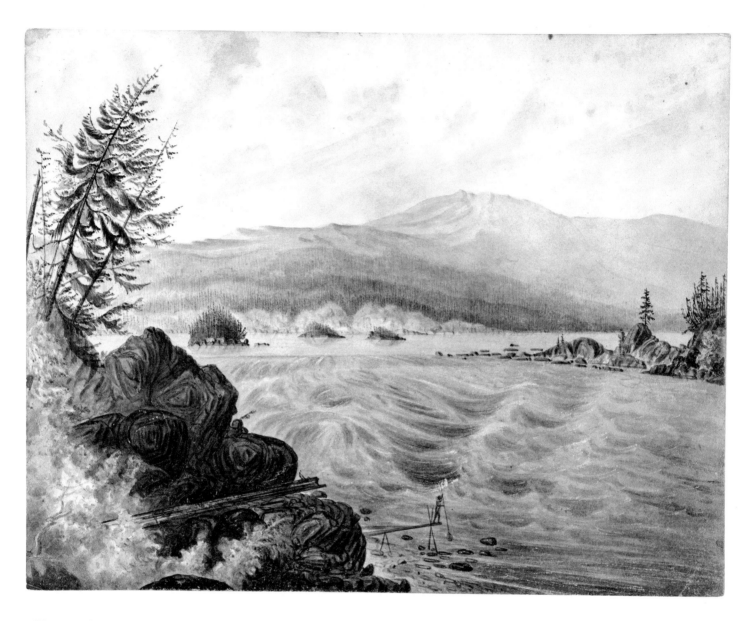

Plate 30. Grand Rapids, Cascades of Columbia.
This 1857 watercolor shows an Indian fishing platform being used. Such platforms or
rock ledges were located where experience had demonstrated that fish could be obtained
by spearing or netting. In some places a dozen or more similar sights were grouped
within a few feet. The right to use individual fishing sites was hereditary.
Watercolor, 9¼ x 12 inches, 1857.
Collection Dr. and Mrs. Franz Stenzel, Portland, Oregon.

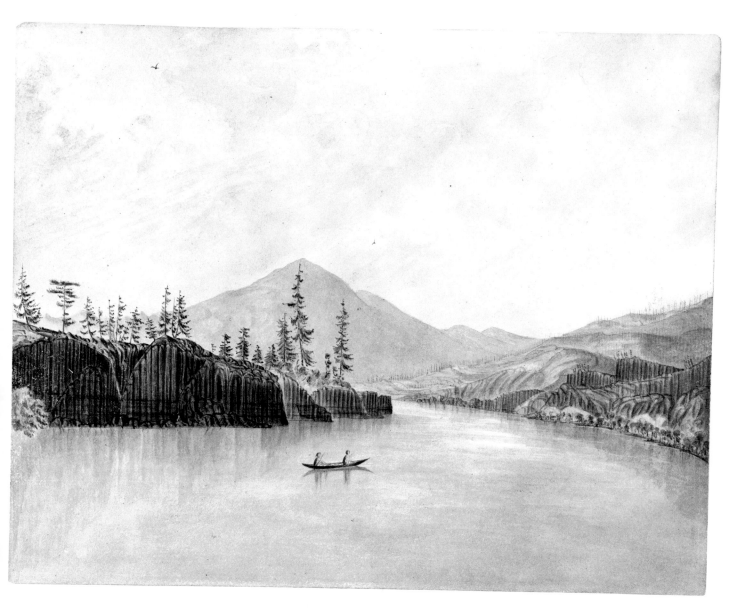

Plate 31. Columbia R. Below the Dalles.
Watercolor, 9½ x 12⅛ inches, 1857.
Collection Sarah Alden Parham, Bloomfield, Connecticut.

Plate 32. Columbia R. Looking Down Fr. Below the Dalles.
Watercolor, 9⅜ x 12⅛ inches [1857].
Collection Dr. and Mrs. Franz Stenzel, Portland, Oregon.

C-17) Sixteen buildings surround the parade ground where three cannon are in place and a squad of men are drilling. The only structure remaining today is the surgeon's house shown in the foreground between the two largest buildings. The central section looks across the river and the third section looks down the river along the narrow plain where not more than two score small buildings constitute the civilian town. The central section of The Dalles triptych is faded from exposure to sunlight for years, while its companion sections were protected in storage. It is nevertheless of special historical significance, as are many of Alden's paintings.

He painted *Mt. Hood Fr. Mouth Dog River, Columbia R. Above Cascades.* (Plate 33) Dog River is now called Hood River, the site of a town of the same name and a bridge crossing the Columbia River.

Artist McMurtrie again emerges. His watercolors of *Columbia River above Memaloose Island—July 28th* and *Wind Mountain—July 28, 1857* reaffirm his presence on this trip and provide a July date on their return journey.[36] Memaloose, which means dead in Chinook Indian tongue, was the island burial place below The Dalles. Wind Mountain was below the sacred island.

There are two additional undated watercolors by McMurtrie which were certainly painted on this 1857 trip. One is called *Rapids of the Columbia River, Oregon* which is drawn from the identical spot as *Grand Rapid Cascades of Columbia, 1857.* The artists had to have been standing but a few feet apart. The other watercolor is the left portion of Fort Dalles—one page of the Alden triptych—and whether the other sections were ever completed by McMurtrie is not known.[37]

In several instances the two artists painted the same scene on Commander Alden's orders. Using the Fort Dalles watercolors as examples of identical scenes, McMurtrie is less faithful in portraying essential detail. The three cannon on the parade ground and the grouped dwellings west of the fort are missing. The several miles of flat land extending west to where the mountains begin and the mountains themselves all lack detail. The truly high and rugged mountains are treated as if they were innocuous hills. Alden's treatment is the more attractive because he supplies more detail and uses a greater range of color.

In October the *Active* returned to San Francisco. A letter addressed to James Madison Alden contained his appointment as Official Artist of the Northwestern Boundary Survey.

Plate 33. Mt. Hood Fr. Mouth Dog River, Columbia R. Above Cascades.
Perennially snowcapped Mount Hood in the Cascade Range seen from the mouth of
Dog River, Oregon Territory, in 1857. Named Dog River to commemorate a gastronomic
event in which a starving immigrant party participated. Local citizens prefer the more
euphonious name, Hood River.
Watercolor, 9¼ x 12 inches, 1857.
Collection Dr. and Mrs. Franz Stenzel, Portland, Oregon.

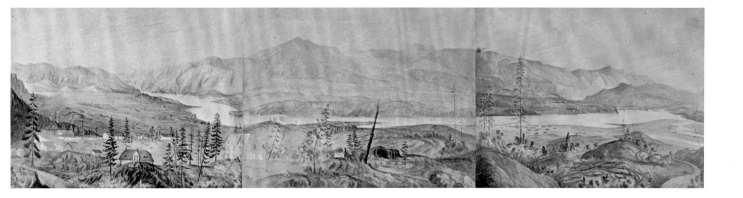

Plate C-17. Fort Dalles on the Columbia River.
This unique three-part panoramic watercolor of Fort Dalles, Oregon Territory, 1857,
shows all buildings of the citadel and those of the pioneer settlement on the banks of the
Columbia River. The left section looks downward toward Astoria, 175 miles below,
and shows Mount Adams in Washington, Territory.
Watercolor, 9⅜ x 36 inches, 1857.
Collection Dr. and Mrs. Franz Stenzel, Portland, Oregon.

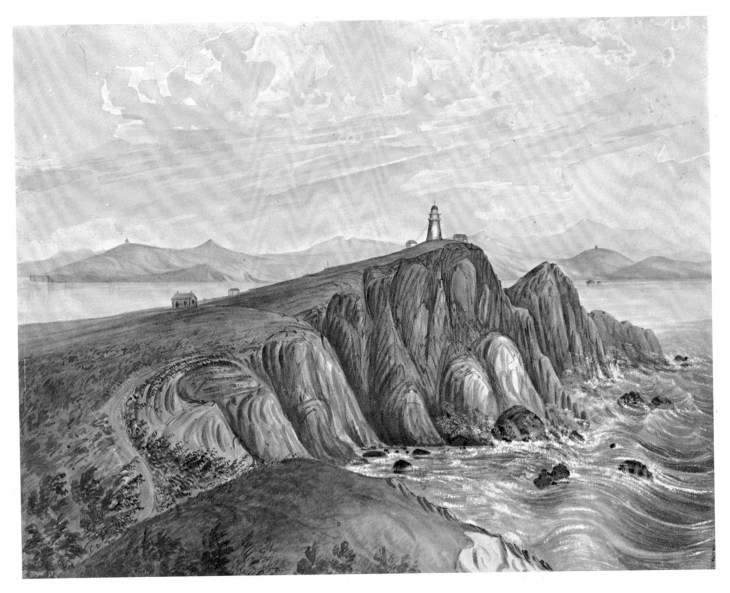

Plate C-18. From Pt. Boneta-Entrance San Francisco Bay.
The new lighthouse on Point Boneta, California, northern side of the Golden Gate (1858).
Watercolor, 9¼ x 12 inches, [1858].
Collection Dr. and Mrs. Franz Stenzel, Portland, Oregon.

III. OFFICIAL ARTIST OF THE NORTHWESTERN BOUNDARY SURVEY, 1858-1860

January, 1858, found James Madison Alden preparing to take up his duties as Official Artist. The Northwestern Boundary Survey was legislated by Act of Congress in August, 1856. The boundary between British America and the United States was stipulated by treaty as being along the 49th parallel. Its extension was "to the middle of the channel which separates the continent from Vancouver Island and thence southerly through the middle of said channel, and of Fuca's Straits, to the Pacific Ocean."[1]

As Alden was well aware, the wording led to a fundamental and irreconcilable difference. The British claimed the middle of Rosario Strait and the United States the middle of the Strait of Haro. At stake were the largest of the San Juan Islands, San Juan itself, Orcas and Lopez, and a number of smaller ones, as well as access to the widest and deepest ship channel.

The Northwestern Boundary Survey began with the appointment in 1857 of the United States commissioners, Archibald Campbell and Lieutenant (later General) John G. Parke, Corps of Engineers, United States Army, as chief astronomer and surveyor. G. Clinton Gardner was assistant astronomer and surveyor. Among the other officers was Joseph S. Harris, assistant surgeon and naturalist, who later became president of the Philadelphia and Reading Railroad. George Gibbs was geologist and interpreter, a graduate of Harvard Law School, veteran of the Oregon Mounted Rifles, and an artist. Dr. C. B. R. Kennerly was the surgeon and naturalist. Both the surveying steamer *Active* and the brig *Fauntleroy* with officers and crews attached were assigned by Superintendent Bache for the duration of the survey.

Captain James Charles Prevost was the British commissioner in command of the H. B. M. S. *Satellite* surveying vessel. A second British commissioner, Captain George Henry Richards, R. N., served as chief astronomer and surveyor. He was delayed by a breakdown of the H. M. S. *Plumper*'s machinery at Rio de Janeiro on her way from England to Victoria and did not arrive until November, 1857. It was too late in the season to commence the water boundary survey, which was the sole province of the two British commissioners.

Captain Richards not having arrived, the Americans began operations related to the land boundary at Point Roberts. At the same time they were redetermining astronomically the location of islands and nearby landmarks to carry triangulations northward into the regions in dispute. So before the spring of 1858, the American parties, working alone, had located four astronomical points on the 49th parallel and had thoroughly reconnoitered in the vicinity of the boundary for a considerable distance eastward.[2]

For Alden his new position meant an increase in pay to $100 a month plus travel expenses, lodging, and subsistence. There would be more money to send home to his mother. On the water he would be living on and working from either the *Active* or the *Fauntleroy*. Ashore he would move from one camp to another with military escort or with a supply train for protection against the Indians. Alden realized he should delay his picture making until the trail along the border was built and the camps were established, which would mean two seasons. Therefore, he planned to concentrate on the water survey in the interim. As usual the working season that far north would be limited to a few months each summer.

In August of the previous year Commander James Alden had turned the *Active* over to Captain Cuyler to complete the season's work. Commander Alden and his wife had returned to the East Coast. Aunt Sarah had become quite unstable at times, and Alden and his uncle were openly concerned. Uncle Alden explained that he was taking Aunt Sarah back to their home in Charlestown to be near her family and seek medical help while he was engaged in Washington City. He would return to assume command of the *Active* for the season's work. Meantime, the vessel was taken to Mare Island for repair of damages sustained during the previous season.

This created a working vacation for Alden prior to the summer cruise. A nearby lighthouse had been recently completed and Alden's watercolor *From Pt. Boneta—Entrance San Francisco Bay* (Plate C-18) is assigned the date of 1858. The Point Boneta lighthouse marked the northern side of the Golden Gate and was a welcome navigational aid because of the ships which had been wrecked at that site.

Cave in the Middle Island of Anacapa, Santa Barbara Channel. 1858. is not readily explained by Alden's known itinerary. He could have arranged a trip on a Survey vessel. The signed and dated watercolor allows little doubt that he was there.

An unusual example of Alden's work is a twelve-inch by nine-inch watercolor portrait of his friend and associate *W. B. McMurtrie, U. S. Str.* Active (Plate C-19). No other portrait by Alden is known, nor is there any other portrait of William McMurtrie. This competent likeness raises the question of other portraits which Alden may have painted.

Alden began a meandering trip in March while the *Active* was at Mare Island. It is not possible, by available accounts, to trace precisely his movements. From his dated works some idea of his course is obtained. His watercolor *Sacramento River, Cal. Mt. Diablo in the Distance* (Plate C-20) points to his travel by riverboat. There was well-established freight and passenger service on the river between San Francisco and Sacramento by this time. The high water is consistent with the time of the year. The 3,850-foot peak of Mount Diablo shown in the painting is about twenty miles south of the river near Walnut Creek.

Alden pursued the muse into Sierra County and painted five scenes in the environs of Sierra City. Three are dated with the year and two with the day and the month. The other two are assigned dates because of their propinquity to the dated items.

The first painting is *Monte Cristo, Sierra Co.* Another is *In Geyser Cañon, Cal^{a.}* (Plate 34) There are many geyser areas in the state beside those in Sierra County. Since Alden made no other trip to this area, the attractive watercolor is included as an 1858 product. On the north fork of the Yuba River was *Downieville Buttes* assigned the date July 1858 through the process of deduction. It is followed by *North Fork Yuba River Near Downieville.* (Plate 35) and then on the following day, Alden painted *Near Downieville, Sierra Co. Cal^{a.} From Monte Cristo Trail. Looking up N. Fork of Yuba (N. E.) 12 M.* (Plate 36) Monte Cristo Trail is shown in both illustrated scenes. It has not been located but was a frequently applied designation in gold mining days and doubtless alludes to Alexandre Dumas' novel.

Downieville was named for Major William Downie, a Scotsman who mined the forks of the Yuba in 1849 and wrote a book on his experiences.[3] His name is associated with some adjacent geographic features. Downieville was located between Goodyears Bar and Sierra City on the north fork. Unfortunately no Alden paintings of the actual mining of gold or the life in gold camps are extant.

Plate 34. In Geyser Cañon, Cala.
Watercolor, 9⅜ x 12⅛ inches, 1858.
Collection Sarah Alden Parham, Bloomfield, Connecticut.

Plate 35. North Fork Yuba River Near Downieville.
The Monte Cristo Trail is in the background. July 8, 1858.
Watercolor, 8⅝ x 11¼ inches, 1858.
Collection California Historical Society, San Francisco, California.

**Plate 36. Near Downieville, Sierra Co. Cala. From Monte Cristo Trail. Looking
 Up N. Fork of Yuba (N.E.) 12M.**
Watercolor, 8⅝ x 11½ inches [1858].
Collection California Historical Society, San Francisco, California.

It is not known where else Alden wandered on this trip but by the end of July he returned to San Francisco. He joined his uncle, again in command of the *Active*. The Northwestern Boundary Commissioner Archibald Campbell and some of his staff were aboard. Their assignment was "the triangulation at the lower part of the Gulf of Georgia; and the topography of the Islands adjacent to the northern entrances of Canal de Haro and Rosario Strait . . ."[4] The ship arrived near the boundary on August 1. She entered the Port of Victoria, Vancouver Island, and firing a salute to the authorities of the island on August 3 at noon, they began the season's work.[5]

McMurtrie was present on this Northwestern Boundary trip. He made a watercolor of *Frazier's* [sic] *River Range from E. of Pt. Roberts. Aug. 1858.*[6] A range is two markers, objects or lights which, when in line, indicate the edge (or center) of a safe channel.

Fraser River was a ready-made water highway over which men, machinery and supplies could be readily carried. It flowed roughly parallel to the 49th meridian for a distance of nearly seventy-five miles before turning north, during which distance it was never more than twenty miles from the border. As will be seen from Alden's paintings, this was a land of high mountains and precipitous ravines. The forests of huge trees were in their dense, primitive state so that a line could not be surveyed without cutting them down. The mountains rose ever higher to the summit of the Rockies. The only access was to utilize the rivers on either side of the boundary for transport. As the valleys and streams led to the border, they were followed. Finally a series of points were located astronomically along the 49th parallel. The points were then connected, stone markers were erected, and trees and underbrush were removed for "at least 20 feet on each side of the line for at least a half-mile, depending on the limiting character of the terrain."[7] The undertaking began on the coast and terminated at the crest of the Rocky Mountains.

Fraser River was named for Simon Fraser, partner in the North West Company and Superintendent of the region he discovered and named "New Caledonia" in 1806. The *Active* entered the mouth of the river, which it was to traverse many times in the course of the Survey, and Alden painted a series of watercolors from the lower river to beyond Fort Hope where the river became broad and too shallow for the *Active* to navigate.

Eight miles from the mouth is the location of *Fraser's* [sic] *R. 15 Miles Below Ft. Langley.* (Plate 37) Alden pictured the Indian longhouses sited on an island which may have been summer fishing lodges. The Indians carried the painted and carved planks which formed the walls of their winter houses to their summer fishing lodges and back each season.

98

Plate 37. Fraser's [sic] **R. 15 Miles Below Ft. Langley.**
Indian fishing lodges on Fraser River near Fort Langley, British Columbia, 1858.
Watercolor, 9⅜ x 12⅛ inches, 1858.
Collection Sarah Alden Parham, Bloomfield, Connecticut

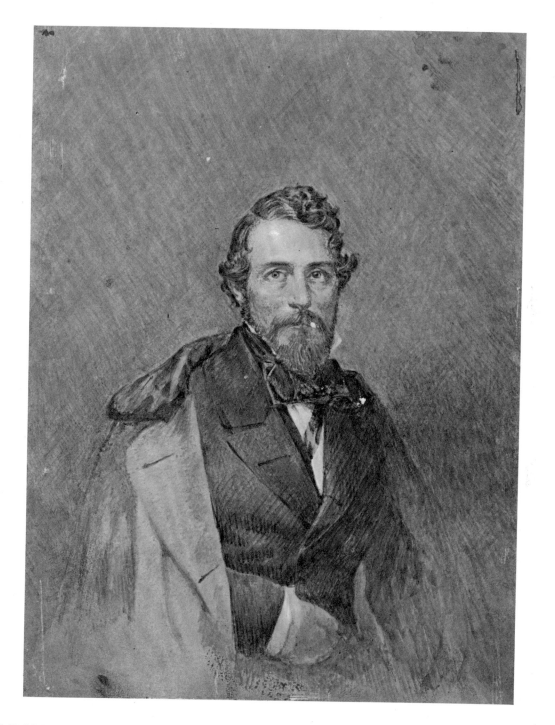

Plate C-19. W. B. McMurtrie, U. S. Str. *Active*.
Portrait of fellow artist William B. McMurtrie, on the U. S. Steamer *Active*, 1858, painted by James Madison Alden.
Watercolor, 8½ x 6½ inches, 1858.
Collection Dr. and Mrs. Franz Stenzel, Portland, Oregon.

100

Plate C-20. Sacramento River, Cal. Mt. Diablo in the Distance.
Watercolor, 9¼ x 12 inches, 1858.
Collection Sarah Alden Parham, Bloomfield, Connecticut.

Plate C-21. H. B. Co. Fort Langley, Left Bank of Fraser River. Langley Buttes in the Distance.
The Hudson's Bay Company's Fort Langley on Fraser River, British Columbia, in 1858.
Across the river is an Indian camp and behind the camp rises Langley Buttes in
the distance.
Watercolor, 11½ x 17½ inches, 1858.
Collection National Archives, Washington, D. C., Record Group 76, Records Relating
to International Boundaries Entry 221, Landscape Views of the Area along the
Northwest Boundary.

102

Plate C-22. Fraser's [sic] **R. Camp.**
Nooning on Fraser River, British Columbia, 1858. Four of the party are at lunch.
Two Indian guides are in the background.
Watercolor, 9½ x 13 inches, [1858].
Collection Dr. and Mrs. Franz Stenzel, Portland, Oregon.

Alden was elated as the reconnaissance of the river brought into view *H. B. Co. Fort Langley, Left Bank of Fraser River. Langley Buttes in the Distance.* (Plate C-21) The British fort is on one side of the river and a large Indian village on the other. Being so located was mutually advantageous. The Survey crews and other white travelers could take refuge in the fort in case of Indian trouble. The Indians in turn felt secure from attack by other raiding Indian tribes. They were primitive and superstitious and did not understand the strange new white men and their magic instruments and activities.

Farther, almost fifty miles upriver, Alden painted *On Fraser's* [sic] *River Looking Up From Near Mouth Chiloweyuck* [sic] *River British Columbia.* (Plate 38) The attempt to spell phonetically what the white man thought the Indians were saying led to several variations of each name. Many of the long and difficult names have since been dropped or modified. Alden employed the current Indian names in the notations on his drawings and watercolors, as did the Northwestern Boundary Survey on their maps and in their literature.

Continuing upriver, Alden reveals *Looking up Fraser fr. above Harrison R.* This river is actually the short outlet from beautiful Harrison Lake.

Fraser's [sic] *R. Camp* (Plate C-22) shows a nooning situation with four men from the *Active* around a campfire. Directly behind them are two Indian guides. The men are ahead of the ship taking soundings and have paused for "dinner."

Alden painted an obstruction which almost stopped their progress in the course of the journey at *Sealino Bar-Fraser's* [sic] *R. Looking Down.* (Plate 39)

His next watercolor was titled *From Fort Hope. Fraser's* [sic] *River.* (Plate C-23) Fort Hope, a Hudson's Bay establishment of 1848, grew rapidly during the gold rush as a supply point and head of navigation. It was named to honor Sir James Hope, Commander-in-Chief of the North American Station.

The final scene from Alden's series along Fraser River is *Indian Village Above Fort Hope* (Plate 40) and reveals details of the Indian longhouses made of split, straight-grained cedar planks and decorated with bright native painted designs. The reconnaissance of the Fraser River was completed.

The party returned downriver. Alden made a pictorial report of the survey of the lower Gulf of Georgia from August 24 to October 10. The *Active* was in the company of the *Satellite. Semiahmoo Bay, From Bluff Near Entrance of "Mud Bay" with Camp Semiahmoo, Drayton's Harbor and Distant View of Mt. Baker to the East* (Plate 41) shows a view of the commissioners'

104

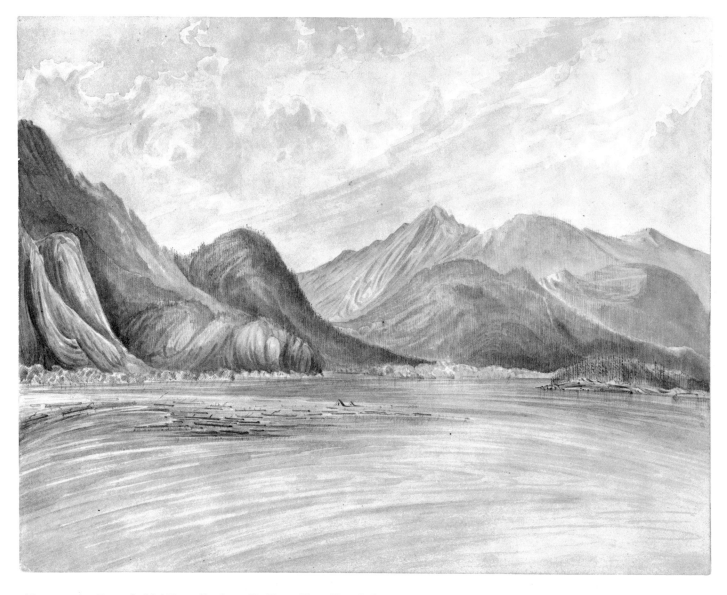

**Plate 38. On Fraser's [sic] River Looking Up From Near Mouth Chiloweyuck
 [sic] River, British Columbia.**
Fraser River, British Columbia, ran along the 49th Parallel for about sixty miles.
Distances were triangulated and accessible routes to the American-Canadian boundary
were located on this 1858 reconnaissance. Surveyors' tents on the sandy bar and the
mouth of the Chiloweyuck (Chilliwack) River are visible.
Watercolor, 9⅜ x 12⅛ inches, 1858.
Collection Dr. and Mrs. Franz Stenzel, Portland, Oregon.

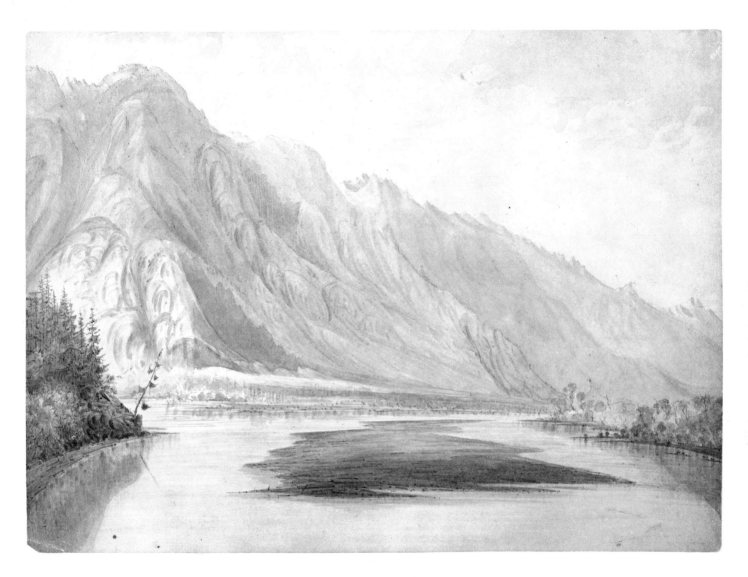

Plate 39. Sealino Bar Fraser's [sic] **R. Looking Down.**
Sealino Bar was an almost impassable obstruction on Fraser River in 1858.
Watercolor, 9⅜ x 13 inches, 1857.
Collection Dr. and Mrs. Franz Stenzel, Portland, Oregon.

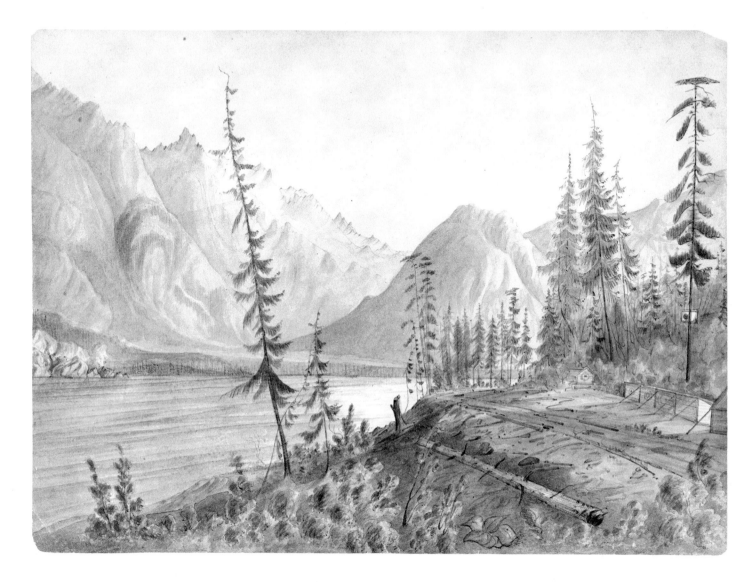

Plate 40. Indian Village Above Fort Hope.
Indian village above Fort Hope, 1858. This was almost the head of navigation on
Fraser River, British Columbia. The hand-split, horizontally placed planks forming the
longhouse walls were transported and applied to other frames as the Indians moved from
summer to winter quarters and returned with the seasons.
Watercolor, 9⅜ x 13 inches, 1858.
Collection Dr. and Mrs. Franz Stenzel, Portland, Oregon.

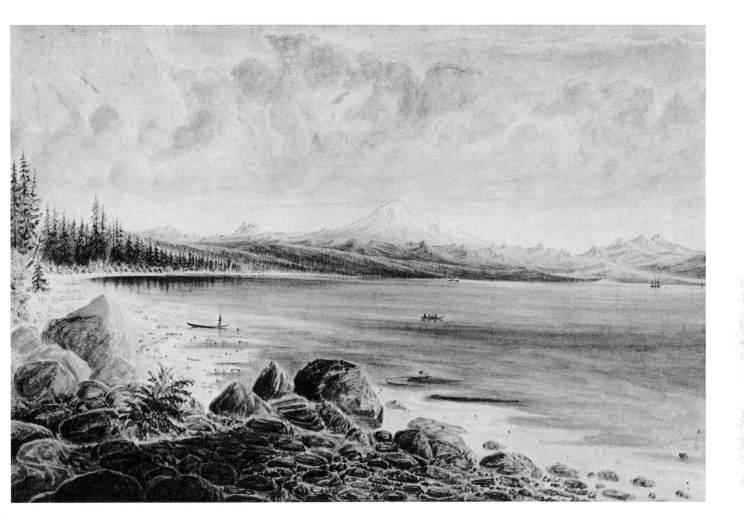

**Plate 41. Semiahmoo Bay, From Bluff Near Entrance of "Mud Bay" with Camp
 Semiahmoo, Drayton's Harbor, and Distant View of Mt. Baker to the East.**
Just below the boundary on the coast of Washington Territory in 1859, Alden painted
the survey vessels *Active* and *Satellite* and the Northwestern Boundary Commission camp,
faintly seen on the opposite shore at Drayton's Harbor, Semiahmoo Bay. Today the
Indian names for the bay and the town have been changed to Blaine.
Watercolor, 11½ x 17½ inches, [1859].
Collection National Archives, Washington, D. C., Record Group 67.

camp across Semiahmoo Bay in Drayton Harbor, named in 1841 by Charles Wilkes to honor Joseph Drayton, one of the artists of that expedition. Drayton Harbor is a protected anchorage just a few miles south of the boundary. Mount Baker, named in 1792 by Captain George Vancouver for one of his officers, is a high peak of 10,750 feet in the Cascade Range and was thirty miles distant in Washington Territory. The *Active*, with the stack between its two masts, is near the center of the painting.

The Americans were meticulously accumulating evidence to support their contention that the Strait of Haro should be the water boundary. Therefore the sounding, carried on to determine depth and physical characteristics of the principal channels, was of great importance.

Alden noted that the San Juan Islands and the Gulf Islands had some common features. Most were covered with excellent timber. Beaches were uncommon. Most shores were rocky and plunged almost straight down to considerable depth. In anchoring it was frequently necessary to carry a bow line ashore, in addition to casting a stern anchor overboard. The stern anchor would lodge against the sloping underwater shoreline so that the vessel was secured at each end.

The ship turned from the Strait of Georgia along the northern shore of Gabriola Island and began sounding. Nearby was the famous Malaspina Galleries which Alden reached by rowing in a small boat. The rocky floor was a few feet above ocean level at high tide. There was a rock overhang about fifteen feet above the base which formed the roof. On top of the roof, trees, grass, and colorful wild flowers were growing. Between the floor and the roof, storm waves had washed away layers of soft sandstone to form the long arcade open to the sea. The main gallery continued for fifty yards, and then transverse sections of rock divided the space into rooms or smaller galleries. The unusual formation was discovered in 1792 during the Malaspina Expedition and visited then by Spanish naval Captains Valdes and Galiano. The latter made a painting of the galleries which was widely circulated in Europe. Alden had seen it illustrated in a schoolbook and was exhilarated by his historical pilgrimage and noted the absence of visible change in sixty-five years since its discovery.

An approximation of the rugged beauty is indicated in Alden's *Straits of Haro. Stewart's* [sic] *Island in the Centre.* (Plate 42) Stuart's Island in Haro Strait was named for Captain Charles Edward Stuart of Hudson's Bay Company, who provided local knowledge to Captain Prevost. The United States advocated this channel as the water boundary.

The British election for the water boundary was *Straits of Rosario, Cy-*

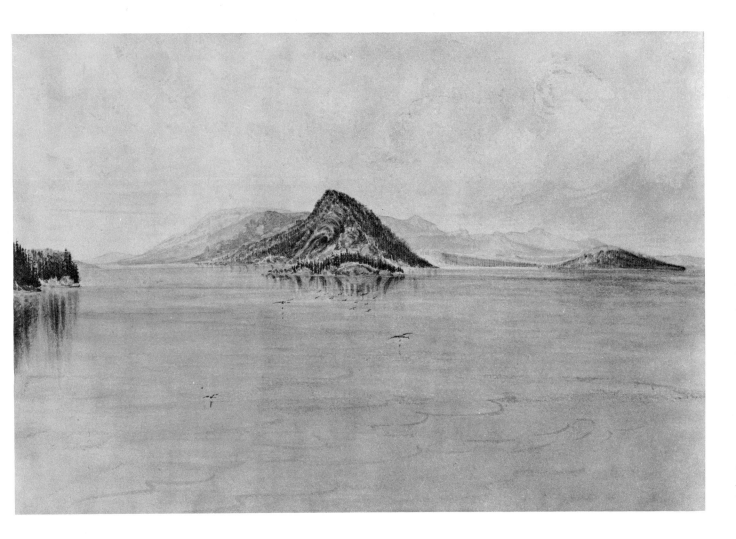

Plate 42. Straits [sic[**of Haro. Stewart's** [sic] **Island in the Centre.**
The Strait of Haro shows Stuart Island dead ahead. The middle of Haro Strait was
advanced as the water boundary by the United States and was adjudicated by Emperor
William I of Germany in 1871.
Watercolor, 9½ x 13½ inches, 1858.
Collection National Archives, Washington, D. C., Record Group 76.

press Island and Strawberry Harbor on the Right. Hautboy Island in the Centre—Mt. Constitution and Orcas Island in the Distance. (Plate 43)

In the course of the 1858 Hydrographic Survey, Commander Alden and his vessel made history by discovering the shoal named Alden Bank in Rosario Strait. The *Active* had been the first steamer to use Active Pass, a narrow shortcut from Trincomali Channel to the Strait of Haro now utilized many times daily by ferryboats and ships. The naval officer and his role in the scientific survey of the regional waters is further commemorated by Alden Point, Washington, on the west cape of Patos Island.

McMurtrie appears once more with his *Sucia Harbor, Sept. 1, 1858* watercolor.[8] The snow on the mountains is unusual for the date. Sucia Island was just north of Orcas and its ownership depended on the outcome of the water boundary dispute.

On October 8 this intelligence was recorded: "Talking of news just reminds me that when the '*Active*' joined us in Cowitchen [*sic*] she told us of the Electric Telegraph being laid and the Queen's visit to Cherbourg."[9] The news was on the front page of every newspaper in the civilized world. The progress in laying the underwater cable had been chronicled for months. In order to be certain of ultimate success, the effort in the Atlantic Ocean had been duplicated in the Pacific. The Western Union Telegraph Expedition had extended from San Francisco up the western coast and onto Vancouver Island while work was progressing on the Asian shore of Kamchatka. The news meant the termination of the Western Union Expedition. The completion of the Atlantic cable was a triumph of modern technology.

The *Active* called for coal a few miles north at Nanaimo. Alden's excellent documentary watercolor supplies a close look at *Nanaimo Indian Village.* (Plate C-24)

Victoria Gazette of October 26, 1858, reported: "California News. The U. S. Steamer *Active*, Captain Alden, arrived at San Francisco in 74 hours from Victoria." The remainder of that season was utilized in sounding for thirty miles abreast of the San Francisco bar and from Point Reyes southward. This work was not completed until the end of February, 1859.

Alden was detached from the *Active* in the spring of 1859 and made an unrecorded art junket to the Yosemite area. Of nine Yosemite watercolors, six bear an 1859 date. In addition there are four scenes, three dated 1859, which he witnessed going to and from Yosemite. The month is not revealed on the thirteen paintings. Because all show high water in the rivers and a great volume of water spilling over the falls, he must have been there in the spring.[10]

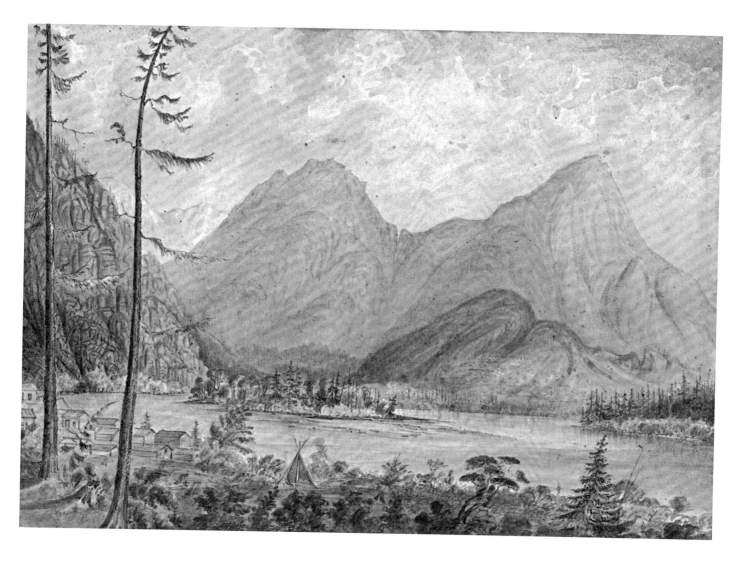

Plate C-23. From Fort Hope. Fraser's [sic] River.
Fort Hope, British Columbia, a Hudson's Bay Company establishment, was booming in
1858 because of the Gold Rush to this area.
Watercolor, 9 x 12⅞ inches, 1858.
Collection Mr. and Mrs. Lee Stossell, Lake Worth, Florida.

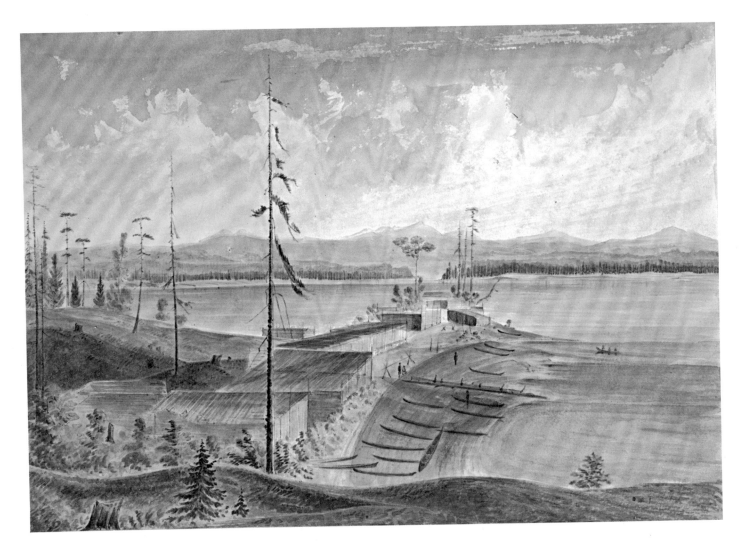

Plate C-24. Nanaimo Indian Village.
Alden's ethnographic study of the Indian village of Nanaimo, Vancouver Island,
British Columbia, was painted in 1858.
Watercolor, 9¼ x 13¼ inches, [1858].
Collection Provincial Archives of British Columbia, Victoria, British Columbia.

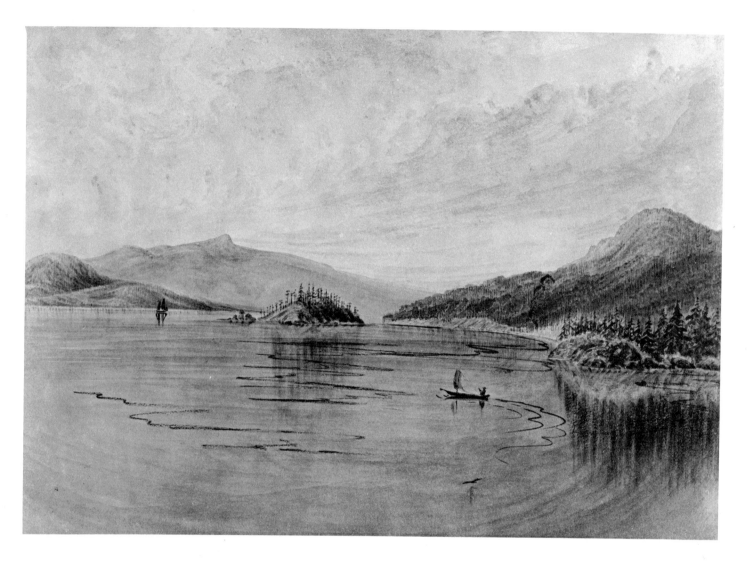

Plate 43. Straits [sic] of Rosario, Cypress Island and Strawberry Harbor on the Right Hautboy Island in the Centre — Mt. Constitution and Orcas Island in the Distance.
Watercolor, 9½ x 13½ inches, [1858].
Collection National Archives, Washington, D. C., Record Group 76.

Alden's horseback route followed the Tuolumne River part of his way into Yosemite Valley. His painting *Tuolumne River, Cala.* (Plate C-25) gives a glimpse of the little town of Jacksonville now buried beneath the waters of Don Pedro Reservoir.

A watercolor, *Torrent—Yo. Semite Valley, Cala.* 1859 portrays an unidentified swollen river which aided in the conclusion that the excursion was made in the spring of the year. Among several watercolors of the valley is *Bridal Veil From the Foot of El Capitan. Yosemite Valley, Cala.* (Plate 44) Perhaps Alden knew he would not return; there is yet another *Bridal Veil, Yo-semite Valley.* (Plate 45) A charming portrayal of *The 3 Brothers. 4000 Ft. High with Distant View of the Falls. Valley of the Yo-Semite* (Plate C-26) is illustrated. The last of Alden's watercolors of this area to be illustrated is *Waterfall Opposite the Bridal Veil. Yo-semite Valley, Cala.* (Plate 47) identified as the Yosemite Falls. The remaining scenes in the valley are repetitious.

On his trip Alden painted the impressive redwoods in *Big Trees. Calaveras Co. Stump 30 Ft. in Diameter* (Plate 48). What appears to be an early hotel or guest house may be identifiable to regional historians.

Also in Calaveras County, Alden painted *Suspension Flume, Cañon Near Murphy's Diggings, Cala.* (Plate C-27) Martin Murphy and his son John came to California in 1844 with the Elisha Stevens party seeking surcease from the malaria epidemic in St. Joseph, Missouri, which had killed some of his family. "Murphy's" grew from John M. Murphy's diggings or mining camp established in 1848.[11] In addition to the suspension flume pictured, two bridges and an incomplete flume at ground level are shown. Water was vital to gold mining; the suspension flume was an ingenious method of acquiring it.

Alden extended his trip to Tehama County and painted *Tuscan Springs Cañon, Cal^a.* (Plate 49) Borax was discovered in California at this site three years earlier by Dr. John A. Veatch, whose abode and bottling works are located in the canyon. This painting concludes the record of Alden's horseback ride to Yosemite and way points.

Alden was back in time for the northern trip. His friend McMurtrie had been transferred to the East Coast and assigned to the coast of Maine. Some of McMurtrie's drawings from that area have been located.[12] The *Active* left July 11, 1859. A resurvey of Humboldt Bay and further soundings of Crescent City, both along the California coast and on their way, were finished by July 22 before joining the Northwestern Boundary Survey.

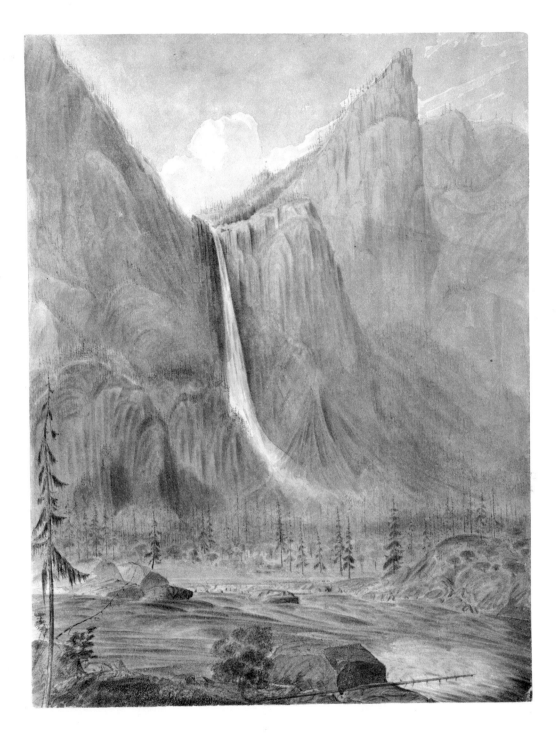

Plate 44. Bridal Veil From the Foot of El Capitan. Yo-Semite [sic] **Valley, Cala.**
Watercolor, 12 x 9⅜ inches, 1859.
Collection Dr. and Mrs. Franz Stenzel, Portland, Oregon.

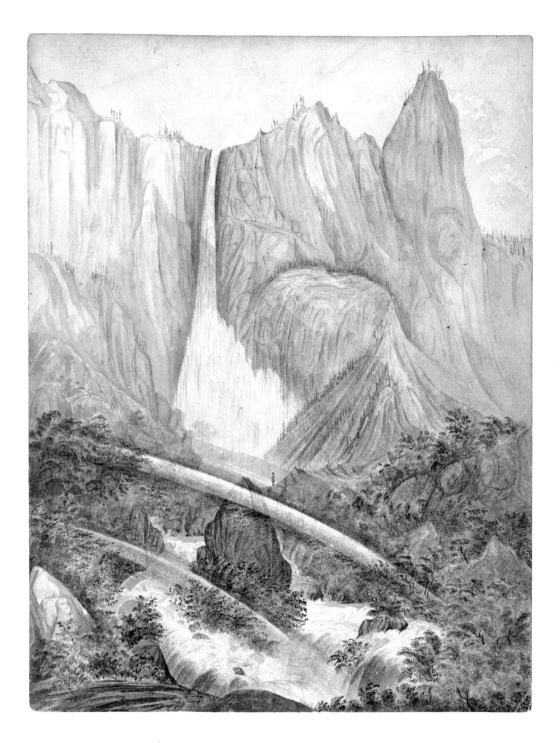

Plate 45. Bridal Veil, Yo-Semite [sic] **Valley.**
Watercolor, 12⅛ x 9⅜ inches, 1859.
Collection Dr. and Mrs. Franz Stenzel, Portland, Oregon.

Plate 46. Nevada Falls and Canyon, Yo-Semite [sic] **Cala.**
Watercolor, 11¾ x 17¾ inches, 1859.
Collection Dr. and Mrs. Franz Stenzel, Portland, Oregon.

Plate 47. Waterfall Opposite the Bridal Veil. Yo-Semite [sic] **Valley, Cala.**
Watercolor, 12⅛ x 9⅜ inches, 1859.
Collection Dr. and Mrs. Franz Stenzel, Portland, Oregon.

Plate 48. Big Trees. Calaveras Co. Stump 30 Ft. in Diameter.
Perhaps Alden and a friend are measuring the big trees of Calaveras County, California, since he describes this large one as being "30 feet in diameter."
Watercolor, 17¾ x 11⅝ inches, 1859.
Collection California Historical Society, San Francisco, California.

Plate 49. Tuscan Springs Cañon, Cala.
Tuscan Springs is the site of the first discovery of borax in California three years before
Alden painted this watercolor in 1859.
Watercolor, 9⅜ x 12 inches, 1859.
Collection Dr. and Mrs. Franz Stenzel, Portland, Oregon.

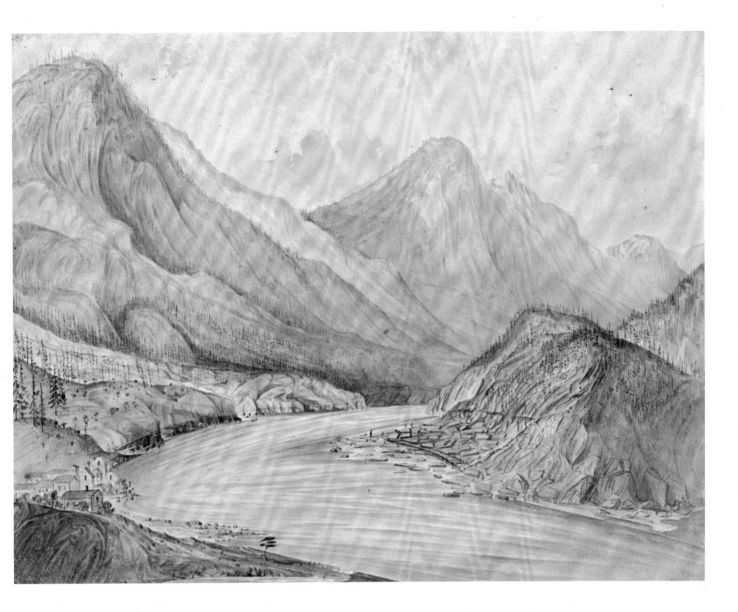

Plate C-25. Tuolumne River, Cala.
James Madison Alden painted this view at Jacksonville, California, in 1859 as he followed
the Tuolumne River into the Yosemite Valley.
Watercolor, 9¼ x 12 inches, 1859.
Collection Dr. and Mrs. Franz Stenzel, Portland, Oregon.

122

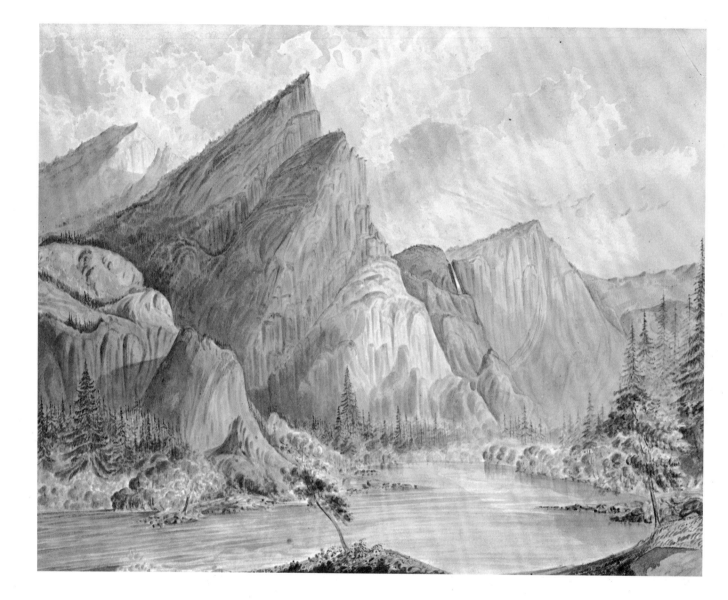

Plate C-26. The 3 Brothers. 4000 Ft. High with Distant View of the Falls.
 Valley of the Yo-semite.
Watercolor, 9⅞ x 12 inches, 1859.
Collection Sarah Alden Parham, Bloomfield, Connecticut.

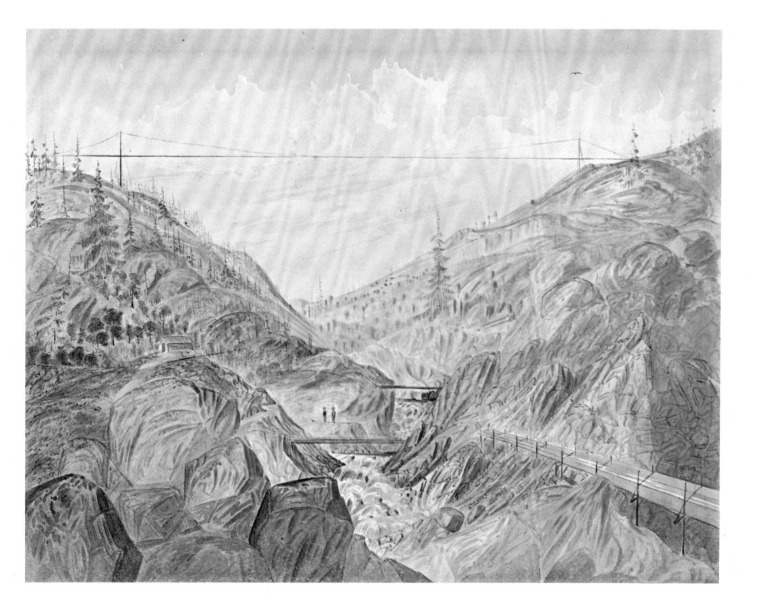

Plate C-27. Suspension Flume, Cañon Near Murphy's Diggings, Cala.
Overhead suspension flume and one at ground level located near Murphy's Diggings,
California, 1859.
Watercolor, 9⅜ x 12 inches, 1859.
Collection Sarah Alden Parham, Bloomfield, Connecticut.

The *Active* played only a tangential role in the British-American comedy skirmish staged that summer. Alden missed all of the actual melodrama. *Victoria Gazette* provides some knowledge of the movements of Commander Alden and the *Active*. She arrived in Victoria on August 6, bringing San Francisco newspapers dated up to July 30 obtained at Port Orford. Then, on August 20 she returned from Fort Vancouver with orders from General William Selby Harney, in charge of the United States Army's Oregon Department. General Harney indulged in some "sword rattling" by sending Company D, 9th Infantry, under command of Captain George E. Pickett from Fort Bellingham, to occupy San Juan Island for the United States.[13]

In response ". . . The Governor of Vancouver Island, Sir James Douglas, asserted British sovereignty over San Juan . . . At one time the United States had some 500 troops on San Juan, while five British ships of war, carrying 167 guns and 2140 men held the island in a state of seige."[14] Cooler heads prevailed. War was averted and the survey of the boundary proceeded.

Alden visited the island of San Juan after the controversy ironically dubbed "the pig war" was settled. The entire fracas was alleged to have occurred when an American settler shot a trespassing pig belonging to his British neighbor. Alden saw no signs of the bristling confrontation and no ships of war. His painting, *View from Hill on San Juan Island Looking S. with Ontario Roads. 'Active' and 'Satellite' at Anchor, Lopez Island and Mount Baker in the Distance* (Plate C-28) does have one cannon in the foreground.

Alden called at the commissioner's base camp on Semiahmoo Bay. He advised that the 1858 efforts had carried the work forward into the valley of the Skagit about ninety miles from the coast. "In the season of 1859 the work of surveying and marking the boundary was carried eastward from the valley of the Skagit to the Columbia River, a distance of 150 miles."[15]

Alden estimated that with 240 miles completed and almost another years' work to be added before he would return the following summer, he could devote the 1860 season to painting the boundary from the coast to the top of the Rockies. This proved to be his working schedule.

The year of 1860 was a busy one for the Official Artist and productive of a host of paintings. Alden was again transported from San Francisco to the boundary camp on the *Active*. Here he was armed with necessary credentials and a revolver. The *Active* carried him to the series of bases along Fraser River where trails led a few miles south to the border.

As Alden rode along on his horse, he became impressed with the back-

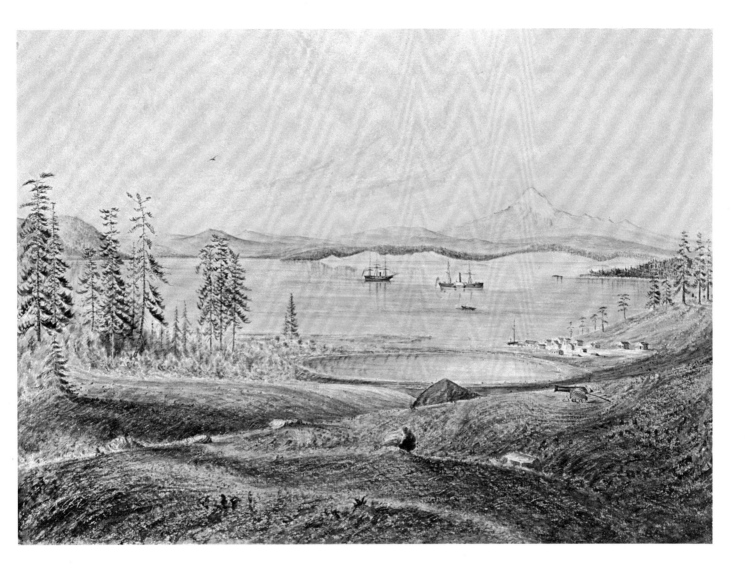

Plate C-28. View From Hill on San Juan Island Looking S. with Ontario Roads.
Active and *Ewing* at Anchor, Lopez Island and Mount Baker in the Distance.
San Juan Harbor on San Juan Island, called Bellevue Island by the British in 1859,
showing Mount Baker in Washington Territory, as painted by Alden. The ownership of
San Juan Island, Lopez Island, partly seen behind the survey ships, and several other
islands were at stake in the water boundary dispute between the United States and Britain.
Watercolor, 9½ x 13½ inches, 1859.
Collection National Archives, Washington, D. C., Record Group 76.

breaking toil required to build the trail over which he rode in ease. Sometimes he passed through dense virgin forests. The foliage started sixty feet or more up, where the first limbs began to interlace with neighboring trees forming an umbrella through which only an occasional ray of light penetrated the dense shade. There was no underbrush since all available sunlight was monopolized high above. Alden pictured a somewhat less dense, through comparable, scene in his *Camp Mooyie, 49th Parallel.* (Plate C-29)

The artist was accompanied by an armed guard. All camps and storage depots were guarded. This was necessary to discourage the Indians from marauding for food and whatever else might appeal to them. Too, the ongoing gold rush brought its quota of less than savory characters. Some appreciation of the influx may be gained by Victoria's transformation in two years from a village of 300 inhabitants to the booming town of over 20,000.

Not far from the coast the trail crossed low and marshy terrain. This was the breeding ground for the incredible swarms of mosquitoes which made work impossible without a hat edged by a curtain of netting falling from its brim to be tucked into the shirt. Alden somehow crossed streams where spring surges had carried away the bridges.

He often crossed the *Mooyie River Valley from Monument W. Side River Looking E. Along the 49th Parallel.* (Plate 50) This is quite typical of a valley between two mountain ranges which flooded every spring. Alden shows a stone monument protruding against the lower margin in the forty-foot swath which had been cleared of trees for several miles. Had the Survey attempted to follow the boundary, it would have been impossible to scramble up and down over mountains which were ever more precipitous and near the summit, snow-covered most of the year. The Mooyie River arises at Mooyie Springs in northern Idaho, flows north across the border, passes the post village of Mooyie on the Canadian Pacific Railroad and enters Kootenay Lake.

At times Alden encountered smoke from a forest fire. It drifted for miles in the valleys. The men told him of such dense, acrid smoke that the workers' reddened and swollen eyes were no longer helped by the flow of tears. Even the native Indians were forced to cease their labor until the smoke was abated by a breeze or the fire was doused by rain.

After about seventy-five miles Fraser River turned north and was no longer as close to the border. Access was then from the United States and depended on rivers running north or south from the border. Best known were the Columbia and the Kootenay rivers, others were the Similkameen, Kettle, Granby and a host of small streams.

**Plate 50. Mooyie River Valley from Monument W. Side River Looking E. Along
 the 49th Parallel.**
The boundary was marked by a forty-foot clearing across rivers and valleys as the
terrain permitted, then marked by stone or iron monuments at intervals. Shown here is
the cleared 49th Parallel across the Mooyie River Valley in Washington Territory
(which became Idaho Territory in 1863).
Watercolor, 10 x 17 inches, [1859].
Collection National Archives, Washington, D. C., Record Group 76.

Alden's portrayal of nature's grand scale dwarfing men and animals comes through in *Chelemta Depot. From Right Bank of the Kootenay Looking Up.* (Plate 51) The Kootenay, or Flat Bow or McGillivray, River arises in British Columbia on the west slope of the Rockies. It runs south into Montana and Idaho, then north, returning to British Columbia where it forms and then drains Kootenay Lake and enters the Columbia River. This is much altered today by Hungry Horse Dam in Montana, one of a series of hydroelectric dams along the Columbia and its tributaries. At the time of the Survey there was Camp Kootenay East and Camp Kootenay West. Chelemta is not readily identified today. In the watercolor a ferry is being sculled across the river. On the opposite bank a string of pack animals are descending a trail to the water's edge and a dozen or so are swimming behind the ferry toward camp. Other animals on land are being unloaded of their packs after swimming across.

Alden was now in the Rocky Mountains. He awaited a packtrain or military escort as he proceeded from depot to depot. Along the way a variety of animals made their appearance. Alden noted three kinds of bear, the brown, the black and some huge grizzlies. The large animals would rear up and watch the trespassers in their domain. They seemed to have no fear, only curiosity, watching until their examination was completed, then dropping down on four legs and ambling off. Bobcats were plentiful but the big mountain lions were seen only from a distance. At night in camp their cries could be heard and Alden learned to distinguish their frightening sound from the varied weird noises of the night.

Alden painted the winding *Kootenay River. Junction with Elk River. View from Trail on Right Bank.* (Plate 52) Elk River is not identified. His vista from the trail at a higher elevation looks over a broad expanse of the Canadian Rocky Mountains with some towering peaks in the distance.

Alden was now but seventy-five miles from the continental divide but the necessary circuitous route was two to three times that long. The incessant hauling meant procurement, care and feeding of great numbers of pack animals. Several score of armed escort, laborers, axmen, packers, and Indians as guides and helpers played their role in the Survey and marking of the border. The lines of supply became ever longer. At times food and supplies failed to arrive. Hunger was a new sensation for Alden.

In June 1860 provisions were in short supply and the men were becoming sick with scurvy. Bleeding gums, loose teeth and easy bruising marked the victims. "Dr. Hammond the Surgeon of the Escort advises that we send them to the Spokane River where there is a wild onion which grows along its bank which may prove of service," noted G. Clinton Gardner.[16] Pre-

Plate 51. Chelemta Depot. From Right Bank of the Kootenay Looking Up.
A ferry is being sculled across the Kootenay River followed by pack animals swimming
to supply Chelemta Depot in 1860. Since the river crosses the 49th Parallel several times
no exact location can be given, but it was near the border between Washington Territory
and British America.
Watercolor, 10 x 17 inches, [1860].
Collection National Archives, Washington, D. C., Record Group 76.

130

Plate 52. Kootenay River. Junction with Elk River. View from Trail on Right Bank.
Beautiful and rugged country allowed occasional access to the 49th Parallel and
astronomical sightings were employed to locate the boundary in the unmarked wilderness.
The party made its own trails or when possible followed rivers. Here is the junction
of Elk River with Kootenay River.
Watercolor, 11½ x 17½ inches, [1860].
Collection National Archives, Washington, D. C., Record Group 76.

sumably such treatment was efficacious. Though Vitamin C was not discovered and therefore the basic cause of scurvy was not known until half a century later, empirical knowledge indicated fresh fruits and vegetables as curative.

George Clinton Gardner, assistant astronomer and surveyor, maintained an extremely interesting account of the land survey and the subsequent office work in Washington City. His personal journal traces daily happenings and names persons concerned, laced with anecdotes of camp and trail. From the hand of an educated man, it is most informative and entertaining.

Alden's painting of *Aspen Camp Looking N. Trail from Palouse R. to Plants' Crossing on The Spokane* (Plate 53) portrays the general area where the scurvy victims were sent to procure the wild onions. Palouse is the name of a town, an Indian tribe, falls, rapids, and a river in southeastern Washington state. It is a tributary of the Columbia River and part of the downhill route from the Rocky Mountains. Alden's interest in the history of the West led him to realize he was following the trail used by all cross-country explorers till the more southerly Oregon Trail had been opened. He perhaps fantasized the presence of Lewis and Clark, the Astoria party, John Work, and David Douglas on their mutual path to the Pacific Coast. Giving free rein to his imagination helped to pass the time on the trail. On his arrival at Aspen Camp he noted the sixteen wagons which transported the camp and the many pack animals which carried supplies.

Gardner first mentions Alden when he noted that "On the 5th day of June Mr. Peabody and Mr. Edward Ross, (a recent appointment from San Francisco) arrived and on the following day the chief astronomer and surveyor [Lieutenant John G. Parke] reached the Sinyakwateen Depot from Walla Walla, leaving the rest of the party, Doctor Kennerly, Mr. King and Mr. J. M. Alden (another recent appointment) for the present at Plants crossing of the Spokane River."[17]

Gardner, though a man of science and action, was not a devotee of the arts. He was not aware of James M. Alden's official position in the Survey. Alden was only "another recent appointment." The artist remained with the principal Survey party or some branch of it until October 22, 138 days, yet Gardner mentions him incidentally only twice after June 5 and apparently had no opinion or comment concerning Alden's work.

Alden painted *Kootenay River Looking S. From Left Bank.* (Plate 54) Another ferry crossing is depicted with swimming pack animals following the raft. The long ears leave little doubt that they are mules.

Several members of the main party were leaving and returning from particular assignments as the Survey probed through the mountains seeking

Plate C-29. Camp Mooyie, 49th Parallel.
Camp Mooyie in northern Washington Territory along the 49th Parallel (later Idaho
Territory). Painted in 1860.
Watercolor, 11¾ x 18 inches, 1860.
Collection Mr. and Mrs. Lee Stossell, Lake Worth, Florida.

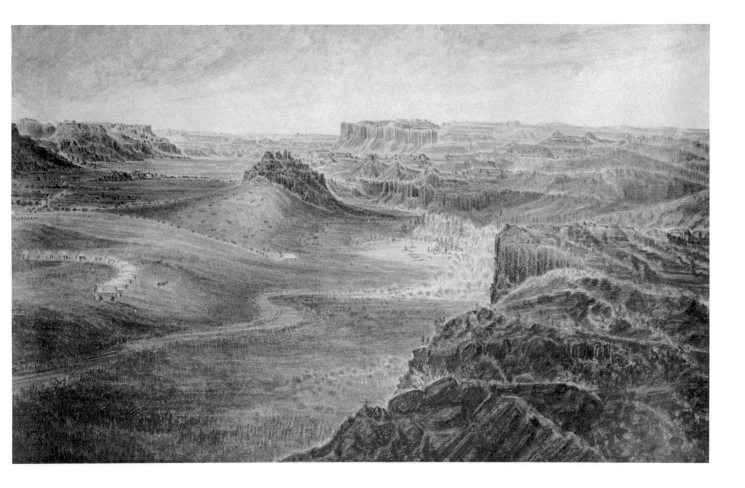

**Plate 53. Aspen Camp Looking N. Trail from Palouse R. to Plants' Crossing on
The Spokane.**
Aspen camp was located precisely "27 miles from Cow Creek" and the men, animals,
and wagons are resting on their way to Plants' Crossing on the Spokane River in
Eastern Washington Territory.
Watercolor, 10¼ x 16⅞ inches, [1860].
Collection National Archives, Washington, D. C., Record Group 76.

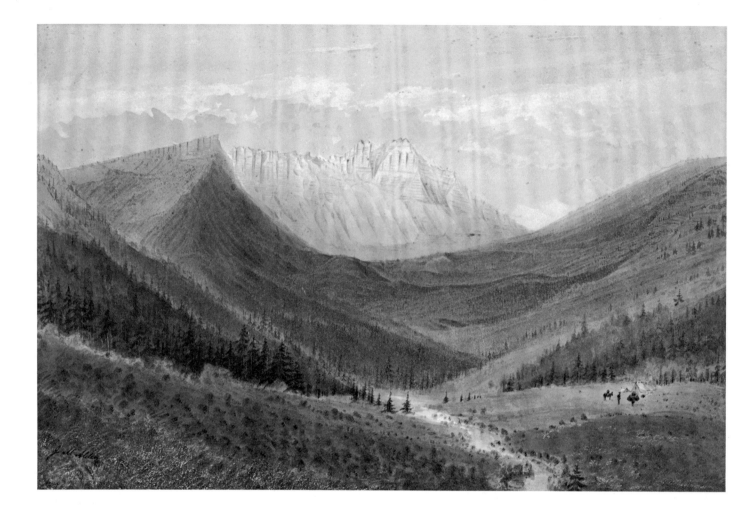

Plate C-30. In the Kishinena Pass, Rocky Mountains, British Columbia.
On the border of Washington Territory (later Montana Territory) and British America
was Kishinena Pass, mountain, creek, and survey camp. Alden's camp is pictured in
this 1860 watercolor.
Watercolor, 11¾ x 18 inches, [1860].
Collection Glenbow-Alberta Institute, Calgary, Alberta.

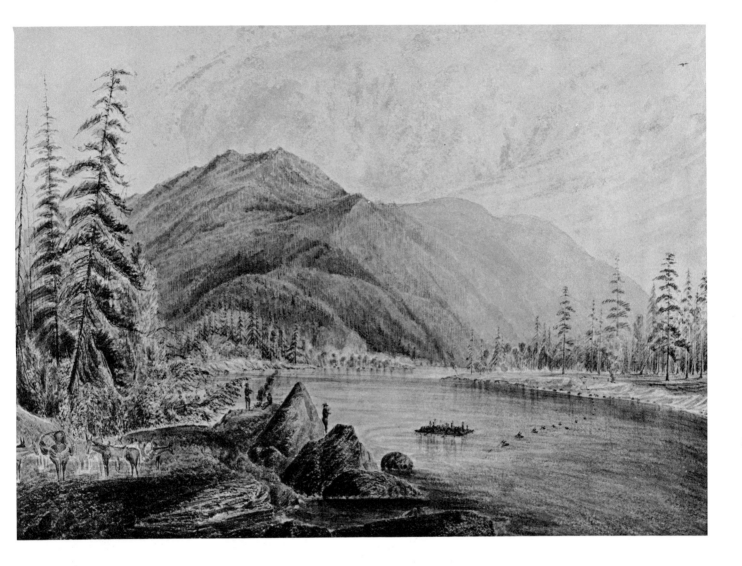

Plate 54. Kootenay River Looking S. From Left Bank.
At the southernmost crossing of the Kootenay River and nearly to the summit of the
Rocky Mountains the supply party employs a ferry and leads the swimming mules.
Watercolor, 9 x 12½ inches, [1860].
Collection National Archives, Washington, D. C., Record Group 76.

routes to the 49th parallel and surveying back to the last visible marker and then forward to locate the next. Each member was continuously accounted for in the Gardner journal, excepting only Alden. Finally, "Mr. Custer returned from the reconnaissance of Vermillion River to the Lake on the 21st and on the 23rd [June] started again with his canoes to make the survey of Kalispellum lake and on this trip Mr. Alden accompanied the party for the purpose of sketching the scenery."[18]

Alden was intrigued to visit and meet a famous Indian in the Kootenay Valley. The episode is recorded in Gardner's journal on the 31st of June. "We encamped near the encampment and were received with marked hospitality by the old Indian Chief Joseph who appeared to be well provided with both horses and cattle and to some extent cultivates this admirably located farm. He sent us milk both night and morning, and the squaws gave us berries, all of which proved very acceptable; yet we regretted not having any thing with which we could return their civilities. We left one of our horses that was much fagged and they loaned us a fresh one which materially expedited our return."[19]

The work slogged on. Alden found he was not alone in being short of breath with exertion. They were now in high altitudes and the nights were freezing. He was grateful for the gloves Aunt Sarah had knitted for him. His work during the day was limited to sketching. He had to stop at intervals to warm his hands. Applying color washes had to be deferred since the water would freeze. Watercolors were completed at a later time.

He painted *Camp Akamina Looking N. 5°E. Across Akamina Lake Down Akamina Pass Toward the Sascatchawan* [sic] *Plains.* (Plate 55) This was their last camp before the continental divide; Alden shows the camp buildings across the lake. The area is now in Glacier Park. Alden was painting some of the tallest peaks in the Rockies.

On August 28 the party was in the region of Mount Kishenehu just north of the continental divide. Boundary Mountain was almost on the 49th parallel and the Kintla peaks south of the parallel.

Alden's watercolor *In the Kishinena Pass, Rocky Mountains, British Columbia* (Plate C-30) is something of a mystery. Alden's identification of Kishinena Pass is not substantiated.[20]

Alden painted one of the few dated watercolors from this portion of the trip *N. W. B. S. Camp #2. N. Fork of Tobacco River* [Yakelt], *30 miles from Camp Kootenay East. Sept. 16, 1860. 6:30 p.m.*

Alden's notation of "writing journal with Harris by Campfire" on the picture is evidence that he kept a journal. Visions of a watercolor showing

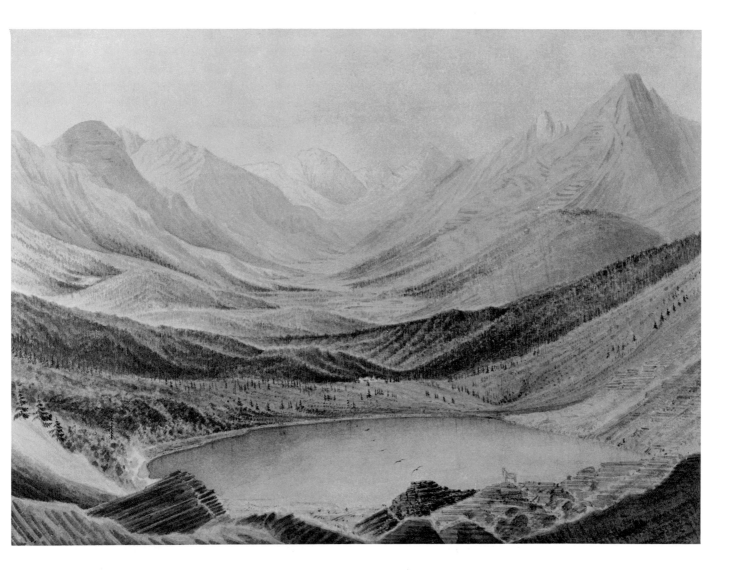

**Plate 55. Camp Akamina Looking N. 5° E. Across Akamina Lake Down Aka-
 mina Pass Toward the Sascatchawan [sic] Plains.**
Camp Akamina was the last camp before the Continental Divide and the end of the
Northwestern Boundary Survey.
Watercolor, 10 x 14 inches, [1860].
Collection National Archives, Washington, D. C., Record Group 76.

Alden, pen in hand, writing in a book with Harris seated nearby and the scene lighted by campfire are easily evoked. The vision is dispelled when the painting is seen. Camp #2 is viewed from a distance of several hundred yards. The closed tents give no clue to any activity inside. The inscription on the painting does suggest the existence somewhere of an Alden journal which to date has not been found.

One week later, almost four months after last noting artist Alden's existence, Gardner wrote, "Mr. Gibbs and Mr. Alden, the latter having accompanied Mr. Harris' party to Camp Kisenchu, had started September 23rd on a reconnaissance over the mountains to Saskatchewan Plains and returned the 29th . . ."[21]

Alden was informed that Camp Akamina meant "summit or divide" in local Indian jargon. He was uneasily aware of impending winter and the acute limitation of time. "By the 13th of October our small rations, coffee, sugar, etc., were entirely out and it being necessary to make some arrangement for supply . . .,"[22] men were dispatched to the last camp for emergency rations and hunters sent for game, which was plentiful and all about. A scout, who had been out in the mountains for ten days, returned with the opinion that the crossing of the 49th parallel and the divide was inaccessible, even on foot. On October 15, following an old Indian trail, the advance party crossed the divide and made camp a short distance from the 49th parallel. The astronomical party arrived and located the exact spot for a monument where the boundary intersected the continental divide.

Twenty-six year old Alden stood at the summit of the Rocky Mountains. Doubtless he had the satisfied feeling of a mission accomplished. He needed only to paint the views from this apex and complete his work, in so doing to perpetuate the intense emotion of that moment. It was a climax of attainment. First, he faced back in the direction he had come and painted *View from Monument at Summit Looking W. Along 49th Parallel. Highest Peak Kintla Range Bears S. 25°W.* (Plate C-31)

Then Alden painted the opposite *View From Monument at Summit Looking E. Across Waterton or Chief Mountain Lake Along 49th Parallel. Yellow Peak on Left Bears N. 30°E.* (Plate 56) By the time he had completed the sketch for the painting, snow was falling. The first storm of winter had arrived.

It was recorded that day, October 22, 1860, that in order "to lessen our numbers as much as possible, Mr. Alden, who had been sketching the scenery, also joined the party leaving. Prof. Nooney, Mr. Major and myself [Gardner] to complete the work at this point."[23]

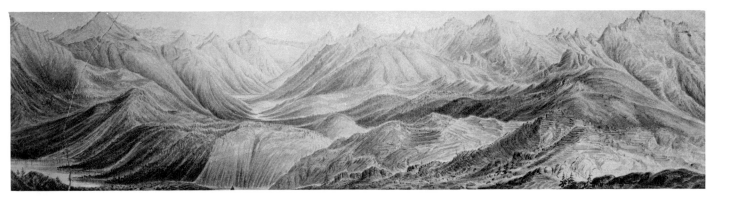

**Plate 56. View from Monument at Summit Looking E. Across Waterton or
Chief Mountain Lake Along 49th Parallel. Yellow Peak on Left Bears N. 30 E.**
Alden was looking east along the boundary when he painted this view. The monument
is in the left third of the picture. Chief or Waterton Mountain lake is partly visible
at the lower margin.
Watercolor, 8 x 28½ inches, [1860].
Collection National Archives, Washington, D. C., Record Group 76.

The return trip was complicated by snow and cold. Food was scarce. They passed depots closed for the winter. In some camps the stored rations had been carried along with the vacating personnel. Storms brought drifting snow which covered the trail. High winds blew down their tents. The horses and pack animals struggled unceasingly through the deep snow and tired quickly. The animals had to rest but the men were hesitant to stop, fearing that worse might be ahead. They fortunately found enough food to replenish their packs. Men and animals were exhausted when ". . . Dr. Kennerly, Mr. King and Mr. Ross arrived at the Spokane Ferry December 10th when together with Mr. Alden they were fitted out for the march to Walla Walla."[24]

Alden and Dr. Kennerly had their orders to proceed to Washington City via Portland, Oregon Territory. Alden continued his drawing and painting along the way. His watercolor of *Spokane Falls,* (Plate 57) a subject most early artists found to be provocative, is illustrated. There were falls along the course of the Spokane River which were called upper and lower, or big and little falls. If the scene is the big or great falls, as it appears to be, the rocky prominence at the left is an island which splits the river for a short distance. Today this site is in the center of the city, crossed by bridges and so otherwise altered that it is difficult to be certain.

The Palouse drops abruptly from plateau country into a deep gorge where it flows for about 20 miles before entering the Columbia River. Alden painted the canyon at its inception which he labeled *Grand Canyon of Palouse River.* (Plate C-32) He then made his way around the almost complete "punch bowl" which the force of the falls had eroded and looking back from the rim, painted the *Great Falls on the Palouse River from Summit of Cliffs on Right Bank.* (Plate 58) Both paintings show the element of design which Alden found in nature. A vermillion hue prevails in the canyon walls. The river's edge is tree-dotted where roots could reach moisture in the otherwise parched land. Alden's painting of Palouse Falls holds up well in comparison to the work of other artists who passed this way and painted the same scene. A partial list would include Henry Warre, George Catlin, Paul Kane, John Mix Stanley, Gustavus Sohon, and Peter Toft. Alden includes a rattlesnake overlooking the edge of the cliff. The artist may have had some experiences which made him acutely aware of these vipers.

From Alden's own records and a government report, one gleans only occasional details of his journey home. He was charged $1.00 per day for lodging and subsistence at old Fort Walla Walla. At Cascades he apparently stayed longer and paid a charge of $6.00. A trip to Olympia is unexplained, but he paid $2.25 for lodging and subsistence "enroute from Olympia to

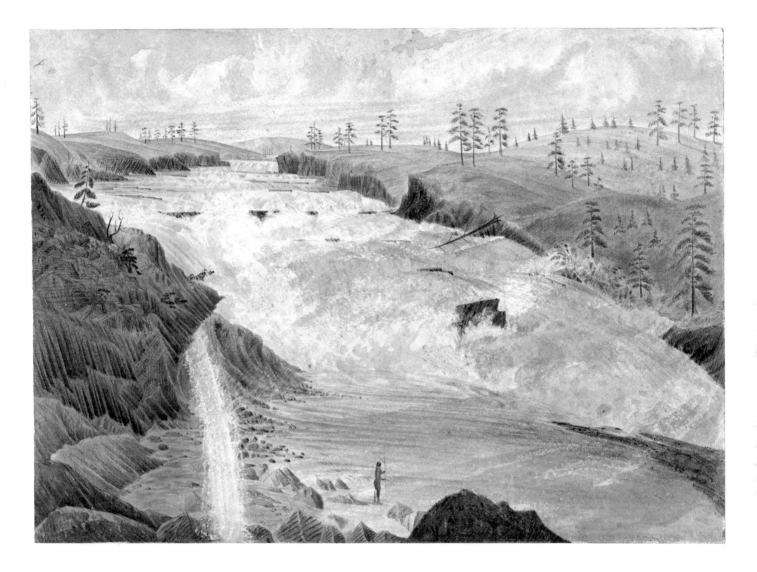

Plate 57. Spokane Falls.
Spokane Falls, in a wilderness when Alden painted this watercolor in 1860, is now in
the heart of the city of Spokane, Washington.
Watercolor, 10 x 13⅞ inches, [1860].
Collection Mr. and Mrs. Lee Stossell, Lake Worth, Florida.

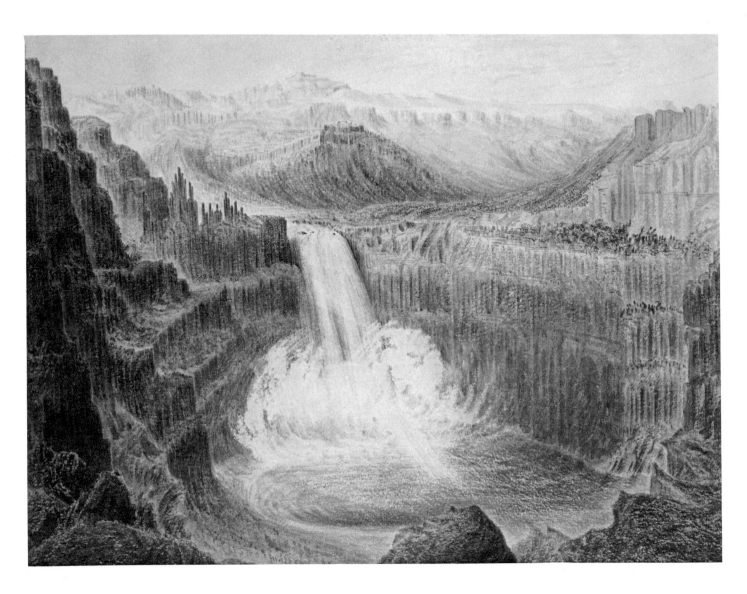

Plate 58. Great Falls on the Palouse River from Summit of Cliffs on Right Bank.
The falls of the Palouse River in southeastern Washington Territory were on the "downhill" route from the Rocky Mountains to the Columbia River and the Pacific Ocean.
Watercolor, 10 x 14 inches, [1860].
Collection National Archives, Washington, D. C., Record Group 76.

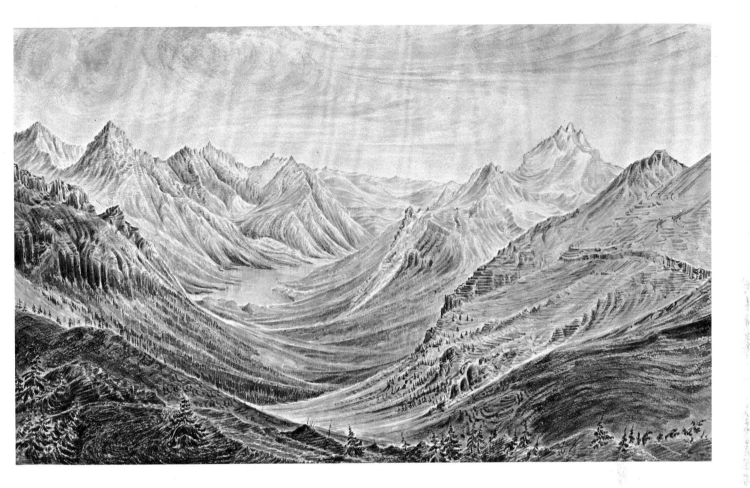

**Plate C-31. View from Monument at Summit Looking W. Along 49th Parallel.
Highest Peak Kintla Range Bears S. 25 W.**
Summit of the Continental Divide on the 49th Parallel and the end of the survey, looking
west. The tip of the marker is barely seen in the center of the lower margin.
Watercolor, 10 x 13½ inches, 1860.
Collection National Archives, Washington, D. C., Record Group 76.

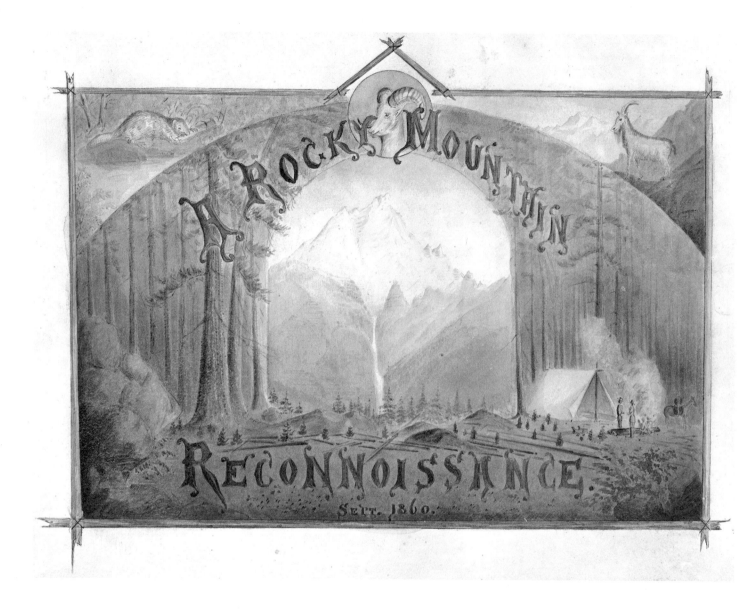

Plate 59. A Rocky Mountain Reconnoissance [sic]
Alden's cover drawing for his "A Rocky Mountain Reconnoissance [sic]," originally
comprising twenty watercolors and dated 1860 was made along the route of the
Northwestern Boundary Survey.
Watercolor, 11¼ x 17¾ inches, 1860.
Collection Washington State Historical Society, Tacoma, Washington.

Portland." On December 30 he paid "Porterage of baggage in Dalles, Oregon" in the amount of 50¢. Passage from The Dalles to Portland cost $8.00. On January 14, 1861, his passage to San Francisco was $20.00 and porterage was $2.00. He departed San Francisco for New York at a cost of $258.50, paid $11.00 for porterage of baggage across the Isthmus of Panama, and arrived in New York on February 26, 1861.[25]

Before leaving San Francisco Alden paid a visit to the *Active*. She was moored at her usual berth but most all else was different. Commander Alden had been transferred back to the Navy and had departed for the East Coast. Lieutenant, now Lieutenant Commander, Richard Cuyler was the skipper and welcomed Alden aboard. There were replacements but many of the officers and crew with whom he had served were there. The news of Abraham Lincoln's election had reached San Francisco. Talk of war was the prevailing conversation. Alden was grateful for the invitation to bunk aboard as his funds were short. After saying farewell to the officers and crew, Alden cast a last fond look at the *Active* and departed for home after almost six years.

On the voyage between San Francisco and the Isthmus, his good friend and fellow Yankee, Dr. C. B. R. Kennerly from Portland, Maine, died and was buried at sea not far from Acapulco, Mexico. Alden and a Lieutenant Camp were the only members of the Survey party with him.[26]

On the long sea voyage home, Alden transformed a number of his penciled sketches, with their lightly inscribed "color notes", into watercolor paintings. He took this time to make an album of views along the American-Canadian boundary for George Gibbs, the fellow artist whose companionship had been most agreeable and with whom he anticipated working in Washington City. There is an illuminated title page with the caption *A Rocky Mountain Reconnaissance* [sic] (Plate 59) sketched along the trail in September when Alden and Gibbs accompanied Mr. Harris' party on a reconnaissance, as reported previously. Why the album was not delivered to Mr. Gibbs is not known. The sixteen individual paintings are listed in the appendix.

In Panama, Alden heard war talk continuing at a high crescendo. The Boston and New York papers reported that seven Southern states had already seceded from the Union and others were threatening to do so. His Navy uniform probably made him the target of several remarks from unrestrained Confederate sympathizers.

After arriving in New York, his first visit was to his family now living on the outskirts of Waltham, a suburb of Boston. His mother had sold the

146

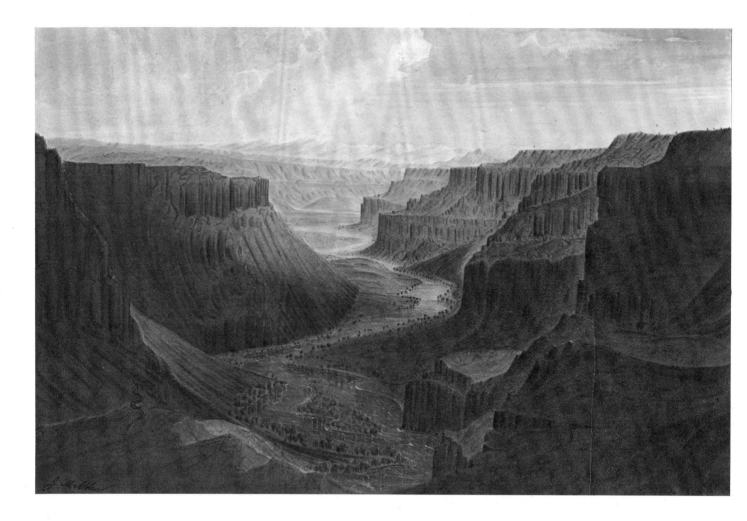

Plate C-32. Grand Canyon of Palouse River.
The Grand Canyon of the Palouse River, Washington Territory, painted in 1859.
The rattlesnake may have been included as a warning to the artist himself.
Watercolor, 11⅝ x 17¾ inches, [1859].
Collection California Historical Society, San Francisco, California.

family business and their home in Boston. Suburban living with a garden, a cow and some chickens was less expensive. She had inherited the beautiful old colonial house and land. It was a more agreeable place to raise five daughters.

Alden was pleased to see how well they were doing. The older girls were now young ladies and his mother looked older to him but was in good health. He probably entertained his family with stories of his adventures, filling in all of the gaps which were missing from his letters. He then declared his intent to serve out his Northwestern Boundary Commission assignment in Washington City and left after a few days.

"The office was located at the southeast corner of Pennsylvania Avenue and 20th street west in a building rented for the purpose where in addition to the Commissioner, Mr. Warren, Mr. Gibbs, who by the death of Dr. Kennerly had charge of all the notes upon Natural History & Botany as well as his own upon Geology, together with Mr. Alden, the Artist were working up the results of their labors," wrote Gardner.

It was here that artist Alden "worked up" his field drawings and watercolors. The repainted views are larger and more carefully executed with greater attention to color and detail. It is not known how many Alden painted for the Boundary Survey, but the National Archives lists sixty-seven, one of which is missing.

The mood of the nation and the need for funds to carry out the war precluded publication of a volume on either the Survey of the West Coast or the Northwestern Boundary Survey.

While working in the Capitol, Alden boarded at the home of Margaret Rapine Bowie, widow of General George Washington Bowie. He met their daughter, Charlotte Elizabeth.

Alden volunteered and became a member of the battalion commanded and financed by Cassius M. Clay for the defense of Washington City before the arrival of Northern troops in 1861. Alden was subsequently thanked for his part in the defense of the Union Capitol by the government.

The Northwestern Boundary Commission continued with the plottings, computations, drawing of maps and preparation of the final report. In October, 1869, the work was brought to a close and the results deposited in the State Department. The report was never published and the manuscript has been lost. All of the original material (perhaps Alden's journal) was placed in two large blue chests which have never been located despite several diligent searches.[29]

The question of the water portion of the Boundary Survey could not be agreed upon. It was finally determined by arbitration. Emperor William I of Germany found for the United States in 1871, and the middle of the Strait of Haro became the boundary between the United States and Canada.

Alden's days at the Boundary Commission Office seemed endless. His activity in the Cassius Clay Battalion only whetted his desire for active participation in the conflict. This feeling was accentuated as he read in the newspapers of his uncle's activities. Commander James Alden had been assigned to Gulf Blockading Squadron under Flag Officer David G. Farragut. Alden read in the Washington newspapers in December, 1862, of his uncle's capturing Confederate vessels, the schooner *J. H. Toone* and the schooner *Ezilda*, while commanding the U. S. S. *South Carolina* off the east coast of Texas. The newspaper stated that these were the fifteenth and sixteenth prize vessels his uncle had captured so far. The vessels and their contents were prizes of war and payment was due the capturing vessel's commander. Alden placed this newspaper clipping from the Washington Post in his scrapbook.

He wrote his uncle to congratulate him and learned from the reply that he had been transferred to command the *New London*. Alden told his uncle of his intention to enlist in the Navy for active service.

During 1862 Alden read of his uncle's gallant service in command of the *Richmond* under Commander David Dixon Porter in the capture of Forts Jackson and St. Philip. Commander Alden was commended for his daring support of the Mortar Flotilla at the capture of New Orleans under Commander Porter. The *Richmond* had been severely damaged at Port Hudson and his uncle was reassigned to command the *Brooklyn* and promoted to Captain.

A letter from his uncle in early 1863 agreed with Alden that he re-enlist in the Navy for the duration of the war and mentioned that Rear Admiral David Dixon Porter had need of a secretary. On Captain Alden's recommendation and with Alden's consent, he would be so assigned. No other post could have pleased Alden more, and he indicated his consent.

On September 30, 1863, Alden's employ with the Northwestern Boundary Commission was terminated. On that date, according to Alden's own records, he had already taken the oath of office in the United States Navy and was on his way to Cairo, Illinois to be secretary for Admiral David Dixon Porter.

IV. EXPERIENCES IN THE CIVIL WAR

J ames Madison Alden took his oath of allegiance to the United States Navy on August 26, 1863. He had been appointed Acting Ensign and assigned to the U.S.S. *Black Hawk*, the flagship of Rear Admiral David Dixon Porter, who had just been made Commander of the Mississippi Squadron. The assignment came from the Admiral himself, who had chosen the twenty-nine-year-old artist to serve directly under him as one of his secretaries.

The Admiral knew that Alden came from an indoctrinated naval family, beginning with his Tate ancestor who served the Russian monarchy in establishing the initial Russian Navy and becoming its first Admiral. James Alden, already a Captain, was marked for advancement. Captain Alden's wife was the niece of Rear Admiral James Lyon. There was the unspoken understanding of tradition and Navy loyalties which the Admiral ascribed to his new Acting Ensign. The personalities of the two men were so diametrically opposite as to provide a most complete contrast.

Admiral Porter's father, a significant figure in the Navy, Commodore David Porter, had climaxed his distinguished career by his performance in the War of 1812 and was made a member of the Board of Navy Commissioners in Washington City. Admiral Porter's mother, Evalina, was a daughter of Major William Anderson, a wealthy and influential member of Congress. Admiral David Dixon Porter was reared on a 100-acre estate not quite a mile from the White House. There were so many servants living there that Meridan Hill was virtually a village. Here Commodore Porter and his wife continually entertained naval and government officials and the prominent and wealthy friends of both families.

In 1824, at age 11 on his first cruise, Admiral Porter had witnessed an impetuous and ill-advised action on the part of his father, who was in command. The United States could have been plunged into war with Spain as a result. A court of inquiry censured Commodore David Porter's action. He rejected the findings, resigned, and became Admiral of the Mexican Navy.

David Dixon Porter felt his father had been right. He took up his father's fight and expressed his scorn for the Secretary and senior officers who ran naval affairs, dubbing them "the arm chair navy." Like his father, he sometimes exceeded orders or misconstrued them for his own purpose. He usually created his own difficulties by his rashness and then blamed others. In order to achieve success, he seemed to need the monumental self-esteem which characterized the five generations of Porters who played an essential, if flamboyant, role in the United States Navy.[1]

Alden's orders required him to travel to Cairo, abutted by the boundary between Missouri and Kentucky and the juncture of the Ohio and Mississippi rivers at the southern tip of Illinois. It was a low-lying, humid, dirty little town of drab brick buildings and houses. When it wasn't muddy it was dusty. Its environs flooded each year. It was said to produce the poorest cotton but the best crop of the largest mosquitoes along the river. Local residents reputedly never set anything down weighing less than five pounds lest it be carried off by a sneak thief or a mosquito.

Alden located the headquarters of the new Mississippi Squadron in a rented commercial building adjacent to the Cairo riverfront. He was directed to the *Black Hawk*, Admiral Porter's flagship, distinguished by his personal blue pennant with a white star. Alden presented his orders to the deck officer and after a brief wait was taken to the Admiral's quarters. The contrast between the clean, freshly painted and polished flagship and the dirty and rundown appearance of all else in the town was conspicuous.

Admiral Porter welcomed Alden, then asked him to sit down and write a letter.

> U. S. Mississippi Squadron
> Flag-ship *"Black Hawk"*
> Cairo, Illinois
> October 5, 1863

Dear Sir—This communication will introduce Acting Ensign James M. Alden, my new private secretary. At this time he will require proper uniforms to be issued him in accordance with my instructions and suitable identification admitting him to all vessels, offices and buildings of the Mississippi Squadron and the U. S. Navy Yard at Mound City, Illinois as my personal representative.

> I have the honor to be, very respectfully,
>
> Your obedient servant,
> (signed) David D. Porter
> Acting Rear-Admiral,
> Commanding Mississippi Squadron

Captain A. M. Pennock, Commandant,
U. S. Mississippi Squadron, Cairo, Illinois

The Admiral read Alden's letter critically, signed it, and passed it back. He dismissed Alden to get his uniforms and personal baggage from the depot and return to the *Black Hawk.*

Alden found a carriage and discovered that as the Admiral's secretary he was accorded an added measure of respect. The recruit driver was loquacious. He probably told Alden about how "the old man" had arrived only a few days before and already changes were being made. The officers and seamen were to strictly follow regulations in dress, as signaled daily from the flagship. For all to see, a white flag meant white uniforms, a blue flag meant blue uniforms, white above blue meant white jacket and blue trousers, and the reverse meant blue shirts and white trousers.

The squadron had been expanded with riverboat captains and crews and their motley assortment of vessels. Admiral Porter was trying, in the short time allowed, to fashion them into something like a Navy. The regulation as to dress was an immediate way to gain a neat and uniform appearance. Other disciplinary measures came in rapid succession as Admiral Porter almost daily delivered lectures and sent directives to his officers, trying in a matter of days to train them into an effective force.

The driver might have further informed Alden that crewmen and yard workers, earlier recruited by the Army in the emergency, regarded Porter, with his fancy dress rules and himself decked out in full-feathers, as a Holy Terror. The civilian population up and down the river shared in the general opinion.

He was quartered adjacent to the Admiral and assumed this was to make him available at the Admiral's pleasure. His quarters were agreeably large and contained a desk, a bookcase, and filing space. The Admiral was up early and at his desk by seven. Alden followed the same schedule and found the working day sometimes ended at midnight. When not otherwise engaged, Alden was at his desk in the Admiral's quarters, returning promptly on the completion of each errand.

His duties were varied and interesting and in sharp contrast with those of the Boundary Survey. He maintained a timed calendar of each day's important events, noting the names and business of significant callers. He screened the incoming messages and mail for the Admiral's attention or for routine handling by staff officers. He wrote and dispatched confidential reports and personal letters when requested. The other secretaries carried out most of the routine tasks. Alden was more frequently chosen for duties requiring judgment and tact.

At the end of his first week the Admiral dictated an order naming Acting Ensign James M. Alden to serve as Judge Advocate of a court-martial to be

held on the U.S.S. *Clara Dolson*, a receiving ship stationed at Cairo. The problems and details of the proceedings are not available. The Admiral was, in fact, using Alden to act as his right arm to relieve him in his myriad responsibilities. Two weeks later the Judge Advocate wrote from the *Black Hawk* and submitted to the Admiral the findings of the court. Alden apparently deported himself well, since he was subsequently assigned as Judge Advocate in two other cases shortly thereafter.[2]

Alden impressed the Admiral with his dependability and good judgment. In their initial relationship, any difficulty in Alden's understanding of the man was transcended by respect for his high office. Gradually he came to appreciate the wide range of Porter's moods and to alter his deportment accordingly. He was aware of the tremendous responsibility in trying to organize, train, and equip the almost non-existent Mississippi Squadron into an effective combat unit and the plaguing problems of supply, accidents and illness, stupidity, and every other conceivable roadblock which thwarted the Admiral's efforts.

Since Alden was privy to all information to and from the Admiral's flagship, he learned that the Admiral was purchasing numerous vessels of all sizes for Admiral David Farragut's fleet as well as his own squadron. He was installing or replacing light armament with heavier guns. Most vessels needed some repair and strengthening of their hulls and decks to carry the increased weight of the guns. On suitable ships, steel armor plates were added. The total activity was in preparation for an assault on Vicksburg and the clearing out of Confederate strongholds along the river to join forces with Farragut in the lower Mississippi. Admiral Porter was in charge of the 600-mile stretch of river down to New Orleans, and with tributaries and side channels, that distance was more than doubled. It was a joint operation with the Army.

Alden's life on the *Black Hawk* and the pressure of new procedures and heavy responsibility was a challenge. It was a confining life in contrast to his six years on the Coast Survey and along the trail on the Northwestern Boundary Survey. There was little time for relaxation and insufficient time for sleep. Alden knew the Admiral was concerned with the health of his men. On taking over the post at Cairo, he found several hundred men sick with the fevers. There was no hospital, so the men were discharged to their homes. The Admiral leased a hotel to serve as a hospital. He ordered an inspection morning and evening to ascertain that the men were properly clad against the intense heat and the fever-bearing mosquitoes and to isolate new victims of the fevers. Fresh vegetables and meat were served three times a week.

The Admiral rode horseback one hour each day as exercise and relaxation. He invited Alden to join the group which escorted him. Alden declined, preferring a period of solitude.

His spirits rose with the institution of his daily hour of walking and drawing. No reference had been made to his art activities and he felt this was not the time to reveal his avocation, although he thought the Admiral must have known of his position as Official Artist on the Boundary Survey. He carried his drawingbook out of sight until he was clear of the *Black Hawk* and on his return locked the drawings and finished watercolors in his sea chest. In due course he hoped to clarify the situation, making it unnecessary to conceal this activity which meant so much to him. But for now he would bide his time and enjoy the freedom of his uncommitted hour.

Alden's pace aboard the *Black Hawk* quickened. The Admiral's efforts and problems to coordinate the Army and Navy necessitated visits to Washington City and conferences with Secretary of the Navy Gideon Welles, General-in-Chief of the Army Henry Halleck, General Sherman, and even President Lincoln. The telegrams, letters, and the requisite answers engaged Secretary Alden's constant attention and kept the Admiral at his desk well into the night on his return. General Grant visited Cairo on December 1 and conferred with the Admiral on final plans for cooperation. Alden was surprised at the short stature of the man in charge of the Union forces, although the Admiral was a scant five feet six inches.

Porter assembled all available ships and sent the "Pook Turtles", or ironclads, down the river. The water was low and he ordered careful sounding in advance across the bars. If the waters were too shallow for the greater draft of the turtles, they were to await the expected rain to raise the level of the water. All vessels were warned about guerrilla sharpshooters along the riverbanks. The Admiral remained behind to gather up ships nearing completion, pick up recruits for their crews, and insure that supplies would be sent downriver to his ships. On December 14 the *Black Hawk*, and every vessel for which the Admiral could find even a skeleton crew, started down the Mississippi River preparatory to the siege of Vicksburg.

It was Alden's first battle experience and he did not have to wait long to see some shooting. Toward evening of the first day Confederates began firing at a vessel ahead of the *Black Hawk* and the vessel returned the fire. As the *Black Hawk* came abreast, her guns were trained on the site of the guerrillas. Alden saw the smoke from the guns on shore, but sound was obscured by the firing of the flagship's cannon. Two shanties, side by side, concealing the ragtag snipers, disappeared before Alden's eyes, and the salvo

was followed by silence. The next day firing was heard downriver, but the ships ahead took care of the guerrillas and terminated the attack.

About 150 miles downriver word of unexpected disaster was received. Commander Thomas O. Selfridge, Jr., who commanded the ironclad *Cairo*, was coming upriver in a small steamer with the intelligence that his vessel had been sunk in the Yazoo River by the first known Confederate torpedo. Porter ordered Selfridge transferred to the *Conestoga* and continued downriver, mooring at Memphis on December 18, where a conference on the situation was held with General Sherman.

A battle plan was devised; the timetable for the combined Army and Navy attack on Vicksburg was Christmas. Both men held practical and similar views. On Sherman's departure, Porter dispatched the *Benton*, Captain William Gwin in command, downriver to collect waiting gunboats and clear the Yazoo River of torpedoes.

Before leaving Memphis the Admiral, in his silver-braided overcoat and plumed hat, accompanied by Alden and other officers in full dress, made a tour of inspection of the recently acquired navy yard taken over from the Army. It was to demonstrate that the Army had forgotten to announce the change to the press and, in turn, to the public. The grandeur of the display dazzled the local citizens and the yard personnel, and gave credence to the existence and power of the Mississippi Squadron. No broadside or proclamation could have better driven home the fact. Even Alden was impressed.

A little farther downriver near Helena, Porter caught red-handed the crew of an Army transport stealing coal from a Navy barge. Porter needed every bushel for his ships, a fact that the captain of the transport would certainly not soon forget. Alden breathed quietly in the office until Porter's temper cooled down. At Helena all women were put ashore and their places aboard were taken by contraband blacks, overjoyed at their emancipation, which they unknowingly would soon have to earn.

The Admiral informed his Secretary that action would soon commence. The *Black Hawk* reached the mouth of the Yazoo River December 24. Captain Gwin, on the ironclad *Benton*, provided the gunfire to protect the several smaller vessels which slowly ascended the Yazoo River. Confederate torpedoes were strung across the river on lines and guarded on each end by troops. The explosives would fire by friction against the hull of a passing ship. As each line of torpedoes was sighted, one end was freed and carefully drawn downriver and made fast to the bank. The procedure was accomplished under the guns of the *Benton*.

Sherman's army would be forced to cross a bayou between the Mississippi and the Yazoo to attack Vicksburg from the heights behind the city.

The Confederates were entrenched on a strip of dry land which guarded both rivers and the bayou. Christmas Eve Sherman's transports arrived and unloaded his troops. The next day a feint drew enemy fire away from Sherman's men as the *Benton* simulated an attack. Her armor was pierced and Captain Gwin was wounded by a deflected shell. Porter put him to bed on the *Black Hawk* and at night quietly repaired the *Benton*, his largest and most imposing vessel, so the Confederates would not learn of its vulnerability.

The siege became a disaster. Sherman's troops could not get through the bayou to reach Vicksburg. They were cut down by the Confederates above them on Chickasaw Bluffs. Attempted assault on the bluffs left over 1,500 of Sherman's men wounded and dying.

Porter sent for mortar boats at Memphis, which did not arrive. A dispatch informed him the telegraph wires to Cairo had been cut. On the day that Porter and Sherman left Memphis, the Confederates had destroyed a huge store of supplies on which Grant was relying and his attack never started. Vicksburg had received massive reinforcements and supplies. Sherman learned the truth only after wasting his men under Chickasaw Bluffs. Rain-soaked and muddy, he made his way to the *Black Hawk* Sherman and Porter sat in silence, each sipping a whiskey. Captain Gwin lay in Porter's cabin *in extremis*. The next morning Captain Gwin died without receiving his last rites. Everything for the past week had gone wrong.

The Admiral revealed his greatness at this time when Union efforts were at their nadir. He joined with Sherman and his fragmented forces and utilized General John McClernand's army, as well as his own incomplete Navy, to attack Fort Hindman. It was a small installation on the river side of the Arkansas Post, but it had 11 guns and the heavy oak structure was covered with railroad iron. It was impervious to any shells the army could throw. Eight days after the defeat at Chickasaw Bluffs Admiral Porter received the surrender of Fort Hindman. Throughout the North crowds ran cheering in the streets, though few had ever heard of the little fort. Admiral Porter was thanked by Congress for a second time.

The capture of Fort Hindman raised Northern spirits and bought time and enthusiastic support of Porter's renewed assault on Vicksburg. Porter and Grant detested McClernand. He delayed making his troops available for the first attempt on Vicksburg. They felt his actions were purely political and that every move was made as a grandstand play rather than for military expediency. Although McClernand had Lincoln's ear and confidence, after Fort Hindman Grant, backed by Porter and Sherman, asserted his priority, took over McClernand's army, and put him in charge of units of the Army

156

of Tennessee along with Sherman and General J. B. McPherson. Porter, Grant, and Sherman met almost daily in the cabin of the *Black Hawk* without McClernand's interference or leaking of news to the press for his own publicity, which would have compromised their plans.

After each battle or campaign Alden roughed out reports which were to go to the Navy Department officials and supporting Army and Navy officers, and with the Admiral's approval or corrections, he delegated them to assistants for final draft. Sometimes Alden signed for the Admiral.

The inevitable courts-martial covering all but clear-cut causes of sinkings, explosions, capture or loss of supplies and contraband in significant amount were investigated and reported. Alden was a frequent Judge Advocate. Court hearings and other business sometimes took him away from the *Black Hawk*.

The Admiral could not always be located by telegraph during his absence, sometimes for a week or longer. Alden found it necessary to make immediate decisions. Knowing the Admiral's plans could give Alden positive or negative answers as to procedure and arrangement. His responsibility had grown over the past year. Sometimes he reasonably wondered if he were exceeding his authority. At times he turned to Captain Pennock or other officers whom the Admiral trusted for advice on technical problems or matters to which his knowledge did not extend.

Occasionally the Admiral, in an expansive, loquacious mood, would talk at length of his past, the Navy, his family, or whatever came to mind. Alden enjoyed these occasions. He gained a deeper insight into the Admiral's values, motivations, and character. Alden was a good listener, asking only an infrequent question.

One instance was prompted by Admiral Porter's reference to Admiral David Farragut as "my brother" and Alden's questioning facial expression. They were not blood relatives, but Porter's grandfather was stricken with the fever in 1808. He was at the Naval Station in New Orleans as Sailing Master. Sickbay was overflowing with feverish and dying sailors. The Farragut family took him into their home and nursed him. Mrs. Farragut came down with the fever and died the same day as Porter's grandfather. In appreciation, Porter's father adopted motherless David Farragut, educated him, and launched him on his career. For years Porter and Farragut lived in the same house and grew up as brothers.

The six months following the capture of Fort Hindman, the clearing out of Confederate positions along the Mississippi River, the Yazoo River, and the criss-cross of small streams and bayous leading down to within a few

miles of Vicksburg, made swamp rats out of the Union Army and Navy forces. High water permitted the passage of the ironclads and smaller ships through the winding water courses, but the struggle was complicated by all manner of obstructions. Overhead branches caught the superstructures and the trees had to be cut away. The ironclads rammed their way through the narrow channels to clear out sunken debris. Trees which could not be bypassed were rammed over by the first vessel, then hauled by the next vessel. There were shallow bars and ships had to be tugged and slid over the muddy bottom by muscle-power of the men. The Confederates entered the swamps, cut down trees across the channel, and harassed the Union soldiers and ship's crews with rifle fire. Paddle wheels were repeatedly fouled with vegetation and broken limbs. Along the way, there were gun battles between Confederates on shore and the armed craft. Strongholds were captured or burned. At length the Yazoo delta was in the hands of the Union forces.

The attack on Vicksburg orchestrated principally by General Grant and Admiral Porter began about the first of June and continued until July 4, 1863, when the city surrendered and quiet superseded the continuous gunfire.

Five days later Port Hudson, about twenty-five miles north of Baton Rouge, was taken by Admiral Farragut's navy in cooperation with the Army. The 3,000 miles of the Mississippi River and its principal branches were controlled by the North and open to Union traffic.

Porter had been Acting Admiral but his permanent rank was Commander. When the news of the capture of Vicksburg reached President Lincoln, he signed Porter's permanent commission as Rear Admiral, skipping three intermediate grades. Porter was placed in command of the length of the Mississippi River, and Admiral Farragut withdrawn and given a less demanding assignment. His health had been impaired during the recent campaign. Throughout the North there was wild exhaltation with fireworks, bands, bonfires, and street dancing. (Plate 60)

Aboard the *Black Hawk* Rear Admiral Porter received General Grant and commanders of the Army and Navy. Admiral Porter was toasted with their congratulations and well wishes. His staff, the officers, and the crew of the flagship were in their dress uniforms and were unrestrained in their cheers and praise for their Admiral. Captain James Alden came aboard but was in no mood to celebrate. His wife's condition was critical. She had been wandering the streets of Charlestown searching for her husband. Captain Henry Wise of the Navy Department, a friend of both Admiral Porter and

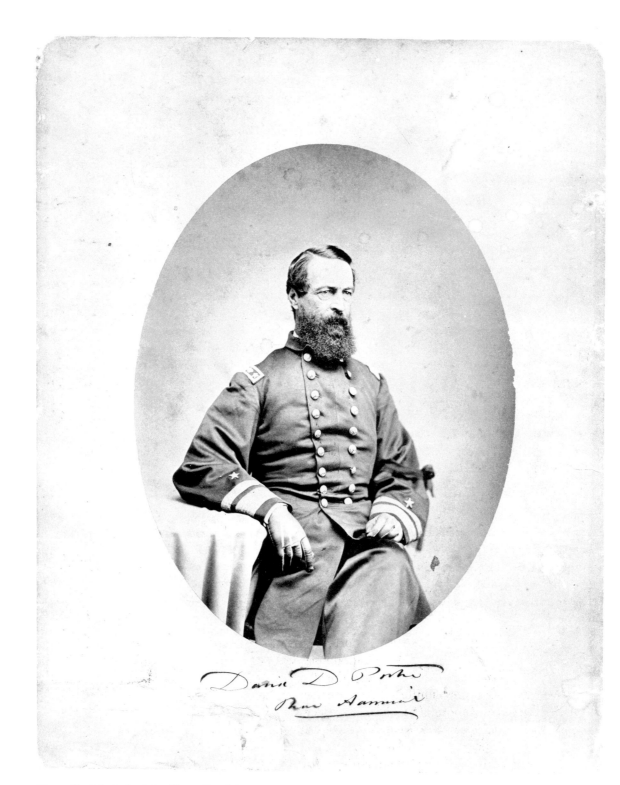

Plate 60. Admiral of the Navy, David Dixon Porter.
Photograph, 13½ x 10⅜ inches.
Collection Mr. and Mrs. Albert W. Ayers, Jr., Darien, Connecticut.

Captain Alden, had ordered his return to Charlestown to take care of Sarah.[4]

Porter and Grant were widely extolled in the Northern press. The Union positions along the Mississippi were consolidated, and unimpeded navigation for military and civilian use was re-established. The battle of Gettysburg, on the same day as the fall of Vicksburg, marked the northernmost sweep of Confederate forces. The massive, bloody carnage could hardly be called a victory for either side. From July 4, however, the Confederates lost geography at home and all hope of aid from England and France. The Army and Navy began to reconstruct along the Mississippi what they had just finished bombarding. New ironclads were built, battle-scarred ships repaired, and ammunition and stores accumulated for an attack on Mobile, Alabama.

The winter was unusually cold. Admiral Porter became ill with pneumonia following exertion and exposure. Alden was alarmed, recalling the similar sequence of circumstances leading to his father's death. The Admiral sustained the attack and continued to work in his office on the *Black Hawk* in Cairo. He refused hospitalization and his convalescence was prolonged into the following spring. Secretary of State William H. Seward and the Army generals prevailed on Porter to cooperate in opening the Red River to commerce and freeing the needed sugar and cotton stored in Louisiana before moving on Mobile. Porter was dubious of there being sufficient water depth at that time of the year, despite assurance to the contrary. Thirty thousand men in two armies were to unite at Alexandria to support Porter.

What started off well in 1864 became the greatest fiasco of the Union Navy. On March 11 Admiral Porter on his flagship *Black Hawk*, accompanied by twenty vessels, made a rendevous with General A. J. Smith and 11,000 troops at the mouth of the Red River. This river flows into the Mississippi about 140 direct miles below Shreveport, but its meandering course almost trebles the distance which the flotilla had to ascend to reach their objective. The large vessels could barely pass over the bar at the river's mouth because of the low and daily falling water. Admiral Porter questioned the wisdom of proceeding, but his orders gave him no choice. An obstruction erected by the Confederates was breached, allowing the passage of the fleet. Fort de Russy was captured.

Artist Alden was on the *Black Hawk* and on March 11 recorded his impression of Fort de Russy, about 10 miles below Alexandria, after its capture. (Plate C-33) In the watercolor only two of Admiral Porter's gunboats

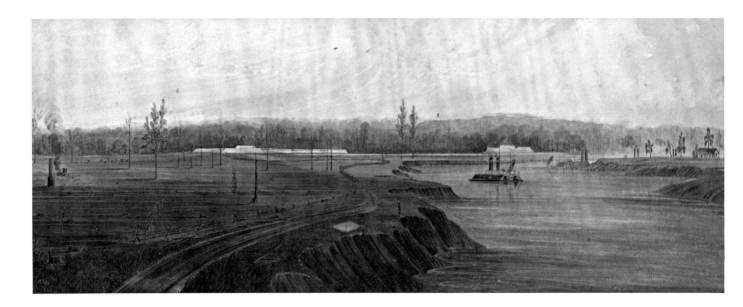

Plate C-33. The Fall of Fort de Russy, Red River, Louisiana.
The Mississippi squadron in command of Admiral Porter in the Red River, Arkansas,
ten miles below Alexandria. The capture of Fort de Russy on March 11, 1864 was
witnessed by Acting Ensign James Madison Alden on the Admiral's flagship *Black Hawk*.
Watercolor, 9 x 22¼ inches, 1864.
Collection Captain Edward M. Day, Bethesda, Maryland.

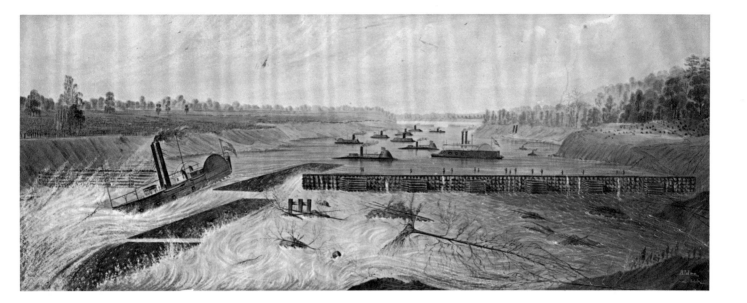

Plate C-34. Admiral Porter's Fleet Passing over the Dam.
The Red River fleet escaping over Alexandria Rapids through a hastily constructed wing
dam which raised the water level. Admiral Porter's fleet then passed over the rapids,
saving millions of dollars in war vessels for the Union navy. Alden witnessed the scene.
Watercolor, 9 x 22¼ inches, 1864.
Collection Elizabeth Logan Janes, Alexandria, Virginia.

are completely visible, but the smokestacks of three others can be seen in the sky around a bend of the curving river.

The naval and land forces pressed on and Alexandria was captured. Almost two weeks were required to get the ships over the "falls" because the water was so shallow.

The water fell still lower although by April 10 the fleet had progressed to beyond the town of Springfield, 40 miles from Shreveport. Here the Confederates had sunk a vessel crosswise in the river, completely blocking farther advance.

General Nathaniel Banks and his men, who were to join Porter at Springfield, had been defeated. Their retreat left the riverbank unprotected and the fleet had no choice but to return down the river. Confederate troops and guerrillas harassed Porter's ships, causing loss of life and severe damage. When he arrived back at the Alexandria rapids with his decimated fleet, there were three and one-half feet of water instead of the required seven.

A seemingly impossible plan of raising the water level was proposed and carried out. General Banks loaned Porter 250 wagons and 3,000 of his remaining troops to build a dam across the river, leaving only a narrow passage for the trapped vessels. In eight days the dam was completed.

Alden's painting shows the U.S.S. *Lexington* passing over the dam and the U.S.S. *Fort Hindman*, U.S.S. *Osage* and the U.S.S. *Neosho* above the dam on May 9. (Plate C-34) The other six vessels shown by artist's license were actually still trapped above the rapids. They did not pass the dam until two days later. This occurrence was almost two months after Alden's painting of captured Fort de Russy.

By extricating his ships from the Red River, Porter saved several million dollars worth of ironclads. He returned to Cairo in late May to rest and repair the damage to his ships. In July the Admiral went to Washington to get current on the thinking of the Navy Department and did not return for almost two months. He had never fully recovered from the severe cold and lung condition of the preceding winter and needed rest. He visited his family and continued his supervision of affairs while vacationing at Perth Amboy, New Jersey. Alden was kept busy receiving reports and relaying messages. The Admiral came back to Cairo to wind up his affairs. He had been ordered to take command of the Atlantic Blockading Squadron and to launch an expedition against Fort Fisher.

Alden was appointed Judge Advocate to inquire into the loss of the U.S.S. *Queen City* at Clarendon, Arkansas in June, 1864. The inquiry absolved the Commander of the U.S.S. *Queen City*. Judge Advocate Alden reported the findings to Admiral Porter on September 6, 1864.[5]

Orders of September 30, 1864 addressed to Acting Ensign J. M. Alden on the *Black Hawk* required him to proceed to Hampton Roads via New Orleans and there await Admiral Porter's arrival. Alden was one of the few staff members selected for transfer to the new Atlantic Blockading Squadron.[6]

In October, 1864, Admiral Porter left Cairo for Hampton Roads, Virginia. Here he boarded his new flagship, the *Brooklyn*, and assumed command of 120 vessels in the Atlantic Blockading Squadron. Acting Ensign Alden joined the Admiral's staff on the *Brooklyn*, commanded by his uncle. Alden was glad to see his uncle again and his cousin, Lieutenant Thomas L. Swann, also on the *Brooklyn*. Their reunion was short-lived since Admiral Porter shifted his command to the *Malvern* and began the challenge of repairing, overhauling, and repainting the huge fleet. Depleted stores were replenished and discipline and morale increased by regular drilling and target practice.

Alden was ordered by Porter to again act as Judge Advocate in December, 1864, in a court of inquiry concerning the sinking of the prize steamer *Florida*. The captured vessel had been taken to Newport News, Virginia, and a guard posted. The *Florida* sank without adequate explanation. Alden reported that the sinking was entirely accidental.[7]

After months of preparation, Admiral Porter's armada was ready. Their objective was Fort Fisher, which stood guard over Wilmington, North Carolina, the most formidable bastion still in Confederate hands and the principal port through which the rebels received vital supplies. While preparing the attack, Porter's ships captured over $2,000,000 worth of vessels attempting to run the blockade of the North Carolina coast. Captain Alden was one of the most active in the capture of vessels and cargo. His prize money made him independently wealthy while Porter's prize money was a staggering figure.

Two days before Christmas the Union vessel *Louisiana*, a power-laden boat, was towed in at night, anchored as near Fort Fisher as possible, and the entire crew taken off. At 1:30 p.m. Christmas Eve 300 tons of high-impact powder were exploded. The sound was barely noted at Fort Fisher and the anticipated damage did not occur. The huge bomb of a vessel proved to be ineffective.

The bombardment of Fort Fisher began on December 25 and lasted for three days.

On Christmas Day Porter directed a renewal of the bombardment and detailed Captains Alden and Glisson to the duty of getting the troops on shore. Alden had less temper and more tact than any other officer in the fleet, and Glisson had befriended General Butler two years ago by hauling the latter's grounded transport off Frying Pan Shoals and enabling him to continue his voyage to New Orleans. The guns from Fort Fisher were now firing only intermittently. The two diminutive Confederate batteries behind sand banks near the chosen landing place of the troops was shelled by two of Porter's gunboats as the soldiers landed.[8]

Admiral Porter blamed General Butler's army for lack of support and felt the withdrawal of troops caused the attack to fail.

The year 1864 ended with General Butler relieved of his command and the Navy reorganizing for a second massive assault. The Army was placed in command of General Alfred Howe Terry. The renewed assault began January 13. The large fleet was lined up in three rows headed by the *Brooklyn* with Captain Alden commanding. In one day General Terry's troops and their equipment were landed.

For three days the naval bombardment continued. On landing, the Army dug in and threw up earthen trenches. These were extended and rows of more advanced trenches completed under the protective bombardment from the ships. Damage to the fort became more extensive each day. From the main fort, a long gallery extended for some 1,500 yards. About every fifty yards was a traverse, a large fifty by sixty-foot area with a bombproof roof. There were seventeen of these. The heavy guns were placed on either side of the traverses. The last one, Mound Hill Battery, provided particularly severe punishment to the Union vessels. The Army advanced from one traverse to the next, and with the capture of Mound Hill Battery, Fort Fisher fell at 10 p.m. Sunday night, January 15, 1865.

Of the 2,500 Confederate troops manning the fort, 1,800 were taken prisoners; the remainder were killed or wounded. Admiral Porter was thanked by Congress for the third time for his services to the Union. Generals Terry and John McAllister's troops occupied Wilmington on February 22.

Alden was advanced in rank to Acting Master and granted a leave to visit his sixty-two-year-old mother, then living at Stony Brook, a suburb of Waltham, Massachusetts. He found his mother living alone and his sisters married and scattered to other areas. She was less able to look after herself, but not yet willing to consider giving up her home. Whenever she decided to move into town, Alden told her he would come home and help her. He remained for two weeks resting, painting watercolors, and enjoying and helping his mother. He received orders on March 28 to join Admiral Porter

at City Point, Virginia.[9] Here he saw the headquarters of General Grant's huge army. The General had just departed for his final campaign. Alden boarded the *Malvern* and reported to Admiral Porter. Abraham Lincoln was expected. Acting Master Alden was introduced to the President, his wife and son Todd. They had come to visit after the President's inauguration at the invitation of Admiral Porter. President and Mrs. Lincoln were friendly people. Todd attached himself to Alden, who was kept busy answering the boy's endless questions and showing him the *Malvern* from top to bottom. Admiral Porter hosted President and Mrs. Lincoln for ten days. Both men needed a rest. The President returned on April 8. On the 10th came word of the surrender at Appomatox, which ended the war. On the 14th, Lincoln was assassinated. Alden was no doubt stunned, particularly since it was less than a week since the President, Mrs. Lincoln, and Todd had been guests aboard the *Malvern*.

Endicott & Co. of New York issued a colored lithograph *The Bombardment of Fort Fisher*. (Plate C-35) The Admiral must have been pleased with his secretary's competence.[10]

The final days of wartime activity, Alden remained on Admiral Porter's flagship in Virginia waters. He was detached and given five months leave, May 4 to October 14, 1865.[11] On December 31, 1865, Alden was honorably discharged from the United States Navy.

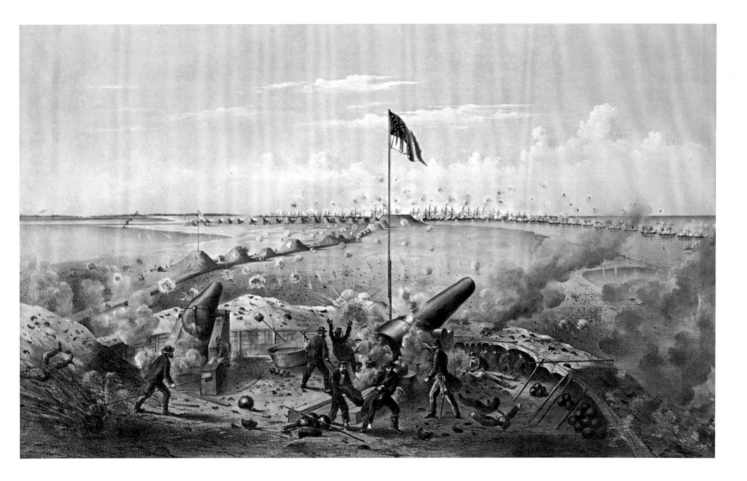

Plate C-35. Bombardment of Fort Fisher.
This extremely rare lithograph by Endicott & Co., New York, in 1865, depicts the
bombardment of Fort Fisher on January 15.
Color lithograph, 18⅛ x 30 inches, 1865.
Collection United States Naval Academy, Annapolis, Maryland.

V. SECRETARY TO THE ADMIRAL OF THE NAVY

In July of 1866 Alden received a summons from his wartime chief, and he made the short trip from Washington to Annapolis. Admiral Porter had been given the assignment he wanted in August, 1865, as the new Superintendent of the Naval Academy. Alden became Secretary to Admiral Porter with the rank of Lieutenant in the Navy by Act of Congress. Alden was thirty-two at this time, and the Admiral was fifty-three.

During the years 1866 to 1870 Alden lived in Annapolis. The Naval Academy had been founded in 1845, but during the war years it was moved to Newport, Rhode Island. It had returned to Annapolis and was the principal object of the Admiral's attention.

> His term of four years was epoch-making. By reason of his national fame he was able to obtain increased appropriations and to enlarge the physical plant of the academy. Determined to make the spirit, government, and instruction of the school predominantly "naval", he substituted line for staff officers and gave himself three votes as a member of the Academic Board. Practical and professional work was emphasized, and new drills, physical exercises, and amusements were introduced. For obedience he depended upon the personal honor of the midshipmen and established friendly relations with them.[1]

> To develop this character in his midshipmen Porter's aims were simple, and compared with the policy of the institution in the past, drastic. He was determined to make the course of instruction more practical and more professional. He would secure voluntary obedience to the regulations by trusting to the personal honor of the midshipmen. He would inaugurate an elaborate system of physical exercises and athletic sports which would divert the midshipmen and at the same time cultivate self-reliance.[2]

170

In 1866 Congress created new top ranks to honor David Farragut and David Dixon Porter, Admiral and Vice Admiral of the Navy. The Vice Admiral lent the prestige of his rank to the building of renown for the Academy. The Porter home became noted as a center for the entertainment of top ranking government officials including the President, members of the Cabinet and Congress and leaders in Army and Navy circles. Superintendent and Mrs. Porter and their guests set the tone for the students' monthly dances, feeling that the training for graduation should include grounding in social graces. The Naval Academy under Vice Admiral Porter rivaled West Point.

> In March, 1869 President Grant installed Porter in the navy department as the 'advisor' of the secretary Adolph Edward Borie, and for more than a year Porter virtually ran the department. Long dissatisfied with the way in which the navy had been administered, he instituted a policy of reform and issued general orders covering a wide range of subjects . . .

Secretary Borie resigned after four months in office. "His [Porter's] exercise of authority aroused much opposition, especially among the staff officers who fared badly under him, and on the coming of a new secretary, his power and influence waned rapidly."[3]

The new secretary, George Robeson, was not supportive of Porter. Admiral Farragut died August 14, 1870, and Porter's appointment to be the next Admiral of the Navy was taken for granted by his friends. President Grant wrote his appointment after Farragut's death, but Senate confirmation was required. After almost five months of controversy, the Senate overwhelmingly confirmed Porter as the Admiral of the Navy.

Alden played out his role of secretary behind the scenes. Many visitors of the Admiral came to know him. Many years later Alden congratulated William H. Taft on his appointment as Chief Justice of the Supreme Court. Taft's reply on July 30, 1921, includes the statement, "I do remember you as the Secretary to Admiral Porter."[4]

Secretary Alden was endowed with an ideal personality for his position. He was always supportive, and the Admiral relied on him increasingly as the years passed. Alden was staunchly loyal to his employer, although he could not always approve of every action, prejudice, and whim. From what is known of the Admiral, it is doubtful that he ever sought his secretary's opinion, and conversely that the secretary ever volunteered it.

On July 10, 1867, Alden married Charlotte Elizabeth Bowie in Washington City. Her father was the late Brigadier General George Washington Bowie of Locust Hill, fifth son of Colonel Thomas Bowie of the Forest of Prince George County, Maryland. The General was forced to sell his family

seat due to a financial crisis in 1853. He and his family moved to Aca Nada on the old Bladensburg Road, near the district line, leading into Washington. His wife named the place, which she found to be disappointing. General Bowie died there in 1856, and Mrs. Bowie moved into the city nearer schools for their nine children. Alden met Lottie while still with the Boundary Commission and living at the Bowie home. He and Lottie had corresponded since that time.

Alden and his bride returned to Annapolis to live. The Admiral and his family were vacationing on the wedding day, but on their return welcomed the newlyweds with a reception in their home. Alden was surprised to see his uncle, recently appointed Commodore, among the guests. His presence added to the happy occasion.

While living in Annapolis, Lottie had two children who died in infancy. Charlotte Bowie Alden, born May 19, 1869, and James Alden, born May 19, 1870, are buried in Glenwood Cemetery in Washington, D. C.

On August 15, 1870, from Narragansett, Rhode Island where the secretary and his wife were visiting the Admiral Porter family, Alden wrote himself a letter:

> Sir: You are hereby appointed Secretary to the Admiral of the U. S. Navy and will report to me for duty at Washington, D. C.
>
> Very respectfully
> (signed) David D. Porter
> Admiral
>
> James M. Alden, Esq.
> Admiral's Secretary
> Stony Brook: Waltham: Masstts.

This was in Alden's hand and signed by Admiral Porter. The letter signified a new term of service at a higher compensation. He reported to the Admiral in Washington at his newly purchased mansion at 1710 H Street. Alden bought a house at 1320 19th Street Northwest, near DuPont Circle, only four or five blocks from his painting retreat along Rock Creek. Here Alden lived for the next twenty-two years and here, on November 10, 1871, his only surviving child, Sarah Alden, was born.

In August, 1868, Commodore James Alden was appointed Commandant at Mare Island. He requested shrubs and trees to be brought by visiting Navy vessels and by laying out shady parks with semi-tropical plantings, he transformed the island from its previously treeless sun-baked condition. Less than a year later he was appointed Chief of the Bureau of Navigation and recalled to Washington, where he lived for two years.

In the Capitol, Commodore Alden paid his respects to Admiral Porter and renewed the long-standing friendship. The Commodore's avuncular feelings for Alden and Lottie was expressed during frequent dinners, visits, and picnics. Alden had matured and there was leisure on weekends for unhurried man-to-man conversations. Commodore Alden was a lonesome man, and he treasured the association with these closest members of his family. All the affection for his own children who did not survive and his wife who could no longer be at his side was transferred to Alden and Lottie. The birth of Sarah occurred only a few weeks before the Commodore was appointed to command the European Station in 1871. He paced the floor together with Alden awaiting the birth. In baby Sarah he saw a resemblance to himself and various members of his family. She was as much a delight to him as Alden and Lottie. When Alden's uncle left for his European assignment, he had been elevated to Rear Admiral.

During the '70s there were few duties for the Admiral of the Navy. Most important was inspection of ships and navy yards. He headed the Board of Inspection until his death. Admiral Porter champed at the inactivity. He made an annual report to the Secretary of the Navy in which a description of the deteriorating fleet and the need for a new Navy were set forth in his blunt and adamant manner. His suggestions were annually disregarded. His relations with the Secretary broke down and for years he seldom entered the Navy Department, a few minutes walk from his home.

"He occupied his leisure with literary efforts which achieved results that he alone greatly admired."[5] *The Memoir of Commodore David Porter* is considered his best book. It is, at once, a full biography and an exoneration of his father, coupled with the Admiral's personal bias.

Admiral Porter wrote his books by dictating to his secretary. After the book was sent to the publishers in 1875, the Admiral and his family left for their summer place. Alden was given a leave and vacationed with Lottie and four-year-old Sarah in Europe.

There are two drawingbooks in which Alden painted European scenes during the 1875 trip. They are, as usual, pencil drawings over which watercolor washes are applied. Both are four by seven inches. One contains thirty-four colored watercolors. The other is not completely filled but there are about twenty watercolors and a number of separate paintings. Dated scenes trace his course through Europe. The Aldens arrived in England in June. After visiting Oxford Cathedral, Ely, Coventry, and other sites, they went to Scotland. They were at Loch Lomond, near Inversnaid, according to a watercolor dated June 20. Edinburgh Castle, Melrose Abbey, and Robert Burns' farm are among the thirty scenes painted in Scotland. They

apparently ended their tour at Cork on June 30. Most of July was spent in Wales, then they crossed the English Channel. After a tour of France, they were in Switzerland at Splugen Pass, near the border of Italy. Italian scenes include Bellagio, Lake Como, the city of Pisa, and, naturally, the leaning tower. September 20 they were back in London, and Alden painted his version of Trafalgar Square. Along the way they visited bookstores, art galleries, and antique shops. Several art books purchased on that tour remain among Alden's effects. His family attests his interest in English watercolors; examples purchased at that time are among the family possessions. The James Madison Alden family returned to Washington.

Admiral Porter was pleased with the success of the book on his father's life. He decided to do more writing. He finished several volumes of fiction, which kept Alden occupied, since they were published in the same year. On weekends Alden sought solace in nearby Rock Creek Park. He drew and painted the length of Rock Creek during all seasons of the year. A folio of many dozens of Rock Creek watercolors is now divided among his several heirs. He valued these restful hours in the fresh air and the melody played by the water as it flowed against the rocks in the creekbed. During his annual vacation, Alden, Sarah, and Lottie traveled more widely, and he painted on each trip.

On February 7, 1877, word arrived of the death of Rear Admiral James Alden. Alden was devoted to his uncle, who had guided his career. Lottie and Sarah loved him for his affectionate place in their lives. Alden attended the funeral services in Portland, Maine, and represented both himself and the Admiral of the Navy, who was unable to travel. Rear Admiral Alden was accorded full honors. A salute was fired at the time of his services in all naval institutions in the United States, and flags were flown at half-mast. His funeral was a solemn and impressive tribute to the Navy hero. Aunt Sarah remained in McLean Hospital in Somerville, Massachusetts. Alden did not call on her. He had been advised that a visit would only agitate her, and that she would not recognize him.[6]

Alden learned later that he was the principal heir. His uncle's wealth had been swelled by the prize money from many captured vessels. There were personal possessions including paintings, fine china, oriental rugs, and furniture which remain in the family today.[7]

When the opportunity provided, Alden visited his mother at Stony Brook. The brook provided subject matter for another large series of watercolors. Eventually his mother found country life more than she could cope with and moved into Waltham. She died on June 12, 1889.

Admiral Porter drew upon his naval experiences for his next book, *Incidents and Anecdotes of the Civil War*, which regaled the reader with a lighter view of the war. The author was the central figure, and he revealed the eccentricities of himself and others. The lampooning was good-humored, and the book generally well-received.

Next came the *Naval History of the Civil War*. Of the huge volume, his best biographer wrote:

> He made an honest effort to deal fairly with his subject; but the task was beyond the scope of even professional historians of his day. Porter had the files of the Navy Department at his disposal, but the impetuous Admiral, who "wrote more in three months than an ordinary writer would do in a year" preferred to resort to memory rather than labor through the mountains of documents in the Navy Department.[8]

Porter's book was published in 1886.

On June 12, 1886, Alden was notified of his wife's death. For several years she had been afflicted with depression and irritability. There was no effective treatment in those days, and she became gradually worse. Finally, it became necessary to place her in an institution and her nervous condition progressed to her death.

Sarah was fifteen years of age at the death of her mother, who had not been home for several years. She and her father lived alone, and each looked after the other as well as possible. Sarah was still in school.

Admiral Porter's health continued to decline. His love of good living was not in keeping with his now sedentary life and slowing of bodily functions. In 1889 he and Georgie celebrated their Golden Wedding Anniversary with a last party at their home. It was the social occasion of the year. President Harrison and other dignitaries were on hand, as well as those of the Admiral of the Navy's old cronies who were still living. The newspapers reported the Golden Wedding reception and retold the glorious wartime achievements of the old Admiral, events of a quarter of a century previous, forgotten or never known by the younger half of the population.

Admiral Porter dictated a letter for his secretary:

> Office of the Admiral
> Washington, D. C.
> May 22, 1890
>
> Dear Sir:
>
> I beg leave to introduce to you my Secretary, Lieutenant James M. Alden. The Honorable Secretary of the Navy has referred Mr. Alden's case to you for your opinion.
>
> When the law passed Congress giving me a Secretary, I appointed Mr. Alden, with the approval of Mr. Secretary

Welles, and up to the present time I have always considered Mr. Alden a permanent officer in the Navy in which he has the positive rank of Lieutenant. Mr. Alden has served with me a period of twenty-seven years besides a previous service afloat in the Navy of six years making a total service of thirty-three years.

It would be a great injustice if anything should happen to me, at a time of life when most officers are looking forward to peaceful retirement, that he should be dropped from the Navy.

I beg leave to draw your attention to the option of Attorney General Cushing which would seem to be applicable to the case.

I have the honor to be,
Very Respectfully
Your obt. Servt.
(signed) David D. Porter
Admiral

Honorable
William H. H. Miller
Attorney General

A copy was retained by Alden and proved to be valuable in solving his problems regarding a pension.

Alden married his second wife, Miss Frances Elizabeth Hewlett, daughter of the late Reverend Thomas William Hewlett of Oxford, England, on June 16, 1890. They had met while she was employed in the British Embassy in Washington. The wedding took place at the home of friends in Baltimore and was followed by a honeymoon in Europe. There are watercolors by the artist of Oxford where the new bride visited members of her family. Other dated paintings in family collections indicate a trip from the end of June into September through England and Scotland.

While Alden and his bride were in England, the Porters returned to their summer home in Newport. The Admiral sustained a heart attack from which he recovered. His convalescence was prolonged after his return to Washington when Alden arrived home. Mrs. Porter was in poor health and confined to her bed. The old Admiral's demands included the Secretary's constant presence at his bedside. He suddenly expired a few months later, February 13, 1891, at the age of 78.

President Benjamin F. Harrison announced the death of the Admiral of the United States Navy. Congress adjourned. All flags on official buildings throughout the nation were flown at half-staff. United States Navy vessels everywhere fired a salute at the time of the funeral. All of the nation's officials, many state governors, Army and Navy officers, including Confeder-

ate leaders, paid their last respects to Admiral Porter. His body was laid to rest in the National Cemetery at Arlington, Virginia, with full military honors befitting the second Admiral of the Navy.

Alden was fifty-seven years old. Since the day he first boarded the flagship U. S. *Black Hawk* as a young Acting Ensign, he had given twenty-eight years of his life to serving the Admiral. No one was closer to Porter except his wife, but even then it was Alden who had lived through the harrowing battles, the agonizing problems, and decisions. Secretary Alden was admiringly aware of Admiral Porter's great and fine qualities, but at the same time Alden was painfully and silently enduring of the personal faults with which the Admiral had been generously endowed. Old age had made his chief increasingly irascible and demanding. Death had assuaged the Admiral's discomfort and was, as well, a respite to Secretary Alden.

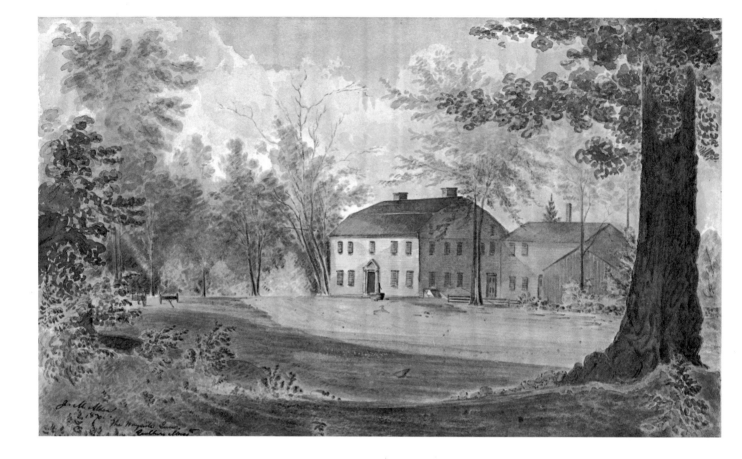

Plate C-36. The Wayside Inn, Sudbury, Mass.
The original Wayside Inn, Sudbury, Massachusetts, which the poet Henry Wadsworth
Longfellow immortalized, as painted by Alden.
Watercolor, 8¼ x 14 inches, 1870.
Collection Dr. and Mrs. Franz Stenzel, Portland, Oregon.

VI. RETIREMENT

In 1892 Alden and Frances moved to Florida. Their new home was Oak Knoll near Orlando, which had a population of approximately 2,000 and was the seat of Orange County. The land was formerly owned by General George Washington Bowie, and Alden inherited it from Lottie, his first wife. The area was becoming noted for the production of oranges, lemons, and other tropical fruit. Alden began growing oranges after clearing the land, planting, and cultivating the trees. Water was available from Pine Lake on the Oak Knoll property. A marketable crop was harvested after a few years and increased as the trees matured.

Alden maintained his interest in painting. Scenes of their home, the lake, and the orange grove are owned by his granddaughters. Alden and Frances periodically returned north, visited friends and relatives, and he painted along the way.

Sarah sent word of her marriage to Vernon Alden Dorsey in a civil ceremony at Portsmouth, New Hampshire. Alden and Frances attended the religious ceremony held at St. Matthews Church in Washington, D. C., on September 26, 1889. The newlyweds established their home at Chevy Chase, a suburb of Washington.

Not until 1909 was Alden's pension granted, $20 a month based on his rank of Acting Ensign. Three years later it was raised to $30 per month for his rank of Acting Master. Continuing applications and submitting of his claim finally succeeded, with the help of William Howard Taft, in granting his pension based on twenty-seven years as a Lieutenant in the Navy.

In 1915 Alden laid aside his pencil and watercolors. At eighty-one years of age he was developing cataracts and his vision was dim. He sold Oak Knoll. He and Frances moved into the town of Orlando and lived at 112 Grace Street.

Alden's last letter of record to his daughter Sarah, whom he addressed as "Sadie," as dictated to Frances, is dated July 29, 1921.

Dear Sadie:

Your Annapolis letter was duly received. I hope you liked the old town. I am very fond of it myself. I lived there several years when Admiral Porter was Superintendent of the Naval Academy. It is one of the most interesting places in the whole country. Like an old county town in England.

I am glad you are to have the portraits of Admiral Tate and Aunt Delia. Cousin Alice wrote to me some years ago and said she had left to you the drawings I had given her. There must be twenty or thirty of them, all nicely framed, and some of my best work is in them. Work that I should not be ashamed to show to any water color painter. Cousin Alice may have made another Will and left out those drawings but I can hardly believe that her mind was probably much weakened before her death. She must have been nearly as old as I am. And when anybody is 86 years old, it is no wonder if their mental facilities are a little out of gear. You and Vernon will have to work out this problem. I am not competent to do it. The portrait of Aunt Delia, Alice must have obtained from Mr. Blodgett of Winchester, Mass. That is an excellent likeness of a very handsome woman. It should be hung with my Father's picture; then you would have a pair.

Admiral Tate's portrait you might give to Alden. He was a very distinguished officer, noted in the Wars of the Turks and the Swedes. He was the son of George & Mary Tate, and was born in London in 1750, and died in St. Petersburgh in 1821. He was brought up near Portland, Maine. His last visit to this country was in 1819. He wished to take my Father with him to Russia, and put him in the Navy but my grandfather would not consent. I expect the portrait of Admiral Tate. He looked like a sturdy old Englishman.

Admiral Tate's father was Mast Agent for the British Government in this Country.

My cousin, Mrs. Blodgett, left in her will, to me, the clock of my great grandfather, Capt. Robt. Tate, brother of the Admiral, who died in 1804, while in command of a ship in British Guiana. Robert Tate had considerable talent as an Artist, although I never saw any of his work. I wish you would keep all the scraps of Family History that I write, because some day some of your family will want to hear about them, and there will be no one to tell them. All the Tates (our Tates) were Sailors and their lives would be interesting. One of them commanded the ship that brought Lord Cornwallis to this country during the Revolution.

Well I will wind up now. If I ever recover the power to see, I will write you more on this subject.

Cousin Alice had a picture of the Old Gates House that I did, which I called "The Abandoned Farm, a Twilight Scene."

Well I will close now. I am feeling alright excepting *Old* and Frances takes good care of me, but we are having awfully warm days, but pleasant nights.

With love to all.

<div align="center">

Your affectionate
Father

</div>

In early 1922 his daughter and his grandchildren visited him for what was to be the last time. They remember it well. Then on May 10, James Madison Alden, eighty-eight years of age, died in his sleep. His remains were interred in Arlington National Cemetery, Arlington, Virginia.

VII. ALDEN'S WATERCOLORS

James Madison Alden, watercolor artist extraordinary, left a heritage which to date consists of 670 located works. There are eighty-four European scenes, 347 along the Eastern seaboard from South Carolina to Maine, four from the Civil War, and 317 of the West Coast from San Diego into Canada and along the United States-Canadian boundary from the coast to the continental divide. There is one portrait.

Some of Alden's western paintings were made while he was on the United States Coast Survey from 1854 to 1857; others when he served as Official Artist during the Northwestern Boundary Survey from 1858 through 1860, followed by his almost three years of subsequent work in Washington, D. C., to complete a series of sixty-six enlarged and repainted scenes along the 49th parallel. They were intended as illustrations for a report which was never published. Badly damaged, grossly incomplete, and unidentified drawings and paintings have not been included in this total. Neither does it include several drawings with incompletely applied watercolor wash.

Today Alden's paintings are distributed among thirty-one owners: three governmental institutions, three university libraries, two historical societies, two art dealers, two art museums, twelve members of the family, two descendants of Admiral Porter, one California mission, and four private collectors. Probably not more than one-half his output has been located, therefore a complete listing is impossible.

Approximately thirty-five of his West Coast watercolors are known to be lost under conditions which make their reappearance most unlikely. Two larger collections which came down through the family were dispersed and

could not be traced. All but four of his Civil War works are missing, as are the watercolors for parts of most every season on the West Coast. The relatively intact drawingbook for less than two months of 1857 indicates that he was producing drawings and paintings at the rate of several per day. This would suggest that he produced many more than 317 works in the six years he painted on the West Coast. The "Rocky Mountain Reconnoissance [*sic*]" which he painted for George Gibbs supports the belief that he made paintings for some of his associates. The Lee Stossell Collection came from a dealer in western New York, in the Buffalo area, years ago. The dealer, now long deceased, stated that they came from an estate there. The seven paintings along the 49th parallel and Alden's trek to Portland, Oregon Territory, are believed to have been made for a former official of the Boundary Survey. It is reasonable to assume that others who found his work attractive purchased some as remembrance of their adventures in the West. His granddaughters affirm his selling watercolors. One stated that after his death, his wife found scant interest during "hard times" but did sell some selected ones.

Unfortunately, almost every printed reference to James Madison Alden and many concerning James Alden are wrong. In order to correct the record, it should be clear that Lieutenant James Alden, who rose to become Rear Admiral, never made any drawings or paintings. This statement is supported by a letter written in 1941 by James Madison Alden's daughter Sarah Alden Dorsey to a researcher who asked about Admiral Alden's role as an artist. The letter states, in part, "I wish to call attention to the fact that you have confused my father James Madison Alden, with the Admiral. My father, having served with his uncle the Admiral on the Coast Survey, made the sketches."[1] Further emphasis from James Madison Alden's three granddaughters, all of whom are well-informed and lifelong students and researchers in Alden genealogy, who were each questioned in detail, positively asserts that the Admiral was never an artist. Finally, no drawing or painting has ever been established as being from the hand of James Alden, whether at the time he was of any rank from Midshipman to Rear Admiral.

After careful consultation of the printed sources, it is rather easy to pinpoint the error in attribution between James Alden and James Madison Alden.

The 1860 report, *Message to the President of the United States, Communicating . . . Information With Regard . . . the Work of Marking the Boundary . . . etc.*, Sen. Ex. Doc. No. 16, 36th Cong., 1st Sess., is correct in its reference to Commissioner Campbell, Chief Astronomer and Surveyor John G. Parke, but completely ignores Alden, despite his appointment as Official

Artist. The 1869 report, *Message from the President . . . etc . . . concerning the Northwest Boundary Commission*, House Ex. Doc. No. 86, 40th Cong., 3rd Sess., contains a brief report from Commissioner Campbell to Secretary of State William H. Seward with a detailed account of pay records, cost of supplies, and transportation. James M. Alden is correctly listed for 1857 as "Purser's Steward" on the *Active*. In 1860 he is incorrectly listed as "T. M. Alden, artist," with a salary of $100 per month. In 1861 he is "J. M. Alden, artist." After returning to Washington, Alden purchased "2 sketchbooks, 3½ cakes of cobalt, 2 camel hair brushes, 1 box of water colors, ½ quire of drawing paper and 2 drawing boards." This is the first printed reference to James Madison Alden.

The Annual Reports to the Superintendent of the Coast Survey never mention his name.

The Marcus Baker *Survey of the Northwestern Boundary of the United States, 1857-1861*, published in 1900 and previously cited, states on page sixty-three: "The artist, James M. Alden, produced a fine series of colored sketches of scenery along the boundary line. These sketches, obviously intended to illustrate the final report, are in the State Department. There are sixty-five of these, all but two (large ones) included in three portfolios."

Mrs. James Madison Alden survived her husband and lived until April 16, 1930. At her death, family possessions were sold at a church sale and James M. Alden's watercolors were purchased by Miss Eliza L. Wright of Orlando, Florida. Miss Wright cast about to sell the paintings to historical institutions. In the process, she wrote letters to prospective purchasers which were laden with misinformation. A copy of one such letter to the Olympia, Washington, Chamber of Commerce, in 1935 contains the following erroneous statements: James Madison Alden is described as being a "lieutenant on the U. S. C. S. Str. *Active*"; George Gibbs is credited along with J. M. Alden as being artist of the "Rocky Mountain Reconnoissance [*sic*]"; and James M. Alden is described as having later became "a Rear Admiral in the U. S. Navy."

This letter led to the purchase by the Washington State Historical Society of watercolors of Washington Territory, the San Juan Islands and sixteen of a series of twenty watercolors from "A Rocky Mountain Reconnoissance [*sic*]." All were by James Madison Alden. None were by George Gibbs. Later correspondence with Miss Wright (by then Mrs. Eliza Wright Duke) did not clarify the situation. She was also the source of two watercolors of British Columbia purchased by Judge Frederick W. Howay and presented to the University of British Columbia. At that time she had

twenty labeled and dated watercolors and a book of fifty-eight drawings and watercolors, all of New England. All seventy-eight were subsequently sold to an Alden descendent from Massachusetts.

Henry Raup Wagner, the historian and collector, purchased some California watercolors and a drawingbook. Based on the incorrect information supplied by Miss Wright, the *California Historical Quarterly*, XII (March, 1933), 87, reported that "Mr. H[enry]. R[aup]. Wagner purchased for the Society a series of watercolor sketches and pencil drawings made during the years 1855-1864 [actually 1854-1860] by *Lieutenant James Alden* [italics added] of the Coast Survey." This seems to be the first printed misattribution.

The confusion in identity continued. The *California Historical Quarterly*, XX (September, 1941), 275, published "Thomas A. Ayers, Artist-Argonaut of California," by Jeanne Van Nostrand, who wrote that, "Some of the original pencil sketches, or copies made by Ayers, were purchased by *Admiral James Alden* of Mare Island, himself *a watercolorist of considerable ability* . . ." (Italics added.) James Alden did serve as Commandant of Mare Island from August 1, 1868, to March 16, 1869, but he was Commodore, not Admiral, at that time. Nor was he a watercolorist. He did, however, purchase Ayers drawings and lithographs for his wife, who admired them.

In Jeanne Van Nostrand and Edith M. Coulter's *California Pictorial* (Berkeley and Los Angeles: University of California Press, 1948), pp. 144-145, the misattribution is compounded. James Madison Alden's *Crescent City, 1859* watercolor is reproduced but wrongly credited to James Alden, whose partial biography is correctly stated. Relying on Van Nostrand and Coulter's statement, James Alden is mistakenly included in George C. Groce and David H. Wallace, *The New-York Historical Society's Dictionary of Artists in America, 1564-1860* (New Haven: Yale University Press, 1957). No other American art dictionary lists James Alden as an artist.

The Los Angeles County Museum followed suit. In their California Centennial Exhibition of Art celebrated September 30 through November 13, 1949, at Exposition Park, two of James Madison Alden's watercolors were borrowed from the California Historical Society. One was reproduced on page ten of the catalogue of the exhibition. It was mistakenly credited to James Alden. On page eleven James Alden's career is correctly capsulized but it has nothing to do with the artist of the watercolor illustrated, *Clear Lake, 1864*. The real artist, of course, was James Madison Alden.

The misattribution continued in *Forts of the State of Washington. A Record of Military and Semi-Military Establishments Designated as Forts. From May 29, 1792 to November 15, 1951.* (2nd ed.; Seattle, Washington:

J. S. Whiting, 1951). Page eighteen shows James Madison Alden's *Fort Bellingham—Bellingham Bay, W. T. July 16, 7 a.m., 1857.* Page twenty-six reproduces his *Fort Nesqually* [sic], *built by Hudson's Bay Company as a Trading Post in 1833.—From a sketch by Lieutenant Alden on U. S. survey steamer* Active, *1857,* original from Washington State Historical Society. Once again, Lieutenant Alden is credited with the watercolors instead of the artist, James Madison Alden.

Robert D. Monroe's, "William Birch McMurtrie: A Painter Partially Restored," *Oregon Historical Society Quarterly*, LX, (September, 1959), pp. 370-371 refers to *Lieutenant Commanding James Alden*, United States Navy, then makes a misstatement McMurtrie was now under the command of a man whose skill as an artist was the equal of his own.

David Lavender, *The American Heritage History of the Great West* (New York: American Heritage Publishing Co., 1965), 300, mentions a few of the "natural wonders farther west" and utilizes a painting in Washington Territory, *Palouse Falls*, done by James Madison Alden. The painting is misattributed to James Alden, the uncle of the artist. The original is in the National Archives, Record Group 76, Number 16.

Lucile McDonald's "Survey Ship *Active*," *The Sea Chest, Journal of the Puget Sound Maritime Historical Society*. V, (June, 1972), 124-129, contains a brief statement of the several trips the *Active* made from the time she became a Government Survey Ship in 1852 through 1859, to the Columbia River, Puget Sound and the Straits of Juan de Fuca. Several of James Madison Alden watercolors are illustrated. The paintings are a part of the collection of forty-six owned by the Washington State Historical Society and were executed by James Madison Alden. Also reproduced is the chart from the Umpqua river to the Canadian border with four vignetted views superimposed on the charts which were drawn by William B. McMurtrie, Official Artist. They are credited in the lower left margin "Drawn by W. M. McMurtrie."

There are numerous other errors, even in Government printed documents. Daniel T. Goggin's *Preliminary Inventory of the Records Relating to International Boundaries (Record Group 76) No. 170* (Washington: The National Archives and Records Service, General Services Administration, 1968), is still being used to provide information and to help writers and publishers in using the sixty-six James M. Alden original watercolors which the National Archives own. Page 42, item 221, contains the statement, "The watercolors are by James *W*. Alden." (Italics added.)

Finally, there is the beautiful, illustrated catalogue, *National Parks and the American Landscape* (Washington: The National Collection of Fine

Arts by the Smithsonian Press, 1972), 50-51, plates 10-13, which correctly credits James M. Alden as the artist beneath each of the four watercolors reproduced, but gives the dates 1810-1877, those of Rear Admiral James Alden, instead of 1834-1922, the correct dates for James Madison Alden, the artist.

The list of errors could be extended but enough examples have been presented to make the point obvious and to terminate the proliferation of such errors.

It is not at all clear what Admiral Porter thought about his Secretary's art activity—if indeed, he held any thoughts on the matter. One has to assume that he knew of Alden's having been Official Artist for the Northwestern Boundary Survey and then having been engaged in Washington, District of Columbia, for the first two and one-half years of the Civil War completing his watercolors. Perhaps he considered this a youthful aberration in view of his statement in the preface to his own book on the war. "Naval ships did not travel with reporters, photographers or sketchers, there was no room for these on board, the discomfort of a man of war, the exacting discipline, and the freer life in camp sent him back to shore, where in most cases he only remembered his associations with the Navy as a trip without any satisfaction, and with no desire to do justice to the work of the naval service."[2]

Porter profusely illustrated his *The Naval History of the Civil War* and states on the title page "Illustrated from original sketches made by Rear-Admiral Walke and others." The generally mediocre illustrations come from several sources. Carl J. Becker drew the majority of the portraits from photographs, as stated. The larger portraits of high ranking officers in three-quarter length show the face in great detail and the uniformed torso presented in line drawing embellished with some shading. The resulting contrast between face and figure is rather grotesque. Carl J. Becker is not identified in the book except by his signature, nor is he listed in the standard American art dictionaries. Very likely he was in the employ of the publisher.

James E. Taylor, 1839-1901, appears as the artist on a few plates. He is listed as an American illustrator in Groce and Wallace's *Dictionary of Artists in America*, previously cited. In 1861 Taylor joined the Union Army and in 1863 became artist-correspondent for *Leslie's Magazine*, where he continued until 1883. He was an independent illustrator in watercolor in 1886 when Admiral Porter's book appeared.

Rear-Admiral Henry Walke, 1808-1896, who is credited with most of the illustrations is listed as a naval combat artist. He served in the United

States Navy from 1827 until 1871. His war scenes of the Mexican and Civil Wars were published in two separate volumes. Individual battle lithographs appear as prints and in magazines, according to *Dictionary of Artists in America*. A sizable collection of his paintings, predominantly oils, are in the United States Naval Museum at West Point. All of his work is representational to the point of being almost photographic.

Strangely, on page 530 of Porter's *Naval History* appears a scene identical to Artist Alden's Red River watercolor showing the Admiral's fleet of gunboats passing over Alexandria Rapids in Louisiana. It is credited "From an Original Sketch by Rear Admiral H. Walke." Admiral Porter owned James Madison Alden's original watercolor of that scene. It is still owned by the Admiral's granddaughter. Apparently Rear Admiral Henry Walke painted from photographs, magazine illustrations and originals by other artists which became his own "originals" once he had copied them.

Admiral Porter listed Alden, together with his rank as an officer of his flagships, following the section in his book which dealt with each of Porter's major campaigns. He did not utilize any of his Secretary's watercolors in illustrating his book—or at least Alden was never given any credits. Porter, moreover, permitted the cribbing of Alden's Red River scene and was unquestionably deferential to Walke, as he was to all high ranking naval officers. The Admiral's area of expertise did not include art and he may have intended no slight to his secretary but simply felt such matters were not important. There are other Admiral Walke "originals" in Porter's *The Naval History of the Civil War* which could well have come from James Madison Alden's pencil and brush. Since a third hand, that of the engraver, further modified the "originals," it is impossible to be certain.

Other Aldens are listed as artists, but James Madison Alden's family cannot identify them.[3] Alden's greatgrandfather, Captain Robert Tate, brother of the Admiral, who died in 1804, had considerable talent as an artist, but Alden never saw any of his work. Writing from Florida to his fifteen-year-old granddaughter Mary Dorsey in 1916, Alden advised that

> I was greatly interested in your account of your studies. I hope you won't work too hard. Try to learn to sketch landscapes. If you use watercolor stick to *few* colors and not more than two brushes. Those who use many colors and lots of brushes are apt to make a mess of things.
>
> As for pastelles—(colored crayons) I once did a little in that medium but dropped it preferring water-colors. I have seen fine work in pastelles, however.

> The best thing to commence with is the black lead pencil. I worked with that sketching, from nature, for years before taking up water-colors. I hope you will develop into an accomplished artist but don't try too many kinds. Watercolor is far more convenient than oil and far preferable, in my judgment. A long lifetime is none too long to get a fair knowledge of it.

None of Alden's pastels, no oil paintings, nor work in any other media has been located.

Alden was benefited by his course of instruction in cartography at the Survey Printing Office. His use of perspective was sharpened and he cannot ever be faulted on this count. He developed skill in drawing the essentials and his landscapes never became complicated with unnecessary detail. Working with engravers taught him, when suitable, to employ a dark and detailed foreground as a threshold across which a viewer was led into his paintings. This and other engraving devices transformed his schoolboy art into competent renditions.

His period of study with Thomas Seer Cummings in New York City was for only a few months and is a testament to his teacher's ability and Alden's being a gifted individual. The instruction did not constrain him to employ academic devices which might have caused Alden to lose the freshness and immediacy of his work. To the contrary, Cummings seems to have helped him become freer in his presentation of natural phenomena and encouraged the development of themes and patterns which the young artist saw in forests, rocks and mountains. This quality helps to produce the individuality and much of the charm of Alden's work.

Alden was a mild-mannered man and this comes through in his paintings. In his placid world, perhaps in compensation for the strife and pressures through which he lived, all in nature was in peaceful equilibrium. He painted no dark ominous clouds, no storm-tossed waves, in effect, no clash of the elements in any form.

Alden's use of light was restrained, although he painted when luminism was avant garde. He presents no bright days with explorations of shimmering light. His shadows are factual and seldom employed as part of the composition or to suggest a mood. A respectful awe of nature on the part of the painter is the principal mood reflected. He set down each scene as its own peculiar and characteristic variation of nature. This explains how the great rugged scenery of the Cascades and the Rockies evoked some of his greatest efforts and resulted in his best painting.

His wooden or amorphous human and animal figures seem anachronistic. Did his concern for nature exclude people and "man's best friends"? Small

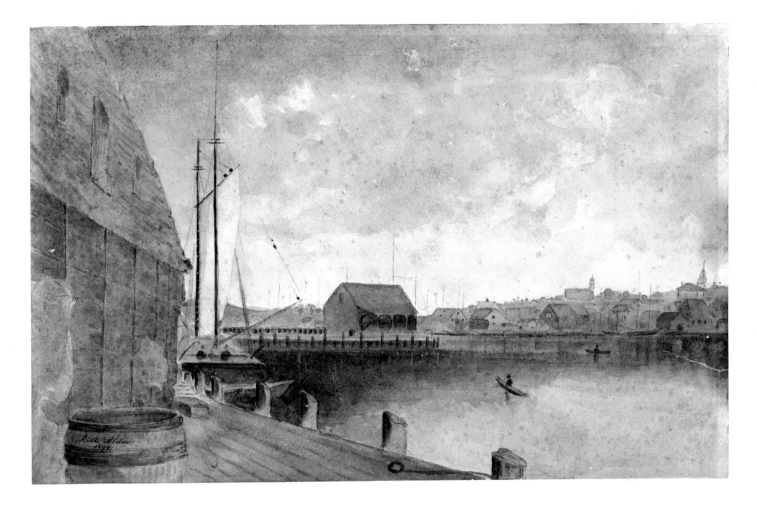

Plate 61. The Wharf at Gloucester, Mass.
Watercolor, 11⅛ x 18 inches, 1894.
Collection Dr. and Mrs. Franz Stenzel, Portland, Oregon.

figures of men and pack animals may indicate the scale of mountains in the background, but sometimes they are essential to the story being told. Did his capabilities fall short of adequate rendition of figures? There is the well executed but unique portrait of his fellow artist, McMurtrie. Among the several hundred watercolors examined, there is one which details human figures. In the middleground a man and woman are walking on a path toward a house at Fletcher, North Carolina. The eight by fourteen-inch watercolor is the home of one of the unnamed relatives. The figures shown are approximately two and one-half inches high. All of the expected detail of face, body and clothing are present, indicating that he could paint human figures well enough when he wished to do so. Perhaps he would have preferred to eliminate the figures and concentrate on the landscape.

Alden produced no extant genre scenes, no ethnographic record of Indian activities and customs, other than tomb figures, and no record of life in San Francisco or at the gold mines. It will be interesting to see if any paintings in these categories turn up in the future.

Alden did rearrange elements in nature for the sake of composition but in his own way and not according to academic or classic rules. He saw patterns in nature. He modified the surface forms of the basalt cliffs on the Columbia River to carry out these patterns. In the Clear Lake watercolors, his trees are placed along the shoreline like regularly spaced strings of Christmas tree bulbs, a device he employed on occasion. In other instances he heaped large boulders into a pile and carved each one so the result resembled a bouquet.

Alden had the ability to use color well. Some half-finished watercolors show how much the color contributed to the composition. The drawing in pencil gains meaning by the adding of color which brings out detail and imparts life. As the artist stated, he used few colors but many narrow gradations of each to give a pleasing result. No small part of the delight of his watercolors lies in his ability to see and control color relationships.

Alden belonged to no art organizations and participated in no exhibitions but maintained his own individual style in his wide ranging series of watercolors. To one acquainted with his work, they are readily recognized.

In addition to his western work which has been detailed in this book, Alden painted an appreciable volume of charming watercolors of New England and mid-Atlantic subjects. Two examples are his *Longfellow's Wayside Inn, Sudbury, Mass.* (Plate C-36) and *The Wharf at Gloucester, Mass.* (Plate 61)

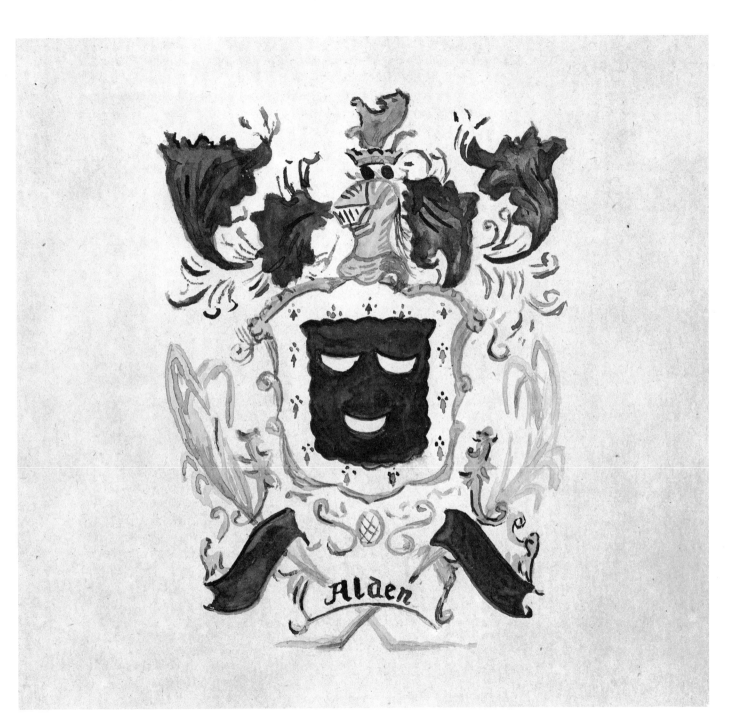

Plate 62. Alden Coat of Arms.
Watercolor, 9 x 8⅜ inches.
Collection Mr. and Mrs. Henry Windsor Adams, Galesville, Maryland.

Hopefully, this presentation of James Madison Alden's life will allow him his own identity and end forever the prevailing confusion with Admiral Alden. The selection of almost 100 watercolors illustrated, most of which were previously unknown, will insure a place in the annals of American art for James Madison Alden.

NOTES
Chapter I

1) Biographical information on James Madison Alden, except where otherwise noted, comes from three granddaughters and one great-granddaughter, whose personal knowledge supplemented by their extensive family records, has been made available. They are Mrs. Henry Windsor Adams, Galesville, Maryland; Mrs. J. William McLure, Union, South Carolina; Mrs. Sidney F. Parham, Bloomfield, Connecticut; and Mrs. Albert W. Ayers, Jr., Darien, Connecticut. Mrs. Henry Windsor Adams has been of continued assistance. Mrs. J. William McLure and Mrs. Sidney F. Parham are now deceased. All three granddaughters were old enough to know James Madison Alden. Their hobby was genealogy, their memories were good, and each was interviewed on several separate occasions over an eight-year period. Alden's sea chest is the property of Mrs. Albert W. Ayers, Jr.

2) The town of Boxborough was composed of parts of the towns of Littleton, Stow, Acton, and Harvard. Mrs. Clyde L. Richardson, Town Clerk of Boxborough, located the early book taken from church records, grave records, and published intentions of marriage, which provided the record of James Madison Alden's parents, who were married on June 10, 1833.

3) Benjamin Franklin, one of seventeen children, was reared in Boston. After a year of grammar school, he was forced to work in his father's shop to contribute to the family finances. He later established the funds awarding medals to six top-ranking students annually as encouragement for them to obtain the formal education he had been denied.

4) Identification of the church comes from Mrs. Ropes Cabot, Curator of The Bostonian Society, Old State House, Boston. In 1862 it became St. Stephens Roman Catholic Church. It has recently been restored.

5) Dr. Abraham Rand Thompson of Charlestown, Massachusetts, is not listed as a Navy Officer, contrary to family documents. He was of Pilgrim stock. After his Navy service, he practiced medicine in Charlestown. His daughter, Sarah Ann Thompson, married Passed Midshipman James Alden, Jr., on June 19, 1838, in Charlestown.

6) Thomas Seer Cummings, 1804-1899, was an English born artist known for his miniatures and portraits. Founding member of the National Academy of Design, he served as its Treasurer for forty years and lived to be its oldest member. He taught Alfred T. Agate. George C. Groce and David H. Wallace, *The New-York Historical Society's Dictionary of Artists in America, 1564-1860*, 2, 158. He was also a teacher of a long-time United States Coast Survey artist. Franz Stenzel, M.D., *Cleveland Rockwell, Scientist and Artist, 1837-1907*, 71. Evidence of T. S. Cummings having instructed James Madison Alden, aside from family lore, is found in his scrapbook. Alongside an unnamed newspaper obituary article detailing the recent death and career of Thomas Seer Cummings in 1899, James Madison Alden has noted, "My Teacher."

7) The 172-foot *Active* was formerly the schooner-rigged *Goldhunter* purchased in 1853 from the Pacific Mail Steamship Company by the United States Government. She was rebuilt at Mare Island, California, and strengthened into the 750-ton side-paddle wooden steamer armed with two guns. She was the fastest Survey vessel on the West Coast. See John T. Walbran, *British Columbia Coast Names, 1592-1906*, 1.

8) The family lot in Eastern Cemetery, Portland, Maine, Section B, Range 6, Graves 1, 2, 3, and 4, was owned by and received the remains of Rear Admiral James Alden. According to the undertaking firm established in 1838, in the same lot are buried Benjamin and Elizabeth Alden, children of Rear Admiral and Mrs. Alden. Surviving members of the family mention Edith, who died in infancy. Since no record of Edith has been found, this might have been Elizabeth, as recorded, or still another deceased infant.

9) The log of the *Active* under Lieutenant Alden's command begins "At anchor off San Francisco" on December 25, 1854. After a hiatus from December 25 until April 5, 1855, it is complete for the balance of 1855 and 1856. The log for 1854 is missing, but a reference to it has been found, which lists James Madison Alden as an officer in June. The itinerary of the ship is sporadically noted. The log is located in Record Group 23, Industrial and Social Branch, National Archives and Records Service, Washington, D.C.

10) The biography and facts of Davidson's career are derived principally from Oscar Lewis, *George Davidson, Pioneer West Coast Scientist*.

11) James Smyth Lawson, born in Philadelphia in 1828, had been a classmate of Assistant George Davidson. Both studied under a great-grandson of Benjamin Franklin, Principal Alexander Dallas Bache, who became Superintendent of the United States Coast Survey in 1854. Davidson came west to head the Pacific Coast Survey and brought Lawson as his helper. Lawson wrote an untitled, unpublished autobiographical account covering his years with the Survey from 1849 to 1878. It is located in the Bancroft Library, University of California, Berkeley. The account supplies background information on San Francisco during James Madison Alden's period of residence.

12) The episode at Neah Bay is described by Assistant George Davidson in the *Annual Report to the Superintendent of the United States Coast Survey-1853*, 51. It is particularly helpful in the absence of a detailed log of the *Active*. After 1850 it was a separate volume.

13) Lawson autobiography.

14) Time has provided several versions of the mutiny. See Erwin G. Gudde, "Mutiny on the *Ewing*," *California Historical Society Quarterly*, XXX (March, 1951), 39–49; Thornton Emmons and Homer C. Votaw, "More on the *Ewing* Mutiny," *California Historical Society Quarterly*, XXXVI (December, 1957), 307–311; Betty Lochrie Hoag, "McMurtrie on the Pacific Coast," *La Peninsula, Journal of the San Mateo County Historical Association*, XVI (October, 1972) 11–15.

15) Lewis A. McArthur, "The Pacific Coast Survey of 1849 and 1850," *Oregon Historical Quarterly*, XVI (September, 1915), 246. The article was written by a grandson of Acting Lieutenant William Pope McArthur, United States Navy. The original letters have disappeared. Photocopies of the letters of William Pope McArthur are now owned by his great-grandson, Lewis Lynn McArthur, who allowed the writer to examine them. There are twelve letters in Lieutenant McArthur's hand, two from Panama May 8, 9, 1849, and seven letters from San Francisco, one each from San Pablo Bay, Trinidad Bay, and Astoria, Oregon Territory. The last is dated November 12, 1850, when McArthur was preparing for his ill-fated return to the East Coast. All of the correspondence is addressed to "Dear Father," his father-in-law Commodore John J. Young, United States Navy. Lewis Lynn McArthur, Chairman of the Oregon Geographic Board, has also aided in the identification of certain of the Columbia River falls which James Madison Alden painted.

16) Hazard Stevens, *The Life of Isaac Ingalls Stevens*, I, 241–284, 425–426 for Stevens' services in the United States Coast Survey and his 1854 visit to San Francisco.

NOTES
Chapter II

1) The most detailed and thoroughly researched biography to date is, Robert D. Monroe, "William Birch McMurtrie: A Painter Partially Restored," *Oregon Historical Quarterly*, LX (September, 1959), 352–374. It is illustrated with six previously unpublished McMurtrie watercolors from the M. & M. Karolik Collection, Museum of Fine Arts, Boston.

2) Charles F. B. Guillou, *Oregon and California Drawings. 1841 and 1847*. With a biographical Sketch by Emily Blackmore and a Commentary by Elliot A. P. Evans. Plate 1, "Fort George or Astoria, July 22nd, 1841."

3) Charles Wilkes, *Narrative of the United States Exploring Expedition During the Years 1838, 1839, 1840, 1841, 1842*. V Volumes and an atlas. The official edition was followed by periodic printing of scientific volumes numbered 6–17, 20, and 23. The remaining five of the planned twenty-four volumes were never issued. There were at least eight editions. The Astoria scene usually appears in the fifth volume.

4) Captain H. Warre, *Sketches in North America and the Oregon Territory*. Twenty colored views on sixteen pages. These are the first lithographic views of the Oregon Territory. The Fort George plate is anachronistic, showing quarter-moon shaped ended birchbark Indian canoes never employed in the region.

5) Howard McKinley Corning (ed.), *Dictionary of Oregon History*, 214.

6) Only a fraction of Alden's work on the 1854 Columbia River trip has been found. McMurtrie was present but no examples of his work have been located. Alden's missing views would have completed his iconography of the first 100 miles of river to Fort Vancouver. However, it is gratifying that so complete a record is preserved after 120 years.

7) *Annual Report, 1854*, 83.

8) *Ibid.*, 78, and Chart J, No. 2.

9) *Annual Report, 1855*. Chart J, No. 71

10) *Ibid.*, 96.

11) Autograph Letter Signed [A.L.S.], Mare Island, California, May 15, 1855, to Hon. I. C. Dobbin, Secretary of the Navy. Extracted from Admiral Farragut's letterbook, August 11, 1854, to September 9, 1856 (in possession of Ernest D. Wichels, Vallejo, California). Wichels spent fifty-one years at Mare Island and for thirty years was Historian and Public Information Officer.

12) Philip C. Johnson, who kept this diary from July 5, 1855, to May 27, 1856, rose to be a Rear Admiral. His son, Rear Admiral Alfred W. Johnson, in command of the United States Fleet Aircraft Base Force, visited Seattle in 1934 in his flagship U.S.S. *Wright*. Edmond S. Meany, Professor of History at the University of Washington, learned of the diary

then in the Admiral's possession, and copied that portion pertaining to the Survey of the Northwest Coast. He presented a copy to the Northwest Collection of the University of Washington Libraries. Robert D. Monroe, head of Special Collections, made it available. See "Private Notes of Philip C. Johnson," July 6 and 7, 1855, 1.

13) *Ibid.*, July 9, 10, 13 and 19, 1 and 2.

14) Two of McMurtrie's 1855 watercolors are in the Honeyman Collection, Bancroft Library, Berkeley, California. The third is in the M. & M. Karolik Collection, Museum of Fine Arts, Boston, and is illustrated in *M. & M. Karolik Collection of American Water Colors & Drawings, 1800-1875*, I, 234.

15) Johnson, "Private Notes," August 13, 1855.

16) *Ibid.*, August 21.

17) James Gilchrist Swan, *The Northwest Coast, or Three Years in the Washington Territory*. Swan visited Shoalwater Bay in 1851 with oyster merchant Captain Charles J. W. Russell. He returned to the area to live and wrote the first book concerning the Washington Territory. He subsequently accompanied Territorial Governor Isaac I. Stevens to Washington City as his secretary. Because he was so well informed, he became known as "Mr. Washington Territory."

18) Johnson, "Private Notes," August 23.

19) Honeyman Collection, Bancroft Library.

20) Johnson, "Private Notes," October 13.

21) Erwin G. Gudde, *California Place Names*, 230.

22) Honeyman Collection, Bancroft Library.

23) Correspondence with Western Coast Superintendents, Party and Extra Observers. Coast Survey, VI, 1850. Item number 155 dated September 30, 1851. Record Group 23, National Archives.

24) One of these is found in the Museum of Fine Arts, Boston. It is an undated watercolor titled "James Peak in the rain, from 25 miles away." James Peak and Pikes Peak were confused until 1865 when present-day names were officially affixed. Research and consultation with Robert M. Ormes, authority and writer on the Colorado Rockies, concludes McMurtrie's James Peak to be present-day Pikes Peak. McMurtrie's obituary asks "Colorado papers please copy," apparently for the benefit of friends living there.

25) *Annual Report, 1856*, 100.

26) Gudde, *California Place Names*, 33.

27) *Annual Report, 1856*, 83.

28) Honeyman Collection, Bancroft Library.

29) *Ibid.*

30) Alden's itinerary is traced by his dated drawings and paintings. The Collection of the Washington State Historical Society includes a drawing book of forty-six Pacific Northwest views in pencil, pen, and watercolor. Thirty-three items are of British Columbia, San Juan Islands, and Puget Sound. The dates run from June 24 to July 17, 1857. Some are incomplete and a few fragmentary, but the completed items constitute an entire drawing book with few, if any, pages missing. This adds up to thirty-three executed in the twenty-three day period and would seem to provide some approximate estimate of his output for any given period.

31) Hudson's Bay Company, Country Letter Book. Manuscript is in the Provincial Archives, Victoria, British Columbia. Citation courtesy of Willard Ireland, Provincial Librarian and Archivist.

32) Edmond S. Meany, *Origin of Washington Geographic Names*, 243.

33) Warre, *Sketches in North America and the Oregon Territory*.

34) Lewis A. McArthur, *Oregon Geographic Names*, 115.

35) Fred Lockley, *History of the Columbia River Valley from The Dalles to the Sea*, I, 890–891.

36) Honeyman Collection, Bancroft Library.

37) Both McMurtrie watercolors are in the Karolik Collection, and are reproduced in Monroe, "McMurtrie," facing 371–372.

NOTES
Chapter III

1) Marcus Baker, "Survey of the Northwestern Boundary of the United States, 1857-1861," *Bulletin of the United States Geological Survey, No. 174*. The extensive literature on the subject is here summarized thirty-nine years later and supplies general background and some facts on James Madison Alden's part in the Survey.

2) *Ibid.*, 13–16.

3) William Downie, *Hunting for Gold . . . The Early Days of the Pacific Coast From Alaska to Panama*.

4) *Annual Report, 1858*, 114, 117.

5) *Victoria Gazette*, August 4, 1858.

6) Honeyman Collection, Bancroft Library.

7) Baker, "Survey of the Northwestern Boundary," 16.

8) Honeyman Collection, Bancroft Library.

9) The Journal of H.M.S. *Plumper* maintained by Lieutenant Richard Charles Mayne, R.N. Manuscript used courtesy of Willard Ireland, Provincial Librarian and Archivist, Victoria, British Columbia.

10) Carl Parcher Russell, *One Hundred Years in Yosemite*, 48–49, misattributes James Madison Alden's watercolors to James Alden. It was James Madison Alden, not James Alden, who visited Yosemite in 1859.

11) Gudde, *California Place Names*, 229.

12) *Annual Report, 1859*, 43. Painting in the Honeyman Collection, Bancroft Library.

13) Edmond S. Meany, *The History of the State of Washington*, 240–241.

14) Charles H. Carey, *A General History of Oregon. Prior to 1861*, I, 463–464.

15) "The Journal of George Clinton Gardner" is in the Honeyman Collection, Bancroft Library. It is a three-volume, 298-page handwritten, unpublished account of the land Survey from August, 1857, to July, 1861, II, 135–136.

16) *Ibid.*, III, 186.

17) *Ibid.*, III, 190.

18) *Ibid.*, III, 207.

19) *Ibid.*, III, 217.

20) Kishinena Pass is not listed among the camps and stations, monuments or elevations by either the Americans or the British. It is probably Kishnehna which is a creek, camp, and mountain. The creek is a tributary of the Flathead River, which crosses the boundary from southeastern British Columbia into Montana.

21) Gardner journal, III, 228–229.

22) *Ibid.*, III, 235.

23) *Ibid.*, III, 241.

24) *Ibid.*, III, 256.

25) "Message from the President . . . etc. . . . Concerning the Northwestern Boundary Commission," *House Executive Document No. 86*, 40th Congress, Third Session, 66–67. The report published conflicting dates for his return. According to Alden's own records, he arrived in New York City on February 26, not January 26. The total time of the return trip was forty-six days.

26) Gardner journal, III, 277.

27) *Ibid.*, III, 280.

28) Kentucky-born, eccentric, wealthy Cassius Clay, 1810-1903, a Yale graduate of 1832 with legal training, raised a force of 300 men when Washington City was cut off and undefended. He was a personal friend of Presidents Andrew Jackson and Abraham Lincoln. Allen Johnson and Dumas Malone (eds.), *Dictionary of American Biography*, II, Pt. 1, 169–170.

29) Baker, "Survey of the Northwestern Boundary," 10, 17–18.

NOTES
Chapter IV

1) Information for background material on David Dixon Porter's life and naval career comes from several sources. The most complete study which impartially treats the controversial aspects of Admiral Porter's life and personality is Richard S. West, Jr., *The Second Admiral: A Life of David Dixon Porter, 1813-1891*. Portions quoted are with permission of Coward, McCann & Geoghegan, New York, current copyright owners. Other sources used are: David Dixon Porter, *The Naval History of the Civil War*; *Appleton's Cyclopedia of American Biography*, V, 73–76; Lewis Paul French [Noel Bertram Gerson], *Yankee Admiral: A Biography of David Dixon Porter*; J. R. Soley, *David Dixon Porter, 1813-1891*.

2) The fact of James Madison Alden's assignment as Judge Advocate on three courts-martial is provided in a one-page summary of his activities in the U.S. Navy accompanying a letter to his granddaughter, Mrs. Henry Windsor Adams, from the Naval Records and Library, Captain John B. Hefferman, Director, April 23, 1948. The source of information is unfortunately, not given, and the letter has not been relocated in Navy Records.

3) West, *Second Admiral*, 18–28.

4) A.L.S. from Commodore Robert W. Hitchcock to Captain Henry August Wise is from the files of the New-York Historical Society.

Charlestown, Mass.
June 22d, 63

My dear Wise:

Well I am off once more under your orders—it sounds a little like old times—you know I am one year behind the times—so point me up.

I wrote a note last week to Fox Assistant Secretary of the Navy [Gustavus Vasa Fox] about Alden— Mrs. A. is *insane* and Alden *must* come home—He left directions that Mrs. A. should not be placed in an "Insane Asylum"—if he was here, he would do it at once for it is the only chance to restore her mind—it is too sad to see her wandering around the streets asking for her husband—

If Capt. Fox has not sent for Alden do beg him to do so, *at once*, and drop me a line to say the order has gone to him.

By the by—do they give *Commissions* to "Commodores"—I have no *papers* of that kind—I do not think much of the situation—but might as well have something of the kind as I draw the pay—

Tell me some of "your noos."

I'm most truly yours,
[Signed] R. W. Hitchcock
[Commodore Robert W. Hitchcock, U.S.N.]

5) "Naval Forces on Western Waters, From March 1 to December 31, 1864," *Official Records of the Union and Confederate Navies in the War of the Rebellion*, Series 1, Vol. XXVI, 421.

6) Naval Records and Library.

7) "The Operations of the Cruisers, From April 1, 1864, to December 30, 1865," *Official Records of the Union and Confederate Navies in the War of the Rebellion*, Series 1, Vol. III, 278–280.

8) West, *Second Admiral*, 282.

9) Naval Records and Library.

10) No other lithograph by James Madison Alden has been located. Correspondence with Mr. Robert L. Harley, The Old Print Shop, Inc., New York City, indicates that their last copy was sold in 1972. One copy is in the Robertson Collection, United States Naval Academy; another copy is in the Print Collection, New York Public Library.

11) Naval Records and Library. The letter states that this "was the usual procedure at that time."

NOTES
Chapter V

1) Malone (ed.), *Dictionary of American Biography*, VIII, Pt. 1, 88.

2) West, *Second Admiral*, 305.

3) *Ibid.*, 88.

4) A.L.S. in Alden family collection.

5) Malone (ed.), *Dictionary of American Biography*, VIII, Pt. 1, 88.

6) An Official Death Certificate indicates that she lived until 1889 in the hospital in Somerville and died from dementia.

7) When the writer and his wife first called on one of J. M. Alden's great-granddaughters, coffee was served in old Staffordshire china cups and stirred with coin silver spoons. It was enhanced by the information that the china and spoons belonged to the Rear Admiral and then the artist.

8) West, *Second Admiral*, 340.

NOTES
Chapter VII

1) A.L.S. in the writer's collection.

2) Porter, *Civil War*, iv.

3) Listed in American art dictionaries are A. C. H. Alden, 1841-1884, and William C. Alden, 1849, of Hartford, Connecticut. By this time John Alden's descendants were widely scattered and numbered in the thousands. See Groce and Wallace, *The New-York Historical Society's Dictionary of Artists in America, 1564-1860*, 4, and William Young (ed. and comp.), *A Dictionary of American Artists, Sculptors and Engravers*, 10.

BIBLIOGRAPHY
Primary Sources

Active, Log of. H. Ms., Incomplete. National Archives and Records Service. Industrial and Social Branch, Record Group 23.

Alden, James M. Book of newspaper clippings, some with Alden's comments and notes, also documents, letters from and relating to the artist. Collection Mrs. J. William McLure, deceased.

Alden, James M. Notebook, imprinted "Navy Register" and dated January 1, 1870. The artist's record of his career, family and art related facts, also assorted letters and documents. Collection Mrs. Henry Windsor Adams, Galesville, Maryland.

Annual Report to the Superintendent of the United States Coast Survey. Washington: Government Printing Office, 1850-1861.

Farragut, Commander David G. H. Ms. Letterbook while Commandant Mare Island Navy Yard 1854-1856. Private Collection.

Gardner, George C. Ms. Journal of the Survey of the 49th Parallel, 1857-1861. Bancroft Library, University of California, Berkeley. 3 Volumes.

Hitchcock, Commodore Robert W. A.L.S. to Wise, Captain Henry August, June 22, 1863. New-York Historical Society.

Hudson's Bay Company Country Letter Book. Ms. Provincial Archives of British Columbia, Victoria.

Johnson, Philip C. Private Notes of. H. Ms. Diary on the U.S.S. *Active* 1855-1856, Excerpt. University of Washington Library, Seattle.

Lawson, James Smyth. Autobiographical account of his years, 1849-1878, with the United States Coast Survey. H. Ms. Bancroft Library, University of California, Berkeley.

Mayne, Lieutenant Richard C. *Journal of the H.M.S. Plumper.* Ms. Provincial Library, Victoria, British Columbia.

Message from the President . . . etc. . . . concerning the Northwest Boundary Commission. House Executive Document No. 86, 40th Congress, 3rd Session. Washington: Government Printing Office, 1869.

Message to the President of the United States, communicating . . . information with regard . . . the work of marking the boundary . . . etc. Senate Executive Document No. 16, 36th Congress, 1st Session. Washington: Government Printing Office, 1860.

Northwestern Boundary Survey Report. House Executive Document No. 86, 40th Congress, 3rd Session. Washington: Government Printing Office, 1869.

Official Records of the Union and Confederate Navies in the War of the Rebellion. Series I Vol. 3. 1896. Also Series I Vol. 26. 1914. Washington: Government Printing Office.

Records Relating to International Boundaries. Preliminary Inventories, No. 170. The National Archives. Washington, 1968.

Warre, Captain H[enry]. *Sketches in North America and the Oregon Country.* London: Dickinson and Company, 1848.

Wilkes, Charles, U.S.N. *Narrative of the United States Exploring Expedition during the years 1838, 1839, 1840, 1841, 1842.* Philadelphia. Printed for Congress, Sherman & Co., 1844. 5 Volumes.

Secondary Sources

Alden, Augustus E. *Pilgrim Alden.* Boston: J. H. Earle & Co., 1902.

Alden, Ebenezer. *Memorial of the Descendants of the Honorable John Alden.* Randolph, Massachusetts: P. S. Brown, 1862.

Appletons' Cyclopedia of American Biography. New York: D. Appleton and Company, 1888. 6 Volumes.

Baker, Marcus. *Survey of the Northwestern Boundary of the United States 1857-1861.* United States Geological Survey. No. 174. Washington: Government Printing Office, 1900.

California Centennials Exhibition of Art. Catalogue. Los Angeles County Museum. Los Angeles. N.P. September-November 1949.

Carey, Charles H. *A General History of Oregon Prior to 1861.* Portland: Metropolitan Press, 1935. 2 Volumes.

Corning, Howard M. Ed. *Dictionary of Oregon History.* Portland: Binfords and Mort, 1956.

Deutsch, Herman J. Ed. "Surveying the 49th Parallel, 1858-61," *Pacific Northwest Historical Pamphlet No. 2*, reprinted from *Pacific Northwest Quarterly*, 53. Tacoma: Washington State Historical Society (January, 1962).

Downie, William. *Hunting for Gold* . . . San Francisco: Press of California Publishing Co., 1893.

Emmons, Thomas and Votario, Homer C. "More about the *Ewing*," *California Historical Society Quarterly*. XXXVI (December, 1957). 307–311.

Fabricas . . . *A Supplement to the California Journal of Mines and Geology*. N.P. California Department of Natural Resources. April, 1952.

Gerson, Noel Bertram. *Yankee Admiral, A Biography of David Dixon Porter*. New York: David McKay Company, 1968.

Gough, Barry M. "British Policy in the San Juan Boundary Dispute, 1854-72," *Pacific Northwest Quarterly*. LXII (April, 1971). 59–68.

Groce, George C., and Wallace, David H. *The New-York Historical Society's Dictionary of Artists in America, 1564-1860*. New Haven: Yale University Press, 1957.

Gudde, Erwin G. *California Place Names*. Berkeley: University of California Press, 1969.

Gudde, Erwin G. "Mutiny on the *Ewing*." *California Historical Society Quarterly*. XXX (March, 1951). 39–49.

Guillou, Charles F. B. *Oregon and California Drawings 1841 and 1847*. San Francisco: The Book Club of California, 1961.

Hoag, Betty Lochrie. "McMurtrie on the Pacific Coast," *La Peninsula, Journal of the San Mateo County Historical Association*. XVI (October, 1972). 11–15.

Johnson, Allen and Dumas Malone. Eds. *Dictionary of American Biography*. Rev. Ed. New York: Charles Scribner's Sons, 1964. 10 Volumes and 2 supplements.

Lewis, Oscar. *George Davidson, Pioneer West Coast Scientist*. Berkeley: University of California Press, 1954.

Lockley, Fred. *History of the Columbia River Valley from the Dalles to the Sea*. Chicago: S. J. Clarke, 1928. 3 Volumes.

Lott, Lieutenant Commander Arnold S. *A Long Line of Ships* . . . Annapolis: United States Naval Institute, 1954.

M. & M. Karolik Collection of American Water Colors & Drawings 1800-1875. Boston: Museum of Fine Arts, 1962. 2 Volumes.

McArthur, Lewis A. *Oregon Geographic Names*. Portland: Oregon Historical Society, 1952.

McArthur, Lewis A. "The Pacific Coast Survey of 1849 and 1850," *Oregon Historical Quarterly*. XVI (September, 1915).

McDonald, Lucille. "Survey Ship *Active*," *The Sea Chest, Journal of the Puget Sound Maritime Historical Society*. V (June, 1972).

Meany, Edmond S. *Origin of Washington Geographic Names*. Seattle: University of Washington Press, 1923.

Monroe, Robert D. "William Birch McMurtrie: A Painter Partially Restored," Oregon Historical Quarterly. LX (September, 1959).

National Parks and the American Landscape. Catalogue, National Collection of Fine Arts. Washington: Smithsonian Institute Press, 1972.

New England Historical and Genealogical Register. XXXI, 363.

Notes. *California Historical Quarterly*. XII (March, 1933). 87.

Porter, Admiral David Dixon. *The Naval History of the Civil War*. New York: Sherman Publishing Company, 1886.

Porter, David D. *Incidents and Anecdotes of the Civil War*. New York: D. Appleton Company, 1885.

Russell, Carl P. *One Hundred Years in Yosemite*. Berkeley: University of California Press, 1947.

Soley, James R. *David Dixon Porter 1831-1891*. New York: D. Appleton & Company, 1903.

Stanley, George F. B. Ed. *Mapping the Frontier. Charles Wilson Diary of the Survey of the 49th parallel, 1858-1862, while Secretary of the British Boundary Commission*. Seattle: University of Washington Press, 1970.

Stenzel, Franz R. M.D. *Cleveland Rockwell, Scientist and Artist, 1837-1907*. Portland: Oregon Historical Society, 1972.

Stevens, Hazard. *The Life of Isaac Ingalls Stevens*. Boston: The Riverside Press, 1900. 2 Volumes.

Swan, James G. *The Northwest Coast* . . . New York: Harper and Brothers, 1857.

Van Nostrand, Jeanne. "Thomas A. Ayers, Artist-Argonaut of California." *California Historical Quarterly*. XX (September, 1941). 275.

Van Nostrand, Jeanne, and Coulter, Edith M. *California Pictorial*. Berkeley: University of California Press, 1948.

Walbran, Captain John T. *British Columbia Coast Names, 1592-1906*. Seattle: University of Washington Press, 1971.

West, Richard S., Jr. *The Second Admiral. A Life of David Dixon Porter 1813-1891*. New York: Coward-McCann, 1937.

Whiting, Joseph S. *Forts of the State of Washington* Seattle: Privately Printed, 1951.

APPENDIX

Collections of Alden's Watercolors

1. Mr. and Mrs. Henry Windsor Adams.
 - 2 Western United States
 - 1 Civil War
 - 52 European
 - 73 Eastern United States

2. Mr. and Mrs. Vernon Dorsey Adams
 - 2 Western United States
 - 1 European
 - 4 Eastern United States

3. Mr. and Mrs. Albert W. Ayers, Jr.
 - 29 Western United States
 - 10 European
 - 35 Eastern United States

4. Honeyman Collection, The Bancroft Library, University of California, Berkeley
 - 1 Western United States

5. Beinecke Rare Book and Manuscript Library, Yale University, New Haven, Connecticut
 - 4 Western United States

6. M. & M. Karolik Collection, Boston Museum of Fine Arts
 - 1 Civil War

7. Provincial Archives of British Columbia, Victoria
 - 2 Western United States

8. University of British Columbia Library, Vancouver
 - 2 Western United States

9. California Historical Society, San Francisco
 - 42 Western United States

10. Library of Congress, Washington, D. C.
 - 4 Eastern United States

11. Captain Edward M. Day, U. S. N. (Ret.)
 - 1 Civil War

12. Harry Downie
 - 1 Western United States

13. Eliza Wright Duke
 - 44 Eastern United States

14. Glenbow-Alberta Institute, Calgary, Alberta
 - 1 Western United States

15. Mr. and Mrs. Robert Herron
 - 1 Western United States
 - 1 European

16. Elizabeth Janes
 - 1 Civil War

17. Kennedy Galleries, Inc., New York City
 - 1 Western United States
 - 37 Eastern United States

18. Mr. and Mrs. J. William McLure
 - 13 European
 - 33 Eastern United States

19. The Old Mission, Santa Barbara, California
 - 2 Western United States

20. The National Archives and Records Service, Washington, D. C.
 - 65 Western United States

21. Mr. and Mrs. Robert W. Orme
 - 4 Western United States
 - 1 European
 - 3 Eastern United States

22. Sarah Alden Parham
 - 11 Western United States
 - 6 European
 - 38 Eastern United States

23. Dr. and Mrs. Franz Stenzel
 - 64 Western United States
 - 2 Eastern United States

24. Mr. and Mrs. Lee Stossell
 - 11 Western United States

25. Washington State Historical Society, Tacoma
 - 62 Western United States

26. Mrs. Harold Cass Weeks
 - 2 Eastern United States

INDEX